Artistic Citizenship

Artistic Citizenship

A Public Voice for the Arts

EDITED BY

Mary Schmidt Campbell
and Randy Martin

Routledge
Taylor & Francis Group
New York London

Routledge is an imprint of the
Taylor & Francis Group, an informa business

F.W. Olin College Library

Routledge
Taylor & Francis Group
270 Madison Avenue
New York, NY 10016

Routledge
Taylor & Francis Group
2 Park Square
Milton Park, Abingdon
Oxon OX14 4RN

Contents

1

Artistic Citizenship

Introduction

RANDY MARTIN

On the face of it, the very idea of artistic citizenship looks like an oxymo-ron. From ancient times to the present, artists have been asked to pay tribute to and have been viewed with suspicion by all manner of officialdom. Plato, who fancied himself a philosopher–king, thought the right music could pro-mote social harmony but wanted to kick playwrights out of his ideal Republic. China's self-proclaimed first emperor, Qin Shi Huangdi (221–209 BC) built extensive public works, including 7,000 terra cotta sculptured soldiers for his mausoleum, but also burned books and banished music. Why would artists seek more of such freighted attentions?

In perhaps the most typical incarnation, the artist epitomizes unsullied individualism, an inner-directed free spirit who answers to the muse, not to the state. Citizenship, by contrast, entails group membership with common privileges and obligations conferred from without and regulated by a national government. Yet in the hurly-burly of experience, where the private realm of the individual leaves off and the public domain of civic life takes up is neither so simple nor clear cut. The realm of the commons where civic engagements are joined provides an arena where personal voice takes flight. Strong per-spectives are forged in dialogue with others. Artists themselves may sense a tension between what can be attributed to talent as a kind of self-possessed natural right and what they seek through training with others as an achieved status—one that is increasingly acquired by means of a college degree.

In practice, art-making is an intricate journey where public and private are at once the vehicle, the route, and the destination. Similarly, the question of what art is for (of its attachments, interests, passions, and commitments) has become inseparable from the matter of how it is brought into the world—from the rigor of training and technical formation to support for production and access to audiences. The keys to artistic citizenship lie in understanding how art and artists are brought into the world. Today, artists' paths to realize cre-ative opportunity most commonly run through professional school, and the lessons as to what the world makes of their endeavors is legible in the swirl of controversies around what can be called public art. No less than artistic

1

citizenship itself, public art and the professional school also could appear to be contradictions in terms. Art in, as, or for the public chafes against the conviction that art exists for its own sake. The professional school—including the arts either as free-standing institutions or as colleges or divisions within a university—similarly rubs against the liberal arts ideal of education as an end in itself, which is devoted not to specialization but to the cultivation of the whole person. The seemingly incompatible terms that compose public–art and professional–school speak to the complexity of the often controversial manner in which art makes its appearance in the world. That, at least, is what I would like to venture here: namely, an exploration of the artist's civic capacities as made legible by mapping what can be learned from the intricacies and tensions evident in public art and the art school.

Public Art

Public art can be understood in a variety of ways. Among them, it can be seen as a site or physical place, as a representation of civic ideas, or as an occasion for people to gather to engage in critical reflection—in short, a way of seeing, a way of knowing, and a way of gathering. These ways of understanding are not necessarily mutually exclusive; they can be evident in the same works of art. Rather, the differences matter for our thinking about art's worldly effects. Sculptures, monuments, and other installations in town squares, parks, and on or around major civic buildings have been in evidence in any number of cultures for millennia. The Sphinx of Egypt, the ornate pyramids of Chichen Itza, the Greek Parthenon, and the twelfth-century Temple of Angkor Wat in Cambodia, site of the Aspara dance, are but a few examples.

Civic monuments have been present since the Republic's inception, and heroic memorials reached their apex under the influence of nineteenth-century beaux-arts traditions. The modern paradigm of public art in the United States can be seen as a response to the urban strife of the 1960s. Tom Finkelpearl pointed out that artists then were called on in a rather unrealistic fashion to right the ills of the city fabric by using public art to engender a sense of a more intimate, premodern community.[1] Policy initiatives meant to use art as a balm to social unrest and to stimulate urban redevelopment were promulgated at all levels of government, whether through commissions from the federal Government Services Organization or, later, the municipally administered 1 percent for the arts programs. The National Endowment for the Arts, launched in 1965, offered initiatives such as its Art in Public Places Program, whose first commission was a sculpture by Alexander Calder called *La Grande Vitesse* (1969) for the Grand Rapids, Michigan, Civic Center. Miwon Kwon, who has written perceptively on public art, observed of such works that the basis of their identification as public "was quite simply their sitings outdoors or in locations deemed to be public primarily because of their 'openness' and

unrestricted access...." The specific attributes of the site "mattered only to the extent that they posed formal compositional challenges."[2]

Public art thus becomes a type of art — one that uses its immediate environment as part of its formal, aesthetic idea. This is art without a frame in the conventional sense. The immediate physical world around the work—city, square, building, park, airport, university campus—becomes its frame. The viewer is invited to consider ordinary surroundings in aesthetic terms; the form of the work extends attention to what is around it. Light and shadow; the extensions of the sculptural lines in the patterns of the urban habitat; and the intensity of color of the sky, street, or shrubbery set against the sculptural form all invest the eye with a heightened attention to the experience of living in a particular environment. What is done with this attention is an open question, and so, too, is how seeing the world aesthetically relates to how one attends to it socially—to the people around us and the concerns that issue from them.

The second understanding of public art is as a form of representation. Here, art can be considered a particular kind of social good that serves as a means to bring forth ideas about our lives together. In this, public art performs a civic function. It seeks to make explicit linkages among the formal properties of a work, its ability to get us to pay attention to our surroundings, and how we value what we perceive. In this, the form and content of public art is fundamentally about how we live together with those around us. Such work rests on a conviction that art is not simply aesthetically enlivening of everyday surroundings but that it is civically ennobling. The representational aspect runs as a thread through the history of public art. The monuments of old, "the hero on the horse," exalted great historical figures around which a nation might be unified that characterized the explosion of nineteenth-century civic sculpture. The populist turn, epitomized by the murals of Diego Rivera in the 1930s, rendered everyday life and ordinary people worthy of artistic memorialization. Community-based works like those of John Ahearn in the mid-1980s and early '90s explored a yet more intimate relation between the artist and certain residents he selected to be the models for his sculptures. In each of these examples, art is treated as the embodiment of shared values—of the nation, public, or community—and serves to integrate through its own legible forms those who might otherwise remain strangers to one another.

The heroic or quotidian figures stand in for what is commonly shared; they evoke sentiments of patriotism, the value of hard work, and the attachment to a location that encourages people to feel they belong together. This sense of mutual belonging, expressed through exemplary figures, lends the artist credibility as providing a social good and not simply a personal statement or private service. Government support of artistic endeavors is justified by treating art as an exceptional type of good, one whose sole purpose is civic engagement and enlightenment. The immediate difficulty lies in separating

good intentions from tangible value—an issue that calls forth both the evaluative criteria for judgment and the question of who is entitled to judge.[3] If art is a highly specialized activity that artists know best, it is challenging to assuage doubts from skeptical politicians, individuals, or organizations that commissions are following highly particularized tastes rather than a general interest. Even if no tax dollars are involved, which is frequently the case for contemporary art like the installation of Jeanne Claude and Christo's *The Gates* in New York City's Central Park, the scrutiny and curiosity over how art comes to represent a common interest remain persistent features of any work that considers itself public. Whether art enjoys government sponsorship or merely tax-exempt status, or whether it requires an official permit for its installation or only police protection as private property, public art rubs up against the state, and some part of the state's function to speak on behalf of the people rubs off on the art. Beyond the particular attributes of a work, public art occupies a space that can confound what constitutes the clear boundary between government authority and private discretion. Controversy issues from this ambiguous border.

The third sense of public art treats it neither as an exceptional type of art nor as an exceptional type of good, for its publicness is not about access or interest; rather, it is treated as a special occasion. Public art hence becomes a vehicle of connection, a means to realize and recognize the commons, a medium for people to gather together to reflect on the very idea of being together. In a world where privacy is typically bound up with a sense of security and where going out in public is conventionally oriented toward commerce, art would treat civic activity, the desire to be critically engaged, as an end in itself. Art-as-occasion is not exempt from expectations of formal aesthetic accomplishment or ideational clarity. The public is, after all, an idea in need of representation as much as it is a tangible ground where folks can gather.

South Cove (1988), Mary Miss's serene harbor within the harbor at Battery Park in downtown Manhattan, or her sublime installation *Framing Union Square* (1998) in the labyrinthine subway station at Union Square, certainly sacralize otherwise mundane places. Art that affiliates with protests and demonstrations operates in a variety of ways, whether as the gigantic figures of Bread and Puppet Theater, which has continued to be active since the Sixties, or as the savvy theatrics of Act-Up, the 1980s activist AIDS Coalition to Unleash Power, or as the ironic protests against the 2004 Republican National Convention in New York City enhanced by initiatives such as Bikes Against Bush and the text messaging system-based Spectropolis. This art helped engage people as part of a civic operation of mobilization for purposes of dissent, it gave voice and comment to a crowd, it captured media attention so that the protest could affect other lives, and it introduced a range of voices—ironic, humorous, outraged, parodic, utopian—into a political gathering usually measured in exclusively strident tones.

Public making, calling the people together, is one of the operations of art, whether in the ancient Greek amphitheater where polis met chorus, or in the call-and-response praise song tradition of the African Ring Shout, or in the Balinese theater-state, which linked court performances to the politics of everyday life, or in the contemporary blockbuster museum show, like Metropolitan Museum of Modern Art's 2003 *Matisse–Picasso*. The unfurling of monuments was once itself a significant public act, as, for example, in 1889 when a quarter of a million Parisians gathered to witness the unveiling of Jules Dalou's "The Triumph of the Public."[4] There is of course no guarantee that art will promote justice and democracy. D.W. Griffith's *Birth of a Nation* (1915) was an allegory of racialist fear and hatred that fanned the resurgence of the Ku Klux Klan. Leni Riefenstahl's *Triumph of the Will* (1935) beautified the Nazi mass rallies used to glorify Adolf Hitler.

When an occasion for gathering is both the means and ends of art, it can be aligned with very different ideas of what the public is and can be seen to either threaten or support the state. Under these circumstances, it is not sufficient for art simply to appear in public; it must understand how to make room for itself and how to join its voice with other voices in public. We would thus want to think of public art not only as a kind of art that concerns itself with access, or as a type of good that does good, but also as the civic practice of artists. This raises the question of where the ability comes from to understand how to craft publics and what ideas, affinities, and commitments people moved by public art might be oriented toward. It invites us to entangle art's means and ends and the artist's ability to create work and the space for it.

Public art so construed reconfigures the relation between public and private at a moment when public figures are judged as much on character as policy and citizens are asked to trade privacy for security. No wonder questions of private character provoke political scandal that so resembles the queasy mix of prurient interest and moral rectitude that swirl around arts controversies. Faith, security, risk, and affection combine uneasily in newsworthy attentions with those people, places and ideas labeled minority, marginal, or foreign. The assertion of properly shared identities jostles against cultural expressions that challenge the consensus conception. The work of artistic citizenship is both to make these fissures legible as matters available to common rumination and to provide a means by which we can navigate and negotiate the differences in our midst so that they become productive and not divisive.

Professional School

As art has become a job for more people, artists have increasingly become formally schooled. Indeed, recognized expertise of a formal body of knowledge is an aspect of what is called professionalization. What was once a response to a calling—a personal apprenticeship passed from generation to generation—has now been treated with syllabi, curriculum, and pedagogy. The pro-

fessional school is modeled on education for a particular occupational ends rather than as an ends in itself. Liberal arts are meant to be holistic, to remove the immediate demand that learning be subordinate to labor. This might work fine when those who attended college need not worry about working, but it would disturb the expectations of a professionalizing world's mandate to school specialists who already knew where learning would lead.

The university-educated artist would add a further wrinkle, both a specialist and, as art itself came to be seen as making people whole, as a model that could be generalized. Further, artists would master techniques and tool their bodies in ways historically associated with craft-based manual labor they would continue to combine their finely-honed physical abilities with the highest faculties of the intellect to generate new creative forms by which people could understand themselves. Rigorous training combined with mastery of art as a discipline meant that art would weave together a craft and a way of knowing, the ability to make something tangible and the capacity to arrive at nuanced understandings about our cultural condition distinct from other academic approaches. The education of an artist would efface the separation between theory and practice, mind and body, which was supposedly at the root of the modern division of labor.

It is safe to say that the entrance of arts into the university has altered the way it is learned and taught. It is also the case that the growth of the arts within the university has signified changes in higher education as such. College education has passed from the imprimatur of the elite to the insignia of the professional middle class, a medium of mobility that promised all who could access it the chance to make themselves into whatever they might want to be. In the middle of the nineteenth century, fewer than 600 institutions granted less than 10,000 baccalaureate degrees. Only one of eight of those receiving degrees was a woman. By the start of the new millennium, well over a million bachelor's degrees were granted, and the number of full-time students had swelled to over fifteen million at more than 4,000 colleges and universities.[5]

During that time not just the quantity of students but also the character of American higher education has changed. The ideal of the liberal arts education as an end in itself is articulated by John Henry Cardinal Newman in his book *The Idea of the University*, published in 1852. By the end of the nineteenth century, new knowledge was meant to master the world, to serve general progress rather than simply individual enlightenment. The research university with its departmental divisions by discipline and ethos of professional specialization gained prominence at places like Johns Hopkins University (founded in 1876), University of Chicago (1890), and Stanford University (1891).

As Christopher Newfield argued, the histories of the large corporation and the research university are mutually, if uneasily, entwined. "The university is a corporate and a utopian environment at the same time, and has been the central site for considering the possibility that once modernity had irreversibly

delivered a world of organizations, the corporate might be made utopian, and the utopian might be post-corporate."[6] The twentieth century saw the university gain in complexity, becoming what University of California president Clark Kerr called in 1963 the *multiversity*. It now required professional administrators of its own to manage the contending interests and demands of its various constituents: students, faculty, patrons, and clients.

The last twenty-five years have seen the rise of what some have referred to as the corporate university, a place where the university offers a veritable supermarket of new products in the knowledge economy.[7] The past two decades have witnessed the advent of proprietary or for-profit institutions and a related explosion in adult education with their on-line, distance-learning programs. There are now over 800 such schools—more than five times the number of research universities. Some of them, like Phoenix University and Laureate University, claim enrollments well over 100,000. Adult education programs are increasingly used by people to retool themselves so that they can move from job to job. At nearly 100 million students they dwarf the number in regular matriculated programs.[8]

The character of the education in the contemporary university has changed with the growth of professional services in the job market. Over the course of the twentieth century manual labor on the factory and farm was replaced by technical knowledge oriented toward practical application. Yet increasingly doctors, lawyers, engineers, teachers, and managers—the occupational basis of the middle class—found themselves working not for themselves but in highly rationalized complex organizations. Especially after the Second World War, access to higher education was an engine of this transformation and to the individual mobility it carried along. Lately, access to higher education and the economic advancement between generations is constricting, as evidenced by the fact that students from the wealthiest quarter of families are six times more likely to receive a B.A. than those from the poorest quarter.[9] When access to higher education is secured, the graduate is launched increasingly into a professionalized world.[10]

In 1970, close to half the undergraduates received degrees in the liberal arts. Thirty years later that number is nearer to a third. Business degrees increased the most, more than doubling in number to over a quarter-million, but although the number of degrees in the arts is far more modest (66,000 in 2002), they too doubled over the same period.[11] In the 1970s alone, the number of working artists in all categories increased by over 80 percent.[12] By 1990 more than twice the number of working artists existed than in 1970, and by 1997 artists in the workforce neared two million, outpacing the rate of increase for jobs in the economy as a whole as well as for professionals in particular.[13] In very broad strokes, the arts saw over a million new graduates in the period, roughly the same number of job opportunities created for artists. That is not to say that every working artist had a degree in hand, but the

demographics were changing. It has been said that in 1980, 20 percent of the working directors in Hollywood had been to film school. By the year 2000 that number had gone up to 80 percent.

In policy terms, the growth of professional education has meant treating students as professionals, in terms of expectations for their work, links to the professional world, and emphasis on measurable success. Perhaps the key policy document signaling the retooling of education around these norms was then secretary of education William Bennett's 1982 report "A Nation at Risk."[14] The document warned that the United States would lose its competitive economic edge due to what it took to be the mediocrity of public schooling. The report was seen to justify cutting aid to public education—federal assistance was halved during Ronald Reagan's two terms—and to promote privatization.[15]

Soon, not just students but also welfare recipients, drug users, criminals, and youth became categories in the population considered to be at risk of failing and of threatening to take the nation with them. Policy initiatives to deal with these domestic issues were framed as wars: on education, on poverty, on drugs, on crime. These in turn became the backdrop for the culture wars to emerge at the end of the 1980s. According to the accusers, like Allan Bloom, Dinesh D'Souza, and Irving Kristol, American culture had become too permissive, and to regain its economic edge new standards of accountability needed to be introduced.[16] Risk could be managed if unwanted outcomes could be subject to a strict and measurable calculus. In education, this meant revising the curriculum along the lines of measurable outcomes and using standardized testing both to measure success and to allocate resources. George W. Bush's "No Child Left Behind Act of 2001" is the legislative consequence of this line of reasoning. It treats primary and secondary students as professionals who must achieve certain measurable thresholds via test performance to justify federal educational funding. Higher education came to be scrutinized and evaluated along similar lines.

For the artist, the association of risk with external measurement and management will seem curious, to say the least. The idea that artists take risks is a sign of the strength of their inner directedness, an expression of their capacity to plunge into the unknown to yield unexpected and novel results. Indeed, the very art said to inflame the culture wars was considered risky, transgressive of established norms, "in your face," and even at times personally dangerous to the artists involved: Consider Australian performance artist Stelarc, who pierces his own body to hang like a mobile, or Liz Streb, whose dancers literally hurl themselves at one another. Just as the idea that art is transgressive harkens back to early twentieth-century avant-gardes, this latest wave of risky art can be traced to the 1980s as well.

The positive connotations of risk were not restricted to artists; the focus on personal responsibility was not simply a civic injunction but was an invitation for households to move their savings into the stock market and to

see their homes as investments, and for ordinary people to undertake fuller participation in financial markets once reserved for the wealthy and professional investment bankers. Education, too, was seen in risk terms: as an investment to affect a positive outcome. If a higher degree increased income by a specifiable amount, one could justify undertaking the debt of tuition for a projected salary increment. Such risk calculus was behind the privatization of higher education and the reduction in government support for it. Though it might accommodate many other motives, higher education would be put under the pressure of being a means for predetermined ends. The art student's question, "Is going to school or even trying to become an artist worth the risk?" would find itself in good company.

The education of artists in universities goes back a long way and has taken many twists and turns. Yale University was first to admit students to study art in 1869, and Syracuse University followed shortly thereafter. By the time the College Art Association was founded in 1912, teaching art had taken precedence over training artists. Art education was being formalized as a professional academic discipline largely to train public school teachers how to use art to encourage a sense of civic purpose. Art was seen to provide young people with a sense of order, and the artist could model the self-discipline and acceptance of refined values needed to turn new immigrants into citizens.[17] Accordingly, many discipline-based art programs—like dance, theater, and film—were initiated in education schools, not as distinct colleges of art. Whereas an MFA was selectively available in the 1920s, it became increasingly available in visual art programs during the 1950s and '60s when, according to historian Howard Singerman, the production of artists became both the subject and the goal of university training, a sign that the question of what art was—not how to make it—had become central to student's experience.[18] When art enters the university it must give up its definition as technique and must become an academic discipline. Singerman's account is insightful, but it also speaks to how discipline specific art school education has become. For actors and dancers, technique remains a vital part of their experience. Filmmakers are promised hands-on training in production. As Judith Adler pointed out, unlike other professional degrees graduation confers no license to practice art; the degree is a credential only for college teaching itself.[19]

While the artistic professions have blossomed along with the professionalization of society and education, professionalization also has presented its own dilemmas for artists. Professionalization has enabled but also has restricted art in more ways than subjecting it to cost–benefit risk assessments. Art is now partitioned by discipline, creating often artificial boundaries around media and techniques that even interdisciplinary initiatives within universities have difficulty surmounting. Art also is restricted by conversations about aesthetic value. Disciplinarity means not just art as a kind of knowledge but also formal judgment over what gets to be called art. The divides between high and

popular culture, peculiar to the emergence of twentieth-century arts markets as much as anything else, have generated much fruitless tension and anxiety over who gets to consider themselves an artist and what the consequences are for saying something is not art.

These aesthetic distinctions often appear to be rooted in economic delineations that are equally difficult to sustain—for example, the difference between commercial and independent art or between for-profit and nonprofit arts organizations. Alternatively, we might consider a different possibility presented by the arts in a university setting: namely, an expanded field of art, a space of generalization rooted or located in a fateful combination of passion, commitment, and knowledge as forms of work. The idea of the committed artist—not one who flees or is free from formative professional context but is grounded in art and in the world—brings us back to the question of citizenship.

Civic Education

Though citizenship may be treated as a birthright, citizens are made, not born. Citizenship is a kind of group belonging that can be described along multiple dimensions at once personal, social, temporal, and spatial.[20] Such multidimensional citizenship provides a range of social attributes: a sense of identity, be it nationally patriotic or globally cosmopolitan; the enjoyment of certain rights, be they legal, political, economic, or social; the fulfillment of corresponding obligations; a degree of interest and involvement in public life; and an acceptance of certain basic societal values.[21] Martha Nussbaum invoked a classical philosophical tradition to call on colleges and universities to promote citizenship by means of a multicultural noninstrumental curriculum. Holistically inclined education "liberates the mind from the bondage of custom and habit, producing people who can function with sensitivity and alertness as citizens of the whole world." Although the United States has taken up liberal education most fully, according to Nussbaum, the "cultivation of the whole human being for the functions of citizenship and life generally" imply a loyalty to humanity rather than allegiance to a particular nation.[22] Nussbaum's calls for reform must contend with the instrumentalizing effects on the curriculum of the professional turn in higher education and with the strident forms of nationalism that have taken the aftermath of September 11, 2001, as justifying a legally enforceable patriotism.

But in many respects the challenges posed by the national focus on terrorism of the past few years are nothing new to the underlying conception of how citizenship is to be imagined and instructed. One strain of thinking about citizenship has surfaced the concern that conflicts emanating from diverse cultural backgrounds of people in the United States might undermine a respect for different viewpoints and might draw people away from civic engagement. By this reckoning, the public arena is too hot, too contestational for all but the most inflammatory participants. In response, some like William Galston have

called for civic education to be "more rhetorical than rational" and to provide "a pantheon of heroes who confer legitimacy on central institutions and constitute worthy objects of emulation." The result would be a "unifying politics of sentimentality in place of apathy, cynicism, or divisive tribalism."[23] Such sentiments can be traced back to Plato's advice that citizens be taught myth to enhance their state loyalty.

Artists today might hear these pleas as a call to action—as an invitation to create epic public art that would elicit strong sentiment so as to bind together the body politic. Such monumental public art has largely gone the way of the nineteenth century. Art that achieves widespread publicity is more likely to be notoriously controversial than famously integrative. Part of the artist's own civic education would seem to be preparation for this very state of affairs, where artists are greeted warily, even when art itself is revered. Carol Becker, dean at the Art Institute of Chicago, observed that young artists respond to this cultural ambivalence with "ontological insecurity." She calls on art schools to "up the ante in our own educational environments."[24]

Art historians have noted that this cultural ambivalence has been an abiding feature of the United States. Public art was "originally viewed by many in the new nation as a luxury incompatible with republican values public art (indeed art in general) was (and continues to be) regarded with distrust."[25] Since the inception of civically directed art in America, there has been controversy around its form, placement, and funding, even as newly wealthy colonists invested in self-portraits to affirm their status.[26] For example, as early as 1781, the U.S. Congress voted to erect a marble column adorned with emblems to honor the American–French victory at Yorktown, Virginia. Although the money was allocated, the memorial was never built. The honor came in the public proclamation of politicians, not in the aesthetic memorialization they might have to live with. These early guardians of the Republic had to contend with the Puritan residues that saw art as a frivolity that might distract from the virtuous path of the fatherland.

It would seem that any prescriptive approach to artistic citizenship, one that made the artist an exemplary representative of the nation, would run aground on the shoals of this tempestuous history. Indeed, the suspicion of artists as marginal outsiders does associate art with a minority status that has allowed it to serve as a voice of marginal cultures. As Vito Acconci put it, art "comes in through the back door like a second-class citizen."[27] The artist is in this respect akin to the foreigner Bonnie Honig suggested is the key to unlocking the secrets of citizenship. The myth of immigrant America treats the foreigner as a supplement to rather than as founder of the nation, which, given the treatment of the indigenous population, was obviously the case. Honig observed that the foreigner can be divided between a good and bad civic object. The latter remains resistant and unassimilated to American culture, thereby affirming that a unifying cultural dimension to citizenship exists. The good

foreigner, on the other hand, becomes the supercitizen, the immigrant who has it all and owes his or her advancement to America's exceptional cultural environment. These people are proof that the system works—that hard work and willingness to embrace self-denial yield class mobility.

The artist, too, is a similarly constructed figure of class mobility, who—driven only by talent—arrives on the scene and succeeds. Artistic creativity enshrines the immigrant drive, the hunger of the foreigner, with the associations of crass materialism that adhere to the nouveau riche. Yet if artists are not in a position to erect national monuments as they were once expected to do, their capacity to serve as model citizens is eroded, and their art no longer mirrors the integrative longing of the state. Honig, who does not consider the idea of artists as foreigners, nonetheless treats the complexity of this situation as an opportunity. She calls on us to pluralize our attachments and to multiply our passions so as to create a mobility of affinities and affiliations among home, profession, community, nation, and world.[28]

This pluralization opens up an interesting prospect for what artistic citizenship might seek to achieve. This achievement would presume that it is possible to amalgamate the private arena of aesthetics, taste, and talent with the public domain of rights and normative expectations. When artists or cultural institutions like universities and museums attend to new constituencies, they operate as what Homi Bhabha referred to as a "minority public interest" that acts to "contradict the idea of a relatively stable and homogeneous cultural citizenship."[29] Art may in the end have something special to say about civic education because of the very ambiguity with which it is inserted into the public arena. Unlike political citizenship, which asks that we take state authority for granted, art compels us to seek in ourselves the authority by which we are obliged to one another in the fleeting, discretionary occasions for publics to gather together. If this is the case, arts controversies have much to teach us not simply about how artists are perceived by the public but also about the very nature of what we take *public* to mean.

The Republic of Art

The state of the arts today does not lend itself to any simple assessment. By some numbers, arts are booming. The number of adults attending live arts events has continued to grow over the past two decades, although the percentage is stable at roughly 4 out of 10, and numbers in the tens of millions across a whole range of artistic activities, performances, shows, and events. Revenues have expanded to over $12 billion for live performance. Television, film, recorded music, and the Internet add hundreds of millions more to the rolls of those touched by the arts, provide billions more in revenue, and are distributed by vast networks of media conglomerates that circumnavigate the globe and stand as international arbiters of public taste and attention.[30] Community-based arts organizations, which have grown from a handful in the

Sixties to several thousand today, have established for the arts a whole range of social purposes and services, whether it be the enhancement of math scores, the fostering of community or democracy, or the assistance of children at risk. Nonprofit arts organizations get about half their funding from contributions, most of it private; in fact, only a tenth of arts funding comes from public monies and only 2 percent from the federal government. Donations to the arts now exceed $12 billion dollars per year, and though hundreds of millions of federal dollars go to a few national institutions like the Smithsonian and the Corporation for Public Broadcasting, most of the policy that governs arts funding is tax law, which provides the framework for private giving and for how institutions manage their revenue.[31]

Yet even as art swirls all around us, a number of recent critics have bemoaned its loss of purpose and its inability to provide a critical reckoning with the deadening conformity in our midst or to reenchant our imaginations by a connection to sensuous and utopian possibilities. Following the philosopher Immanuel Kant the aesthetic realm could create a distinct value system that would engender a critical faculty of public judgment. These at least were the promises offered by modern art: the prospect of negating the alienating existence of mass society and challenging the senses to see the world afresh and full of innovative and expansive form. One author, Aleš Debeljak, stated this view succinctly: "The progressive displacement of radical and innovative impulses by the mechanisms of professionalism, commercialism, and art bureaucracy has brought about modernist art's loss of its negative impulse."[32]

Krzysztof Ziarek catalogued a number of current approaches to art that leave it in a state of aesthetic crisis. Among these are various scenarios of art's death and exhaustion, efforts to turn back the clock to older forms of beauty, a replacement of art altogether in favor of the subversiveness of popular culture, and a fusion of art with technology as either digital or transgenic.[33] Art would need to reinvent itself to transcend these various limitations. Still others see the prospect for art's way out of crisis in the development of a critical audience that has the ability to demand the art it deserves. "Until the public reclaims its right to applaud and condemn, the art of our age will remain in the dark, the self-indulgent plaything of a few."[34]

These views of crisis share a restrictive view of what art can be, typically along the lines of the early twentieth-century avant-gardes of visual artists. As such they seem to miss the collaborative and social nature of creative endeavor that especially characterizes film, theater, dance, and popular music, as well as the turn to performance and installation in visual art itself. More consequentially perhaps—especially if those same avant-gardes are understood as collaborative communities in their own right—the crisis of art restricts the role of the artist in bridging the gap between making and judging art. The Kantian distinction between the sublime excellence of expression and the critical evaluation that gathers a public assumes that the artist participates in the former

but not the latter. Accordingly the artist is asked to be mute regarding the conditions, terms, and meanings by which art makes its way in the world. In this respect, artistic citizenship is the refusal of the divide—but not the distinction—between creating work and creating a public, between art-making and the assembly of a civically engaged capacity to evaluate represented ideas about the world around us.

Recently, some artists have embraced this civic operation. Choreographer Bill T. Jones was accused by dance critic Arlene Croce of making "victim art" when he created a work based on the experiences of people facing death. Croce refused to see the piece, defending her decision on the basis of Jones's referencing her on stage in an earlier piece. Croce felt that her role as a critic was being usurped—that the critic, stripped of a distinctive voice and with nothing to see, was being made a victim of art.[35] As with the controversies surrounding the work of photographer Robert Mapplethorpe, who came under attack by Senator Jesse Helms, or the *Sensation* exhibit of British artists at the Brooklyn Museum of Art, which then New York City mayor Rudolph Guiliani condemned, the formal response of critics and politicians who would pass judgment is to invite the public literally not to see the work in question.[36] Curiously, judgment is based on a refusal to encounter the work and to be part of the public it occasions.

Much of the law that applies to artistic expression revolves around constitutional First Amendment protections from censorship. This law is designed to protect political speech and must be tested by having a clear political message. If a work is deemed offensive it is treated as obscene and does not qualify as an act of speech. As legal scholar Barbara Hoffman noted, for the law "artistic expression is seen as primarily derivative in nature and therefore marginal in value."[37] Not only does this law presume that form and content can be separated in artistic works but also that art is not art at all; instead it is a kind of speech act. According to W. J. T. Mitchell, this slippage helps explain how public arts controversies segregate the actual encounter with art from its reputation. "The confusion of images with speech acts is one reason people can be offended by images that they have never seen."[38] Freedom of speech is really about the context for reception rather than the content of the work.

Art's journey to the public provokes the question of context, of how people are to gather, of what they are to make of being together without any prescribed purpose, of how they are to relate the forms of work they encounter to the world around them. The reduction of art to speech denies it the practical, embodied power of assemblage that has so commonly made it uncomfortable to governments. As Ngugi wa Thiongo aptly put it, "While the state performs power, the power of the artist is solely in the performance. The state and the artist may have different conceptions of space, content, goals of performance, either of their own or of the other, but they have the audience as their common target. Again the struggle may take the form of the state's intervention in

the content of the artist's work, which goes by the name of censorship, but the main arena of struggle is the performance space—its definition, delimitation, and regulation."[39]

No small wonder then, that dance and theater has had its adversaries since the time of the Puritans. Censorship has been a multimedia event. A few examples are illustrative. In 1322 Pope John XXII banned improvised melodic lines during mass. American slave owners proscribed the use of African talking drums. Section 1140a of the New York State Penal Code was used to prosecute plays deemed to corrupt the "morals of youth" like the 1922 production of *The Demi-Virgin*. Hollywood's cinematic output was subject to the preproduction censorship of the Hays Office of the Motion Picture Producers and Distributors of America.[40] Added to this is the issue of economic censorship, which can entail anything from work deemed unfriendly to the profit-taking inclinations of the market to work that offends art patrons' market interests, as Hans Haacke found out when his 1971 show at the Guggenheim where he planned to exhibit the board of director's real estate holdings was canceled by the museum's director.[41]

By contrast, artistic citizenship is an invitation to view the work where the artist forms a partnership with the public. The artist collective Guerilla Girls dons ape masks to conceal individual identities so as to make public statements about the exclusion of women in the art world.[42] The artist-as-critic is in no position to claim a monopoly over what can be said about art, including their own, but rather offers a bridge between the silent world of artistic production and the noisy din around its reception. Artists who make a commitment to speaking on behalf of their work undertake a social compact with their audience that opens routes between creativity and judgment and between who gets to make art and who gets to decide what is done with what is made. The artists' own shuttling between private making and public viewing discloses the limitations on the present incarnation of the public sphere and points to what an expanding realm of civic participation might entail.

Art and Publicity

Today's artists are challenged by the gulf between quantity and quality, the gap between opportunities for art to be made and seen, and by the desire for it to have significant cultural impact. As art has become an industry, its romantic trappings of isolated craft production have been left behind. As appealing as the images of past artistic freedom may be, they can obscure the real difficulties artists have always faced in creating their work and can promote nostalgic longing where artists will be better served by grasping actual obstacles and opportunities. Artists may wear the mantle of heroism uncomfortably. Ironically, select artists now enjoy a public persona that exceeds the reach of the lone hero on the horse. Stardom is more likely to be the equivalent mode of publicity for the artist. Certainly Pablo Picasso, Salvador Dali, Marcel

Duchamp, and Andy Warhol had artistic careers forged in the cauldron of media attention, but their capacity to serve as public intellectuals pales by comparison with contemporary artists whose medium is media, especially film and music.

Because of the cultural value that attaches to fame, some artists have parlayed their creative accomplishments into media access on a range of causes and issues over which they could not have otherwise claimed any particular expertise. Charlton Heston was for many years head of the National Rifle Association. Alec Baldwin defended the value of the National Endowment for the Arts when it came under threat of being eliminated by the legislature. Russell Simmons parlayed his hip-hop profile into a national campaign to get out the vote during the 2004 presidential election. Jeanne Garofalo helped launch the liberal response to the conservatively oriented talk radio show "Air America." Susan Sarandon used her 1993 Oscar acceptance speech to advocate for people with AIDS in Haiti. Rock group U2's lead singer, Bono, has lobbied world leaders to drop the debt they hold on poor nations. Arnold Schwarzenegger leapfrogged from his success in the *Terminator* trilogy to a public run on the California governor's office. In these cases, the ideological orientation of the artists in question varies widely, and silence is maintained as to the relation between creative talent and civic legitimacy. These examples of media mastery pose a number of challenging questions to the notion of artistic citizenship. Though celebrity certainly presents its own standards of success and the famous have proven essential for fund-raising and access to the legislative process, can fame be leveraged to the public significance or influence of art as such? When does celebrity co-opt, and when does it legitimate artists' public interests? How is a message taken to the legislature, and how is it taken public and connected to social movements, arts organizations, and advocacy groups? When art does become a matter of widespread interest, has the nature of media attention made it more difficult to make sense out of what art or artists might contribute to the social realm?

Artistic citizenship is a paradox—one that artists may be well served to embrace. The divide between the private world of aesthetic creativity and the public realm of exhibit has been unkind to many artists. Under such circumstances artists are left free, or alone to make their work, but are stripped of their concern to make room for it in the world. Understandably, artists could be burned by the public unless they develop the means to shuttle between worlds, to create room for their art, and to affirm by acts of speech the work images should be left to do. Public art would become that aspect of the artist's work that concerns how the world is made as art makes its way into the world: how spaces of attention, hope, interest, affiliation, entanglement, commitment, passion, empathy, possibility, and imagination are crafted when people pause to reflect on what it means to be together. This is art's public project, one that can embrace all manner of spaces and interest, all the more so if the

public is to be an achievement and not a passive environment that artists and audiences take up. This public project for art rests on a partial citizenship, both grounded in a particular experience and committed to a specific means of civic participation.

Art schools have become the commons for artists: the place where their responsibilities to one another are posed, where rights of practice are exercised, where ambitions for the world are honed. The university is no refuge from the professional world. Rather, the professional school invites students to take up the development of their own competencies as a means to operate in the world. Poised among affinities—to cultural communities, to professional and aesthetic attentions, to civic engagements—the art school's curriculum should incorporate the commons within it that it would wish on its graduates. The larger trends toward credentialing and professionalization that have brought artists into higher education present an opportunity and a challenge for art schools. They can be precisely the arena where ethical responsibility and artistic excellence intersect, where a commitment to an artistic community is harmonized with civic interests, where art earns its freedom to practice by being worthy of worldly attention. In this the art school might aspire to confer on its graduates nothing less than artistic citizenship itself.

Art in the World

This collection of essays reflects one such effort. It is rooted in an initiative at the Tisch School of the Arts at New York University called the Department of Art and Public Policy. The department formed in 2000 and embodies the school's recognition that young artists and scholars need an opportunity to incubate their ideas outside of the safe haven of the academy in a dialectic with real-world problems. To this end, it offers a revolving suite of elective courses but also a core curriculum that partners with the university's program in expository writing. The year-long experience aims to develop students' interest in critical analysis and reflection on the place of art in the world and their own capacity to make room for themselves as artists by means of a series of art-centered essays. Essay writing—its own aesthetic medium—gives form to the student's individual voice and acts as a forum where student ideas can be generalized as a public voice. In addition, students attend a plenary experience where they encounter others in their cohort from diverse fields of the arts. The lectures model critical approaches to seeing the public operations of art, and students must grapple with a lecture that is a resource for their writing rather than an instruction in how to write.

Each year, the department sponsors an all-school symposium, themed to the mutually challenging relation of art to politics: censorship, democracy, patriotism, and dissent—even the very role of the arts at a research university. The contributors have all participated in one way or another in these events. Some essays, like those of E. L. Doctorow and Ngũgĩ wa Thiong'o, were actual

keynotes; the rest were specially written for this collection and either explore the meaning of artistic citizenship or are expressions of it. They reflect the conversation we have been conducting over the years, one that addresses students, faculty, and artists to the open question of what might constitute their common calling. We look forward to your multiple responses.

Notes

1. Tom Finkelpearl, *Dialogues in Public Art* (Cambridge, MA: MIT Press, 2000). "Just as architects were demonized as the destroyers of the city, artists were unrealistically asked to salvage it" (p. 21).
2. Miwon Kwon, "Sitings of Public Art: Integration versus Intervention," in *Alternative Art New York, 1965–1985*, ed. Julie Ault (Minneapolis: University of Minnesota Press, 2002), 284–5. Kwon's paradigms are slightly different than the ones employed here. Hers are the art-in-public-places model, the art-as-public-spaces approach, and the art-in-the-public interest model, the last of which is part of a new genre in public art. In this essay, I am more concerned with art's operations and social effects, which for reasons I hope will become clear are not most usefully confined to a particular genre—even a very exciting one.
3. This point is made by Arlene Raven in the introduction to her edited volume, *Art in the Public Interest* (New York: da Capo Press, 1993), 1.
4. See Sergiusz Michalski, *Public Monuments: Art in Political Bondage, 1870–1997* (London: Reaktion Books, 1998).
5. U.S. Department of Education, National Center for Education Statistics, *Digest of Education Statistics 2002* (Washington, DC: National Center for Education Statistics), table 171, 205.
6. Christopher Newfield, *Ivy and Industry: Business and the Making of the American University, 1880–1980* (Durham, NC: Duke University Press, 2003), 4–5.
7. The relevant figures here are John Henry Cardinal Newman, *The Idea of the University* (location: publisher, 1852); Abraham Flexner's formulation of research-based professional education, *Medical Education in the United States and Canada* (Boston: Updyke, Merrymount Press, 1910); Clark Kerr's *The Uses of the University*, 4th ed. (Cambridge, MA: Harvard University Press, 1963; and Larry Leslie and Sheila Slaughter's *Academic Capitalism* (Baltimore, MD: Johns Hopkins University Press, 1999).
8. On the for-profit university sector, see John Sperling, *Rebel with a Cause: The Entrepreneur Who Created the University of Phoenix and the For-Profit Revolution in Higher Education* (New York: John Wiley, 2000); and Richard Ruch, *Higher Ed., Inc.: The Rise of the for Profit University* (Baltimore, MD: Johns Hopkins University Press, 2001). For figures on adult education, see U.S. Department of Education, *Digest of Education Statistics 2002*, table 330, 404. For an overview of adult education, see, Harold W. Stubblefield, *Towards a History of Adult Education in America: The Search for a Unifying Principle* (London: Croom Helm, 1988); and Harold W. Stubblefield and Patrick Keane, *Adult Education in the American Experience: From the Colonial Period to the Present* (San Francisco: Jossey-Bass, 1994).
9. John Parker, "Degrees of Separation: A Survey of America," *Economist*, July 16, 2005, 13.
10. See Harold Perkin, *The Third Revolution: Professional Elites in the Modern World* (London: Routledge, 1996); William J. McGlothlin, *The Professional Schools* (New York: Center for Applied Research in Education, 1964), which provides the Flexnerian code; Solomon Hoberman and Sidney Mailick, eds., *Professional Education in the United States* (Westport, CT: Praeger, 1994); and Sinclair Goodlad, ed., *Education for the Professions* (Surrey: Society for Research into Higher Education, 1984) for curricular and institutional developments; and Jeff Schmidt, *Disciplined Minds: A Critical Look at Salaried Professionals and the Soul-Battering System that Shapes Their Lives* (Lanham, MD: Rowman & Littlefield, 2000).
11. Figures on education taken from U.S. Department of Education, *Digest of Education Statistics, 2003*, http://nces.ed.gov/programs/digest/d03/tables/dt297.asp, table 297.
12. Bonnie Nichols, "Artist Employment 2003," (Research Note #87, Washington, D.C. 2004, National Endowment for the Arts).

13. The data is taken from the Bureau of Labor Statistics. See National Endowment for the Arts, "Artist Employment in America—1997" (Research Note, #61, Washington, DC: 1998), 1. Artist's employment had increased at an annual rate of 2.7 percent, as opposed to a 2.4 percent increase for professional specialists and an increment of 1.3 percent in the total civilian workforce. At the same time, unemployment, defined as those actively seeking work but unable to find it, tends to be higher for artists than for the population as a whole.
14. *A nation at risk: the imperative for educational reform: a report to the Nation and the Secretary of Education, United States Department of Education*, by the National Commission on Excellence in Education (Washington, DC: Commission).
15. Gary K. Clabaugh, "The Educational Legacy of Ronald Reagan," *Educational Horizons*, Summer 2004, http://www.newfoundations.com/Clabaugh/CuttingEdge/Reagan.html.
16. Allan Bloom, *The Closing of the American Mind* (New York: Simon and Schuster, 1987); Dinesh D'Souza, *Illiberal Education: The Politics of Race and Sex on Campus* (New York: Free Press, 1991); and Irving Kristol, *Reflections of a Neoconservative: Looking Back, Looking Ahead* (New York: Basic Books, 1983).
17. See Foster Wygant, *School Art in American Culture: 1820–1970* (Cincinnati: Interwood Press, 1993).
18. Howard Singerman, *Art Subjects: Making Artists in the American University* (Berkeley: University of California Press, 1999), 3–8.
19. Judith Adler, *Artists in Offices: An Ethnography of an Academic Art Scene* (New Brunswick, NJ: Transaction Books, 1979).
20. See Martha Nussbaum, *For the Love of Country: Debating the Limits of Patriotism* (Boston: Beacon Press, 1996), 11.
21. These five attributes are named in John Cogan, "Citizenship Education for the 21st Century: Setting the Context," *Citizenship for the 21st Century: An International Perspective on Citizenship*, ed. John J. Cogan and Ray Derricot (London: Kogan Page LTD, 1998), 2.
22. Martha Nussbaum, *Cultivating Humanity: A Classical Defense of Reform in Liberal Education* (Cambridge, MA: Harvard University Press, 1997).
23. See Eamonn Callan, *Creating Citizens: Political Education and Liberal Democracy* (Oxford: Clarendon Press, 1997), 101.
24. Carol Becker, *Surpassing the Spectacle: Global Transformation and the Changing Politics of Art*, ed. Carol Becker (Lanham, MD: Rowman and Littlefield Publishers, 2002), 12, 19.
25. See editors' introduction in Harriet F. Senie and Sally Webster, eds., *Critical Issues in Public Art: Content, Context, and Controversy* (Washington, DC: Smithsonian Institution Press, 1992), xi.
26. As art historian David Bjelajac observes of this contradiction, "Moderate enjoyment of the visual arts particularly signified the alchemical transmutation of the individual self to a higher state of spiritual being." Bjelajac, *American Art: A Cultural History* (New York: Harry N. Abrams, Inc. Publishers, 2001), 108.
27. Acconci quoted in W. J. T. Mitchell's introduction to his edited volume, *Art and the Public Sphere* (University of Chicago Press, 1992), 4.
28. Bonnie Honig, *Democracy and the Foreigner* (Princeton, NJ: Princeton University Press, 2001), 120.
29. Homi Bhabha, "The Subjunctive Mood of Art," in *Unsettling "Sensation": Arts-Policy Lessons from the Brooklyn Museum of Art Controversy*, ed. Lawrence Rothfield (New Brunswick, NJ: Rutgers University Press, 2001), 94. Bhabha argued that the university and the museum fall in the "complex area of the public-cum-private" (ibid., 93).
30. Data on artists and the economy taken from (Washington, D.C. National Endowment for the Arts, 2003) "2002 Survey, Public Participation in the Arts" Research Division Reports, #45. National Endowment for the Arts and Bonnie Nichols, "Artist Employment 2003" Research Note, #87 National Endowment for the Arts Bonnie Nichols, "The Performing Arts in the GDP, 2002" Research Note, #86
31. A map of public and private arts funding is provided by Tyler Cowan, "How the United States Funds the Arts," National Endowment for the Arts, October 2004, http://arts.endow.gov/pub/how.pdf.
32. Aleš Debeljak, *Reluctant Modernity: The Institution of Art and its Historical Forms* (Lanham, MD: Rowman and Littlefield, 1998), 168.

33. Krzysztof Ziarek, *The Force of Art* (Stanford, CA: Stanford University Press, 2004), 6. Ziarek would like to hold out the possibility that art could model alternate ways by which people could relate to one another beyond the conventional models of power based upon domination and subordination but suggests that only avant-garde art is in a position to do so.

34. Julian Spalding, *The Eclipse of Art: Tackling the Crisis in Art Today* (Munich: Prestel, 2003), 9.

35. See Arlene Croce, "Discussing the Undiscussable," *The New Yorker*, December 26, 1994-January 2, 1995, 54–60. For a broader look at the controversy, see Carol Martin, "High Critics/Low Arts," in *Moving Words/Re-Writing Dance*, ed. Gay Morris (New York: Routledge, 1996) 320–33.

36. For sociology of arts controversies of the late Eighties and early Nineties see Steven C. Dubin, *Arresting Images: Impolitic Art and Uncivil Actions* (New York: Routledge, 1992).

37. Barbara Hoffman, "Law for Art's Sake in the Public Realm," in *Art in the Public Sphere*, ed. W.J.T. Mitchell (Chicago: University of Chicago Press, 1992), 127.

38. W.J.T. Mitchell, "Offending Images," in *Unsettling Sensation*, ed. Lawrence Rothfield (New Brunswick, NJ: Rutgers University Press, 2001), 124.

39. Ngugi wa Thiongo, "Enactments of Power: The Politics of Performance Space," in *Penpoints, Gunpoints, and Dreams* (Oxford: Clarendon Press, 1988).

40. For discussions of censorship in various artistic media, see Ann Wagner, *Adversaries of Dance: From Puritans to the Present* (Urbana: University of Illinois Press, 1997); Peter Blecha, *Taboo Tunes: A History of Banned Bands and Censored Songs* (San Francisco: Backbeat Books, 2004); John H. Houchin, *Censorship of the American Theatre in the Twentieth Century* (Cambridge: Cambridge University Press, 2003), 76; and Gregory D. Black, *Hollywood Censored: Morality Codes, Catholics and the Movies* (Cambridge, UK: Cambridge University Press, 1994).

41. Bjelajac, *American Art*, 375.

42. For a discussion of the Guerilla Girls, see Elizabeth Hess, "Guerilla Girl Power: Why the Art World Needs a Conscience," in *But Is It Art? The Spirit of Art as Activism*, ed. Nina Felshin (Seattle: Bay Press, 1994), 309–32.

Bibliography

2002 Survey, Public Participation in the Arts." Research Division Reports, #45. National Endowment for the Arts. http://arts.endow.gov/pubs/NEASurvey2004.pdf.

Adler, Judith. *Artists in Offices: An Ethnography of an Academic Art Scene.* New Brunswick, NJ: Transaction Books, 1979.

Becker, Carol. "The Artist as Public Intellectual." In *Surpassing the Spectacle: Global Transformation and the Changing Politics of Art.* Lanham, MD: Rowman and Littlefield Publishers (2002): 11–20, 12 and 19.

Bhabha, Homi. "The Subjunctive Mood of Art" in *Unsettling "Sensation": Arts-Policy Lessons from the Brooklyn Museum of Art Controversy*, ed. Lawrence Rothfield. New Brunswick, NJ: Rutgers University Press (2001): 93 and 94.

Bjelajac, David. *American Art: A Cultural History.* New York: Harry N. Abrams, Inc. Publishers (2001): 108 and 375.

Black, Gregory D. *Hollywood Censored: Morality Codes, Catholics and the Movies.* Cambridge: Cambridge University Press, 1994.

Blecha, Peter. *Taboo Tunes: A History of Banned Bands and Censored Songs.* San Francisco: Backbeat Books, 2004.

Bloom, Allan. *The Closing of the American Mind.* New York: Simon and Schuster, 1987.

Bureau of Labor Statistics, reported by the National Endowment for the Arts Research Division Note #61 "Artist Employment in America—1997." Washington, DC: National Endowment for the Arts, 1998.

Callan, Eamonn. *Creating Citizens: Political Education and Liberal Democracy.* Oxford: Clarendon Press (1997): 101.

Clabaugh, Gary K. "The Educational Legacy of Ronald Reagan." *Educational Horizons*, summer 2004 (accessed July 2005).

Cogan, John J. "Citizenship Education for the 21st Century: Setting the Context." In *Citizenship for the 21st Century: An International Perspective on Citizenship,* eds. John J. Cogan and Ray Derricot. London: Kogan Page LTD (1998): 2.

Cowan, Tyler. "How the United States Funds the Arts." National Endowment for the Arts, October 2004. http://arts/endow.gov/pub/how.pdf (accessed 2004).

Croce, Arlene. "Discussing the Undiscussable." *The New Yorker,* 1995.

Debeljak, Aleš. *Reluctant Modernity: The Institution of Art and its Historical Forms.* Lanham, MD: Rowman and Littlefield (1998): 168.

D'Souza, Dinesh. *Illiberal Education: The Politics of Race and Sex on Campus.* New York: Free Press, 1991.

Dubin, Steven C. *Arresting Images: Impolitic Art and Uncivil Actions.* New York: Routledge, 1992.

"Earned degrees in visual and performing arts conferred by degree-granting institutions, by level of degree and sex of student: Selected years, 1970–71 to 2001–02," *Digest of Education Statistics, 2003,* Table 297. http://nces.ed.gov/programs/digest/d03/tables/dt297.as p (accessed February 2005).

Finkelpearl, Tom. *Dialogues in Public Art.* Cambridge, MA: MIT Press, 2000.

Flexner, Abraham. *Medical Education in the United States and Canada.* Boston: Updyke, Merrymount Press, 1991.

Goodlad, Sinclair, ed. *Education for the Professions.* Surrey: Society for Research into Higher Education, 1984.

Hess, Elizabeth "Guerilla Girl Power: Why the Art World Needs a Conscience." In *But Is It Art? The Spirit of Art as Activism,* ed. Nina Felshin. Seattle: Bay Press (1994): 309–32.

Historical Summary of Faculty, Students, Degrees, and Finances in Degree-Granting Institutions: 1869–70 to 1999–2000." *Digest of Education Statistics.* Washington, DC: National Center For Education Statistics (2002): 205, Table 171.

Hoberman, Solomon and Mailick, Sidney, eds. *Professional Education in the United States.* Westport, CT: Praeger, 1994.

Hoffman, Barbara. "Law for Art's Sake in the Public Realm." Mitchell, J.T., ed. *Art in the Public Sphere.* Chicago: University of Chicago Press (1992): 113–146.

Honig, Bonnie. *Democracy and the Foreigner.* Princeton, NJ: Princeton University Press (2001): 120.

Houchin, John H. *Censorship of the American Theatre in the Twentieth Century.* Cambridge: Cambridge University Press (2003): 76.

Keane, Patrick and Harold W. Stubblefield. *Education in the American Experience: From the Colonial Period to the Present.* San Francisco: Jossey-Bass, 1994.

Kerr, Clark. *The Uses of the University.* Cambridge, MA: Harvard University Press, 1995, 4th ed. Baltimore, MD: Johns Hopkins University Press, 1995.

Kristol, Irving. *Reflections of a Neoconservative: Looking Back, Looking Ahead.* New York: Basic Books, 1983 .

Kwon, Miwon. "Sitings of Public Art: Integration versus Intervention." In *Alternative Art New York, 1965–1985,* ed. Julie Ault. Minneapolis: University of Minnesota Press (2003): 284–85.

Martin, Carol. "High Critics/Low Arts." In *Moving Words/Re-Writing Dance,* ed. Gay Morris. New York: Routledge, 1996.

McGlothlin, William J. *The Professional Schools.* New York: The Center for Applied Research in Education, 1964.

Michalski, Sergiusz. *Public Monuments: Art in Political Bondage, 1870–1997.* London: Reaktion Books, 1998.

Mitchell, W. J. T., ed. "Introduction." In *Art and the Public Sphere.* Chicago: University of Chicago Press (1994): 4.

Mitchell, W. J. T. "Offending Images." In *Unsettling Sensation,* ed. Lawrence Rothfield. New Brunswick, NJ: Rutgers University Press (2001): 115–33.

National Commission on Excellence in Education. *A nation at risk: the imperative for educational reform: a report to the Nation and the Secretary of Education, United States Department of Education.* Washington, DC: Commission, 1983 [Supt. of Docs., U.S. G.P.O. distributor].

Newfield, Christopher. *Ivy and Industry: Business and the Making of the American University, 1880–1980.* Durham: Duke University Press (2003): 4–5.

Newman, John Henry Cardinal. *The Idea of the University.* London, New York: Longman, Green, 1899.

Nichols, Bonnie. "Artist Employment 2003" Research Note, #87 National Endowment for the Arts. http://arts.endow.gov/pubs/Notes/87.pdf.

Nichols, Bonnie. "The Performing Arts in the GDP, 2002" Research Note, #86. http://arts/endow.gov/pubs/Notes/86.pdf.

Nussbaum, Martha. *Cultivating Humanity: A Classical Defense of Reform in Liberal Education.* Cambridge, MA: Harvard University Press, 1997.

Nussbaum, Martha. *For the Love of Country: Debating the Limits of Patriotism.* Boston: Beacon Press (1996): 11.

Parker, John. "Degrees of Separation: A Survey of America." *The Economist* 16 (July 2005): 13.

"Participation in adult education during the previous 12 months by adults 17 years old and older, by selection characteristics of participants: 1991, 1995, and 1999," *Digest of Education Statistics* (2002): 404, Table 360.

Perkin, Harolld. *The Third Revolution: Professional Elites in the Modern World.* London: Routledge, 1996.

Raven, Arlene. *Art in the Public Interest.* New York: da Capo Press (1993): 1.

Ruch, Richard. *Higher Ed., Inc.: The Rise of the for Profit University.* Baltimore, MD: Johns Hopkins University Press, 2001.

Schmidt, Jeff. *Disciplined Minds: A Critical Look at Salaried Professionals and the Soul-Battering System That Shapes Their Lives.* Lanham, MD: Rowman & Littlefield, 2000.

Senie, Harriet F. and Webster, Sally, eds. "Introduction." *Critical Issues in Public Art: Content, Context, and Controversy.* Washington, DC: Smithsonian Institution Press (1992): xi.

Singerman, Howard. *Art Subjects: Making Artists in the American University.* Berkeley: University of California Press (1999): 3–8.

Spalding, Julian. *The Eclipse of Art: Tackling the Crisis in Art Today.* Munich: Prestel (2003): 9.

Sperling, John. *Rebel With a Cause: The Entrepreneur Who Created the University of Phoenix and the For-Profit Revolution in Higher Education.* New York: John Wiley, 2000.

Stubblefield, Harold W. *Towards a History of Adult Education in America: The Search for a Unifying Principle.* London: Croom Helm, 1988.

Thiongo, Ngugi wa. "Enactments of Power: The Politics of Performance Space." *Penpoints, Gunpoints, and Dreams.* Oxford: Clarendon Press, 1988.

Wagner, Ann. *Adversaries of Dance: From Puritans to the Present.* Urbana, IL: University of Illinois Press, 1997.

Wygant, Foster. *School Art in American Culture: 1820–1970.* Cincinnati, OH: Interwood Press, (1993).

Ziarek, Krzysztof. *The Force of Art.* Stanford, CA: Stanford University Press (2004): 6.

2
The Role of the Arts in a Time of Crisis*

MARY SCHMIDT CAMPBELL

The United States is in a state of crisis; given the nature of this crisis, there is a role only artists and intellectuals can play. First, a word about the nature of the crisis: Make no mistake; there is no physical threat—no genocide, no civil war, and no occupation by hostile forces, at least in the United States. This is not a crisis having to do with kidnappings, abductions, or disappearances. Nonetheless, the crisis is real. The origins reach back at least to when the United States began its inexorable tilt to the political right. With the triumphs of the civil rights era behind us, the possibility of cultural reconciliation in my country had become remote. Indeed, by the late 1980s our divisions and differences erupted into the now-famous culture wars.

During these culture wars, artists, as represented by some members of Congress, were the symbol of what was wrong with America. Senators and members of congress outdid each other on the floor of the Senate and in the House with their performances of righteous indignation against the antiauthoritarian, provocative instigations of certain individual artists whose work represented the antithesis of a conservative right-wing ideology. Around these displays of outrage, there coalesced vocal, well-organized right-wing religious groups who provided political capital to these elected officials. Cultural advocates—the left-wing liberals—made surprisingly little fuss. We seemed curiously unable to frame the debate in a way that connected with a public beyond the world of art and culture. Trained communicators, we failed as public intellectuals. As a result, public funds for individual artists were discontinued, the infrastructure of public support for art and culture slowly collapsed, and institutions daring to present or to exhibit work that dissatisfied conservative ideology were threatened with a loss of public support. The stage was set for muting voices of dissent.

The events of September 11, 2001, accelerated this muting of dissent and debate. The single most troubling action taken by the U.S. government after

* Portions of this chapter were included in a November 10, 1998, lecture on art and human rights delivered at George Mason University and in a lecture, "The Role of the Arts in a Time of Crisis," delivered on June 5, 2004, at Swarthmore College.

the attacks was the passage of the Patriot Act. The Patriot Act radically expands government authority to conduct surveillance of its citizens and to gain access to records of their lives from a range of institutions. The records of libraries, universities, doctors' offices, Internet providers, bookstores, travel agencies—the places where we leave records of our lives—are among those open to scrutiny. American foundations, traditionally sources of financial support that feed independent projects and innovation in our culture, are by no means exempt from the U.S. government's increased surveillance. Failure to abide by the requirements of the Department of Homeland Security could risk a suit of their assets by the U.S. government. My guess is that it is just a matter of time before this threat results in a more cautious conservative agenda on the part of major foundations.

In the sciences the tilt to the right has had an insidious impact on freedom of inquiry and scientific objectivity. In February 2004 a group of sixty scientists, including Nobel laureates, medical experts, former agency heads, and several college presidents, wrote to President George W. Bush protesting the way in which research funds were awarded according to conservative political ideology rather than rational decision making. One former government agent observed that policy decisions are now made not on what will happen but on what certain ideologues want to happen. Noting the reliance on freedom of inquiry and objectivity in the pursuit of scientific research, they wrote, "… This administration has obstructed that freedom and distorted that objectivity in ways that were unheard of in any previous administration."[1]

Add fear to the narrowing of civil liberties and the muting of dissent, and the public has been given a rationale for giving up their rights and privileges. Fear—constant red alerts, fear of further attacks, election tactics that preyed on that fear—clearly convinced the majority of voters in the 2004 U.S. presidential election that the United States needs more, not less, security and protective interventions. For the political right, the elections provided what amounts to a national consensus legitimizing aggressive surveillance.

Suppression of rights in the United States is not new. At the end of the eighteenth century the Alien and Sedition Acts were passed; during the Civil War Abraham Lincoln suspended the writ of habeas corpus; in the twentieth century Jim Crow laws were enacted; and during World War II Japanese Americans were interred, to name just a few examples.[2] As noted in the book *The War on Our Freedoms: Civil Liberties in an Age of Terrorism*, "In each generation America … witnesses a tug of war between the instinct to suppress and the instinct for openness. Today, with the perception of a mortal threat from terrorists, the instinct to suppress is in the ascendancy … The war on our freedoms is just as real as the war on terror and, in the end just as dangerous."[3]

Most recently, large corporations and the press have become eager partners with the government in following the instinct to suppress. One notorious

example of a failed effort was the Walt Disney Company's efforts to keep Michael Moore's documentary *Fahrenheit 9/11* out of the market. Another documentary, however, shown as part of the Sundance Film Festival in January 2005, which critiqued the American presence in Iraq, brought a storm of criticism by Fox Five against Sundance. Its director, Ken Brecker, and its founder, Robert Redford were berated for showing something critical of American foreign policy. Unpatriotic was the charge. And who can forget the indiscretion of Sponge Bob Square Pants, for which he was also publicly berated by the right-wing media. On a serious note, the constant harangues against Public Broadcasting System ultimately led to the resignation of its chief executive officer.

We are a money culture, and money, too, has played a critical role in dividing and silencing dissidents. One egregious example is what has happened to the U.S. public school system. By almost every measure, education is one of the best guarantees of social mobility in U.S. culture. Yet less and less money, particularly for urban, inner-city schools, has left public schools crumbling. Students who go to them often find themselves unable to compete academically for places in the most elite colleges and universities in the United States. When I first came to the Tisch School of the Arts at New York University (NYU), I wondered why more students of color were not admitted. One of the things we found is that students from the most disadvantaged high schools almost never completed our rather complicated admissions process because, for the most part, many of them received virtually no counseling or guidance in these schools where a single guidance counselor might have literally hundreds of students.

Meanwhile, the cost of the most elite U.S. colleges and universities is spiraling out of control. A recent article in the *New York Review of Books* suggested that we are rapidly moving in the direction where we will have returned to the nineteenth century, when college was only for the very rich. National statistics support this observation. Even though the richest colleges in the United States are need blind—that is, if a student is accepted—they award scholarships to cover need; national statistics tell us that 25 percent of the top performers academically in U.S. high schools do not even bother to apply to college. Families in the top 25 percent economically are 13 times more likely to send their children to college than families who are in the bottom 25 percent economically. What has been our national response? Federal and state subsidies to higher education have dropped precipitously, and in most state budgets prisons, which used to be the lowest priority, have replaced education as the number-one budget priority, driving education, in most states, to the bottom of the list.[4]

The retreat in America from the support of art and culture is no different. Once upon a time in the United States, artists and scholars were celebrated as essential to the idea of a democracy. National endowments were established

by Congress to support the work of individuals and organizations. Language used in the endowments' enabling legislation in 1965 was positively lofty. "Democracy demands wisdom and vision from its citizens."[5] The year 1965 was also the year of the Civil Rights Act, the same year NYU's School of the Arts was founded. The school's mission, to be "a daring adventure," resonated with the sense of excitement of the era. Challenging the status quo and risk-taking were core values for NYU's New School of the Arts.

I suppose anyone who asks the arts to play a role in political and social issues should all be mindful of words from a passage of a play by Irish poet Seamus Heaney, *The Cure at Troy*, which is an adaptation of Sophocles's fifth-century play *Philoctetes*. Toward the end, the chorus laments,

> Human beings suffer
> They torture one another
> They get hurt and get hard
> No poem or play or song
> Can fully right a wrong
> Inflicted an\d endured[6]

None of us is naive enough to believe that a poem or play or song can cure anything.

Yet I worry. I worry that Americans have lost a sense of the potency of what we do as artists and intellectuals. I worry that the university is one of the few remaining spaces in the United States where we can have real debate and dissent without fear of reprisal and revenge. I worry that we use the privilege of this protected space to consider the condition of the world around us and the relation of our work as artists and scholars to that world. I worry that as a school of the arts, we are very good at teaching craft, production values, and the vocabularies of our specialties. But are there other lessons our students need to learn? Far be it from any of us to prescribe the type of artist or scholar anyone should become. At the very least, as educators, we have a responsibility to present the full range of how art engages the world. Looking at the twentieth century alone, a partial list of the range of engagement is instructive.

Czechoslovakia

Vaclav Havel and his colleagues led an underground theater in Prague after the communist takeover of Czechoslovakia. Their plays often satirized the absurdities of communist bureaucracy and fueled an ongoing resistance to the Soviet Occupation. Havel has written eloquently about his expectations for theater. Theater, in his words, should be "a living spiritual and intellectual focus, a place for social self-awareness ... a space, an area of freedom, an instrument of human liberation."[7] In 1989, after the fall of the Soviet Union, Havel was elected president of the new Czech Republic.

South Africa

Athol Fugard, John Kani, Mbogeni Ngema, and others mounted plays at the Market Theater in Johannesburg and the Place Theater in Cape Town during the era of apartheid in South Africa. Defying the strict separation of the races under apartheid, these productions boasted multiracial casts, collaborative authorships, and multiracial audiences who, in defiance of South African law, came to see plays that exposed the cruelties and contradiction of apartheid as well as the complicity of big business worldwide.

The plays of Havel, Fugard, Kani, and Ngema, thanks in part to the efforts of Lloyd Richards at Yale University, made their way to American and European stages, giving full articulation to issues worldwide while those same issues were suppressed in the Czech Republic and South Africa and were forced underground. Satire, theater of the absurd even the form of the classical Broadway musical in a work like *Sarafina,* brought the issues in those countries to life and helped to globally articulate issues in both countries. It has been interesting to watch as the artists and intellectuals in these countries have recalibrated their work as the circumstances have changed where they live. Even when no change was instigated, the arts have played a critical role in terms of conscience, moral critique, and collective action.

Kenya

Kenyan playwright, poet, novelist, and essayist Ngũgĩ Wa Thiong'o led a literacy effort in a small Kenyan village in the mid-1970s. Although more than 80 percent of the villagers were illiterate when he first began working there—which was typical for a small rural village at that time—he was able to organize a movement among the villagers to build a theater and with him to cowrite in their own language, Kikuyu, plays that were probing critiques of current social and political practices. Their first effort, one of Ngũgĩ's most important works called *I Will Marry When I Want* (1977) was closed by the Kenyan authorities after nine performances of standing-room-only audiences. A few years later, another play titled *Mother Sing for Me* (1986) so infuriated the authorities that they razed the theater altogether and jailed Ngũgĩ. Though the playwright eventually had to leave his homeland, the Kenyan authorities' response attests to their recognition of the extraordinary potency of the artistic work and the capacity of the arts to inspire the imagination to imagine unimaginable possibilities.

What all of these artists understood was that the work of art commands attention and makes us divert our time and energy away from our day-to-day lives and enter into the force field constructed by it. Having experienced an authentic work of art, we leave the experience seeing the world differently. We know the world in a more profound manner. Protesting and boycotting does

not change us in quite the same way. In an article in the *Guardian* in 2004, British artist Jeannette Winterson observed about the power of art that it

> ... can offer no obvious return, its rate of exchange is energy for energy, intensity for intensity. The time you spend on art is the time it spends with you; there are no shortcuts, no crash courses, no fast tracks ... What art can do is prompt in us authentic desire. By that I mean it can waken us to truths about ourselves and our lives; truths that normally lie suffocated under the pressure of the 24 hour emergency zone called real life. Art can bring us back to consciousness, sometimes quiet, sometimes dramatically ...[8]

In Czechoslovakia, South Africa, and Kenya, not only did the work "waken ... truths" but also the institution of the theater provided the framework for collective action. Audiences were not just spectators; in the case of Ngũgĩ, they were also collaborators and coconspirators in the building of the theater. And in the case of all three countries, the choice of attending was an action—an act of defiance. Sometimes even when the work of art fails to find its audience, the fact of its making and its existence plays a role in a time of crisis.

Chile

Two years before Ngũgĩ began his work in Kenya, in Chile Patricio Guzman discovered that the portability of the then new video cameras gave him extraordinary mobility as he set out to document what he thought would only be a hotly contested congressional election in March 1973. Though Salvador Allende's left-wing Popular Front prevailed in those elections, the U.S. supported Christian Democratic Party continued to challenge the legitimacy of the sitting president. Using the new camcorder with synchronized sound, Guzman used his mobility to interview individuals as they stopped at an intersection; he followed members of parliament into session; he went inside the headquarters where election results were tallied; he captured spontaneous riots and street protest; he attended labor union meetings. His camera was ubiquitous, giving equal time to the Christian Democrats and the Popular Front, though he was an unabashed supporter of Allende. Ultimately he filmed the bombing of La Moneda, the presidential headquarters with Allende inside, and the ascendancy of one of the leaders of the coup, General Augusto Pinochet. Guzman was exiled from Chile and finished his film in Cuba. For the next seventeen years, Pinochet attempted to invent a narrative of legitimacy. Meanwhile, *The Battle of Chile,* banned from the country, remains a narrative of authentic documentary.[9]

United States

In the United States, the rise of hip hop in the South Bronx of New York City came in response to the crisis of hopelessness in the inner city. In the 1970s, *permanent underclass* was the epithet the conservative American press and conservative intellectuals used to describe people living in the inner city in urban areas that had grown impoverished and ruinous. The word *permanent* conveyed emphatically the sense that those of us who lived and worked in those ruined neighborhoods belonged to a caste, a status in the culture from which there was no way out. Nonetheless, out of the most deteriorated areas in the United States emerged not only a new art form, a new way of making music—scratching and sampling—but also scathing social and political commentary.

Many of these young artists later became successful entrepreneurs, finding ways to connect with their audiences and to distribute their work that allowed them to bypass conventional structures. Later, many also became co-opted and seduced by the money culture, and some permutations of hip hop were deeply problematic. Violence, misogyny, and the glorification of the gangster life are not my cup of tea. Whatever we may think of hip-hop culture, however—whatever distorted image of itself it has become—in its earliest manifestations the generative force, its impact on youth culture worldwide, is undeniable. As for the South Bronx, once given up on as forever lost, has long since been rebuilt.

Harlem

My own experience, when I came to Harlem in 1977, also a ruined community in those days, suggests the institutional potency of the arts. I had the privilege of joining a small army of artists and activists who started out in lofts, converted garages, and church basements in northern Manhattan and over time built world-class cultural institutions that were the lynchpin for the slow transformation of this inner-city community.

At the Studio Museum in Harlem where I was executive director for ten years, the almost complete absence of black artists from the history of American art compelled the museum to organize defining exhibitions, to build a permanent collection, and to create a literature around these artists. Catalogue publications published by the museum provided some of the earliest literature on the visual culture of diasporic Africans in North America. Equally as important as the content of the museum's exhibitions and collections was the physical assertiveness of its space. Designed by the black architect Max Bond, the space established a beachhead of physical clarity and beauty amid the ruined buildings of 125th Street. Inside, symposia and lectures provided a place for public discourse on issues of critical importance to the Harlem community. As a young scholar, I felt that my work was important not only to

me or to a community of scholars but also to a larger audience affirmed by the institutional presence of the museum.

But that was thirty years ago. What about now? At the Tisch School a group of faculty and I working independently of each other came to the same conclusion in the mid 1990s. We needed a space: not necessarily a physical space but an intellectual and artistic space within our school. We thought of it as a front porch, so to speak, that opened out onto the world so that we could consider these issues of how we engage with the world. Lorie Novak, photographer and chair of the Department of Photography and Imaging, and Jan Cohen-Cruz, a scholar of community-based theater in the department of Drama, both of whom had considerable experience in constructing opportunities for their students to work collaboratively with a range of communities in New York City, were the galvanizing force within the faculty. Their work directed their students to think about communities outside of the academy and, in some cases, such as the community gardens project headed by Cohen-Cruz, to work collaboratively with the community to author and perform a theater piece.

Both Novak and Cohen-Cruz partnered with the Tisch School administration to create a new intervention within NYU called the Department of Art and Public Policy and the Center for Art and Public Policy. The department awards no degrees and has no boundaries so that faculty who want to teach from all over the school can participate. Graduate as well as undergraduate students can take courses. Though there are only a few full-time faculty in the department, there is also an advisory group of faculty from around the school who vet proposals for courses. The department, however, does have a mandatory set of writing courses for all Tisch School of the Arts freshmen.

Titled "Art in the World," the writing courses form the core of art and public policy. The goal is to teach students to look closely at the world around them, to consider it from multiple often contradictory perspectives, to form ideas, to bring evidence to bear on those ideas, and to do careful readings of authors who have thought deeply about the arts. As one of my students explained to me, we are teaching a way of thinking that, as it observes the world closely, is assertive, defiant and informed. In addition to the core courses, a suite of courses engages students to think about the conditions under which they make art, how they connect with their audience, and the historical circumstances that have impacted the way artists engage the world. Perhaps when the time comes, our students will do a better job than their elders in framing a debate around the arts that connects to a broader public outside of the cultural community. They will be the ones who construct the models for making art that will waken us to our truths, will make a way out of no way, will correct the tilt and bring us back into balance.

Or at least I believe they will. As an educator, I am an idealist. I need to see possibility in the face of every student who sits in front of me.

In closing, I return to the song of the chorus in *The Cure at Troy*. The play was produced in 1990 in County Derry, Northern Ireland. Dramatizing the clash between private vengeance and public responsibility, the play stood as a parable for Ireland's seemingly irreconcilable divisions. After issuing their warning about what a play, a poem, or a song can or cannot do, the chorus concludes with words of hope and possibility.

> **History says, don't hope**
> **On this side of the grave.**
> But then, once in a lifetime
> The longed-for tidal wave
> Of justice can rise up,
> And hope and history rhyme.
>
> So, hope for a great sea-change
> On the far side of revenge.
> Believe that a further shore
> Is reachable from here.
> Believe in miracles
> And cures and healing wells.
>
> Call miracle self-healing
> The utter, self-revealing
> Double-take of feeling.
> If there's fire on the mountain
> Or lightening and storm
> And a god speaks from the sky
>
> That means someone is hearing
> The outcry and the birth-cry
> Of new life at its term.[10]

Notes

1. Dr. Neal Lane, former director of the National Science Foundation and former presidential advisor, is quoted in the Web site article "Preeminent Scientists Protest Bush administration's Misuse of Science," the Union of Concerned Scientists: http:www.ucusa.org/news/press-release.
2. Many thanks lo my husband, Dr. George Campbell Jr., who cited these historical incidents in his commencement speech to the graduates at Cooper Union, May 27, 2004.
3. Richard Leone and Greg Anrig, Jr. (eds.), *The War on Our Freedoms* (New York: Public Affairs Press; Century Foundation, 2003).
4. Sources for statistics TK.
5. Quoted from the National Foundation on the Arts and the Humanities Act of 1965 (Public law 89-209).
6. Seamus Heaney, *The Cure at Troy: a version of Sophocles' Philoctetes* (New York: Farrar, Straus and Giroux, 1991), 77.
7. Vaclav Havel, *Disturbing the Peace: A Conversation with Karel Hvízdala/Vaclav Havel*, trans. Paul Wilson (New York: Knopf, 1990), 41.
8. Jeanette Winterson, "The Secret Life of Us," *The Guardian*, November 25, 2004.
9. Patricio Guzmán, *The Baffle of Chile* (Brooklyn: First Run/Icarus, 1975–76).
10. Seamus Heaney, *The Cure at Troy, Op.Cit.*, 77.

Bibliography

Campbell, George. Commencement speech to the graduates at Cooper Union 27 (May 2004).

Guzmán, Patricio. *The Battle of Chile*. Brooklyn: First Run/Icanus (1975–76).

Havel, Vaclav. *Disturbing the Peace: A Conversation with Karel Hvízdala/Vaclav Havel*. Translated by Paul Wilson. New York: Knopf (1990) 41.

Heaney, Seamus. *The Cure at Troy: a version of Sophocles' Philoctetes* (New York: Farrar, Straus and Giroux, 1991), 77.

Lane, Neal. "Preeminent Scientists Protest Bush administration's Misuse of Science." Union of Concerned Scientists: http:www.ucusa.org/news/press-release.

Leone, Richard and Greg Anrig, Jr. (Eds.), *The War on Our Freedoms*. 1st edition, New York: Public Affairs Press; the Century Foundation, 2003.

National Foundation on the Arts and the Humanities Act of 1965 (Public law 89-209).

Winterson, Jeanette. 'The Secret Life of Us." *The Guardian*, 25 (November 2004).

3
A Polity of Its Own Called Art?

RICHARD SCHECHNER

Ordinary citizenship is tough enough on its own. Why be burdened with a subcategory like *artistic citizenship?* Can a profession enact its own brand of citizenship? Or is being an *artistic citizen* just hot air?

Historically, the practice of citizenship developed as a way to draw people from diverse backgrounds, opinions, and interests toward a common purpose. If the people—as in "We, the people"—remain America's most encompassing civic designation, "I am an American citizen" parses the collective into its individual agents each acting purposely with a commitment to the polity. That does not mean that all citizens agree on policy, values, opinions, what constitutes the public good, or anything else. Citizens must agree on only two things: that the polity is worth preserving; and that preserving it requires participating in its governance.

More needs to be said. The concept of *citizen* is multifarious. Historically, a citizen is of the city, not the countryside; a commoner, not gentry; a civilian, not a soldier. These distinctions no longer hold. What remains intact is that each citizen is an enfranchised inhabitant of a political entity, not an alien—legal or illegal. For Athenians, citizenship was restricted to permanent male residents only—not to women, slaves, and non-Athenians. In the United States, African Americans were not citizens until 1868 when the 14th Amendment to the Constitution was ratified (and even afterward, this citizenship was imperfect); women were not enfranchised until 1920 with the ratification of the 19th Amendment. During the French Revolution, *citoyen* was the term signifying the bond of ordinary people united against aristocratic power, those addressed *monsieur.* Later, the communist *comrade* made the same point. Both terms were relatively short lived. And how different from all this is the *anticitizenship* implied in being a citizen of the world, a cosmopolitan free from the parochialism of this or that place.

Etymologically, the English word *citizen* is rooted in the Greek *khinen*, to rouse or move. Thereby, one of its branches leads to *cinema*, moving pictures, whereas hanging on another branch are such words as *citation, excitement,* and *incite.* But *citizen* also has roots in the Sanskrit *shiva,* the name of the god who dances the world into existence and obliteration. Paradoxically, *shiva* also

means "friendly" and "homey." This root connects to the sense of a citizen as someone who enjoys the privileges and accepts the obligations of belonging to a particular place: for example, one's *home country* and *native land*.

In common usage, to be a citizen means to enact one's affiliation with a place and its people, their aspirations, common purposes, rights, duties, history, and future. Good citizens are willing to lay down their life in defense of the common purpose; bad citizens avoid performing the duties of one who belongs.

To be a *noncitizen* is another matter altogether with many possibilities. A noncitizen may be someone who belongs to someplace else. "She is not a citizen *here*" implies that she is a citizen *there*. Or one can pretend to be a citizen expressly to do harm, as spies and terrorists do. Or one can be rejected, as are millions of today's nomads and stateless. Or one can withdraw to the forest—actually or figuratively—as did Vedic ascetics long ago or, more recently, Henry David Thoreau, who spent his famous year on Walden Pond. Thoreau developed the theory and practice of civil disobedience—a paradoxical performance in which one acts the bad citizen in the service of good citizenship. Civil disobedience demonstrates to the majority just how wrong their laws are. By willfully suffering the consequences, the civilly disobedient exposes, subverts, attacks, and often ultimately overturns these unjust laws. Mohandas Gandhi and Martin Luther King, Jr., inspired and led millions in masterful performances of civil disobedience.

Artistic Citizenship

Is artistic citizenship separable from citizenship in general? Is there a special species of citizenship that pertains to artists only? If so, what are its qualities? Is such a category a good thing? Or to put it another way, is there a polity called *art* to which persons belong, owe allegiance, and derive benefits? If there is such a polity, what practices does being an *artistic citizen* require? Raising money? Helping other artists get their work produced? Forcefully speaking truth to authority even at the expense of losing public financial and other support? Donating one's art to socially uplifting, charitable, or progressive causes? But what about Thoreau-like actions, in violation of the law, performed to change the way things are? Or played out in protest of wrong decisions made by those in authority as Antigone did at the cost of her life? What kinds of laws—the conventions and habits of art, the laws of the state, or both? Is being avant-garde—violating the canons of art—comparable to breaking the law of the land? Do the two kinds of laws operate in tandem or independently of each other? That is, can one be perfectly law abiding with regard to the state and be artistically a law breaker; vice versa, can one be an activist, anarchist, or terrorist with regard to civil society but be conventional as an artist?

Of course, art history provides plenty of examples of both kinds of artistic citizenship, from those who accept commissions from wealthy patrons and entrenched governments to those who explode the bases on which power

stands. There is, also, the very broad middle path, much followed today because of the contradictions in which many artists find themselves living. On this middle path, artists speak out and act up, but only within the rules of the game. There are many tenured radicals (count me one) and house avant-gardists who self-censor when they fill out National Endowment for the Arts or foundation applications or accept work at venues whose curators cannot afford to violently rock the boat. These are all good people trying to make a living and to reform, if not revolutionize, the social order.

The persistence of the jihadist and terrorist movements, which are nihilistic to some and idealistic to others, complicates the matter greatly. Is exploding a bomb in a subway an extreme instance of civil disobedience or of a sociocultural disease? Are these bombs—suicide or not—weapons of choice in a war or an extreme example of a reality show—artwork of those who want to obliterate the polities they attack? Can terrorism and jihadism be both a war and artwork? This is what composer Karlheinz Stockhausen said after September 11, 2001; it is worth looking at a little more closely.

Terrorism and Art

The 9/11 attacks destroyed the World Trade Center, damaged the Pentagon, and crashed a third plane, which was probably headed for the White House or the Capitol, in the woods of Pennsylvania. United Airways Flight 93 never struck its target because passengers banded together to bring that plane down. Given four planes and three targets, why almost immediately did 9/11 mean the destruction of the World Trade Center? Did the jihadists and terrorists know Frank Sinatra's "New York, New York … If I can make it there, I'll make it anywhere"? The World Trade Center was the epicenter not only of the attacks but also of the imaginary that is 9/11. And what kind of imaginary is that? When, a few days after the attacks, Stockhausen was asked to comment, he called the destruction of the World Trade Center

> the greatest work of art imaginable for the whole cosmos … Minds achieving something in an act that we couldn't even dream of in music, people rehearsing like mad for 10 years, preparing fanatically for a concert, and then dying, just imagine what happened there. You have people who are that focused on a performance and then 5,000 [sic] people are dispatched to the afterlife, in a single moment. I couldn't do that. By comparison, we composers are nothing. Artists, too, sometimes try to go beyond the limits of what is feasible and conceivable, so that we wake up, so that we open ourselves to another world.

Also commenting on 9/11 was the 1997 Nobel laureate for literature, Dario Fo, who circulated an e-mail stating, "The great speculators wallow in an economy that every year kills tens of millions of people with poverty—so what is 20,000

[sic] dead in New York? Regardless of who carried out the massacre, this violence is the legitimate daughter of the culture of violence, hunger and inhumane exploitation." Stockhausen's remarks were met with outrage, whereas Fo's hardly caused a ripple. Why?

Fo left art out. He uttered boilerplate left politics: The chickens come home to roost; what goes around comes around; the U.S. imperialists got their just desserts. Ironically, Fo's playwriting and directing is highly political, whereas Stockhausen's grand—some would say grandiose—compositions are apolitical. Stockhausen claimed for art an importance, a place in the real world, not artlike art but lifelike art—art that is action, not representation. As theorized by Allan Kaprow, "Artlike art holds that art is separate from life and everything else, while lifelike art holds that art is connected to life and everything else." Kaprow's lifelike art is sustaining, constructive, and meditative. 9/11, if it is art at all, operates destructively, on the dark side.

Literary theorists Frank Lentricchia and Jody McAuliffe were not shocked by Stockhausen, whom they saw as one of a long tradition of artistic fanatics:

> The desire beneath many romantic literary visions is for a terrifying awakening that would undo the West's economic and cultural order, whose origin was the Industrial Revolution and whose goal is global saturation, the obliteration of difference. It is also the desire, of course, of what is called terrorism. Transgressive artistic desire—which wants to make art whose very originality constitutes a step across and beyond the boundaries of the order in place—is desire not to violate within a regime of cultures (libel and pornography laws, for example) but desire to stand somehow outside, so much the better to violate the regime itself ...

> As any avant-garde artist might, Stockhausen sees the devotion of high artistic seriousness...in the complete commitment of the terrorists... Like terrorists, serious artists are always fanatics; unlike terrorists, serious artists have not yet achieved the "greatest" level of art...The terrorists did the thing that he would do but hasn't yet done, having not yet reached in his music the plateau of "the greatest."

In other words, Stockhausen, and the artists who agree with him, is envious of the artists who devised 9/11. The jihadists and terrorists are center stage, whereas artists are marginalized. A single attack changed world history. What art act can even come a fraction of the way?

But who are those artists? Surely it is not Mohammed Atta and his crew, who would absolutely reject the labels *art* and *artist* in relation to their actions. If there is art in 9/11, it is in the reception: what Stockhausen imagined when he saw the media representations of the attack on the World Trade Center, or

in the unfolding event and its aftermath: what visual artists, performance artists, writers, and artists of any kind do with what happened. There is nothing new in that: Francisco de Goya and Pablo Picasso, not to mention Aeschylus, Vyas, William Shakespeare, Leo Tolstoy, and Ernest Hemingway—from a very long list—made masterpieces from the horrors of war. The question here is different: It is the act itself, not its representation. Can the lifelike tendency in art go too far? But what of nonrepresentational arts such as the martial arts, the art of cooking, or any activity executed with graceful expertise? Is art in this sense mere metaphor? I do not think so. What the nonrepresentational categories indicate is an artistic approach or style that can inflect any activity.

Lentricchia and McAuliffe do not stop by situating the 9/11 attacks within a tradition of transgressive art. They go on to discuss 9/11 in relation to popular culture: how soon after 9/11 the New York site of the attack became "Ground Zeroland," a "mecca" (how's that for irony) for tourists, and a site for nationalist myth making.

> On December 30, 2001, Mayor [Rudolf] Giuliani opened a viewing platform for the folk over the mystic gulf that is Ground Zero, a stage to which he urged Americans, and everybody, to come and experience "all kinds of feelings of sorrow and then tremendous feelings of patriotism.". . . The platform's purpose is to connect tourists to their history at a site that perfectly conjoins terrorism, patriotism, and tourism.

By now the platform is gone, but its intention lives on in the work of the Lower Manhattan Development Corporation.

Maybe I am missing the point. What comes after something like 9/11 can certainly be anything at all: art, commercial exploitation, or reenactment, such as restaging the 1863 Battle of Gettysburg. The fascist bombing of the Basque town of Guernica in 1937 was one thing; Picasso's great, anguished painting *Guernica* is something else entirely. The question before us is can 9/11 in itself be art, or can it usefully be understood under the rubric of art? If so, what kind of artistic citizens perpetrated such a horror? I am exploring the possibility not to validate terrorist actions or to insult the dead and wounded but instead to point out that terrorism and jihadism as art works more on states of mind—and feeling—than on physical destruction. Put another way, the destruction is the means toward the end of creating terror, which is a state of mind. From this perspective, 9/11 was an example of Antonin Artaud's prophetic assertion in "No More Masterpieces" that "we are not free. And the sky can still fall on our heads. And the theatre has been created to teach us that first of all."

A Special Kind of Person?

We artists like to think of ourselves as special. Perhaps all human beings with a healthy self-esteem consider themselves special. No matter: Whether uniquely or universally unique—or somewhere in between—artists tout their peculiarity in regard to both their individuality and their social position. Here I am talking about modern and postmodern artists: artists within societies that mark art as a separate occupation. There have been, and continue to be, plenty of times, places, and cultures where artists are regarded as artisans or ritual specialists, or both, such as the anonymous souls who architected, sculpted, painted, and formed the stained glasses and mosaics of many Romanesque and medieval churches or the shamans who dance, sing, tell stories, and costume themselves so magnificently while they cure or exorcise. However, these differences are evaporating in the heat of the market economy. In today's markets, including the museum market, the works of these anonymous and shamanic artists fetch top euro, yen, and dollar—with the rupee and the yuan on the way.

Returning to modern and postmodern artists, how are they, we special? First, we operate in a way approaching the double agency of moles, spies, and cons. Artists both work within and stand aside from the dominant culture. Many filmmakers, even while trying to make it in "Bollywood, Hollywood," think that artistically they are independents. Actors circulate from media to live, from off-off Broadway to the regional theaters and from art to commercials. Visual artists want their stuff to hang in the trendiest Chelsea galleries but also want to end up in the Museum of Modern Art or even the New York Metropolitan Museum of Art. Vincent van Gogh's trajectory is iconic: from disrespected outsider to masterpiece maker whose work is traded for megamillions. The dream of many an art student is to make it while maintaining both a critical stance in relation to society and an independence from the very success one craves.

Can this triple objective be achieved? Paradoxically, as long as an artist is unsuccessful, she can flaunt her outsider position; but when success kisses her, or even while trying to make it, she must play the game. In today's America—although other countries are not excluded—the game consists of pleasing patrons or producers, private foundations, and government and of knowing how to promote and market one's artistic product—from artifacts to the intangible *it*—to network, and to find sequestered time and space to do the work. All this involves being on the inside to some degree or other. How many lifelong outsiders who also have made it do you know of? The two categories are mutually exclusive. By using the term *outsider*, I mean to say our present-day culture is so media saturated that success equals notoriety. Lonely success is impossible. Take Andy Warhol as an example whose lifestyle and art continue to reverberate. Once Warhol achieved success, he was copied many times over,

which was to be expected, of course, because Warhol was the "King of Copy," his factory the home of his so-called individuality. Warhol's trail is now a superhighway not only linking the pop and the high but also even obliterating differences between the two.

But does being inside and winning at the game preclude being critical of the way things are? Michael Moore's films are simultaneously good box office—relatively speaking—and severely critical. Many other artists in many genres also succeed with the public while maintaining their independence. This is partly because there is no single public, but multiple publics. One finds support within one's own community. In a way, different artists are citizens of different nations. The paradox here is that if we sing to the choir we are not likely to really be effective in reshaping society; and if we insist on bringing our message to the seats of power, we risk retaliation that can damage our careers or even can have more deleterious outcomes. Of course there also is a great deal of art that has no message or that is designed to entertain, not to educate or to criticize. It would be very nice for me to be able to say, "Of course, I can be successful and critical at the same time! I oppose the war in Iraq and support the Kyoto Accords." Sorry, the answer is not so simple.

Societies are increasingly organized according to dominant codes: not merely to ways of behaving but to deep modes of conforming. How one gets money (e.g., appearances managed by presenting organizations, government and private funding, rich patrons) commits artists at all levels to play the game. The game is tightly bound by a myriad of rules. Standing outside this encompassing system is somewhere between difficult and impossible. To be truly independent economically equals failure. And to be part of the managed care system of the arts industry—from arts schools onward into the various professional fields—means that one is playing the game. Of course, individual artists and groups find their niches. And one niche is, naturally, that of rebel, outsider, independent, social and political critic, radical, or whatever you want to call what used to be called the avant-garde. There is nothing outside the game. Is this game the polity called *art*, and does playing the game mean being an artistic citizen? All artists are in the position of either licking or biting the hands that feed them. And if one bites too hard, not only does funding dry up, along with appearances, but the government also comes down. Remember what happened to the NEA Four[1] in the early 1990s and to Steve Kurtz of the Critical Art Ensemble in 2004.[2]

The Polity Called *Art*

Almost always, artistic citizens will hold dual or even multiple citizenships. No one I know is exclusively an artist. Artistic citizens inhabit a conceptual region within a tangible political territory where individuals pay taxes and obey laws. Or, to some artists, the artistic polity is the larger domain containing within it the sociopolitical one. When these citizenships are in harmony,

there is no problem. But when they conflict, individuals must decide how to enact, or to ignore, the conflict. Thoreau acted out his U.S. citizenship by accepting the consequences of disobeying the law. By writing about what he did, he brought his artistic skills to bear on the problem. But he did not play the role of an artistic citizen. He did not go to jail because he was an artist or to make a point about art.

Artists like the NEA Four or the Critical Art Ensemble suffered because of their art. Their artistic citizenship and their U.S. citizenship collided. Many other artists have suffered much more grievously in societies that demand ideological orthodoxy. The Soviet theater director Vsevolod Meyerhold was harassed, arrested, and shot because of his work. The Nazis hounded Walter Benjamin to suicide because he was gay and because he was a leftist intellectual. Bertolt Brecht fled Germany first to Denmark and then to the United States, where, ultimately, he was called before a committee of the House of Representatives to explain his communist beliefs. The day after testifying, Brecht left America for good. There are too many examples from the present as well as the past.

Let us return to the question asked at the outset of this writing: Can a profession enact its own brand of citizenship? Is there is a polity called *art*—that is, an entity populated by artistic citizens dedicated to their particular community? Is anyone an artist who says she is an artist? Are there rules or canons of art? Can we say with assurance that the job of artists is to make works that are beautiful, emotional, critical, and engaged? Cannot art also be ugly, dry, accepting, and detached—or ironic, parodic, and bitter? Are the rules and canons in place both to be accepted and destroyed? Just as civil society encompasses the sheriff and Thoreau, does artistic citizenship not include the conventional artist and the avant-garde experimenter? The important thing may be for artists to know what kind of work they are doing in each particular circumstance. But the opposite also may be true: to strike out into the unknown without predetermining what the process or outcome will be. Do artists hold the mirror up to nature or construct a separate reality, or both, depending on the work, the artist, and the circumstance? Should art be artlike or lifelike? Are ordinary activities, political acts, and terrorist attacks all subsumable under art? Is art the practice of artists or a method of critical inquiry or both? And if it is not possible to define what art is or what it does, how can we possibly say what an artistic citizen is?

So many questions; so few answers.

Notes

1. In 1990, responding to pressure from Congress and the right, John Frohmeyer, head of the National Endowment for the Arts, acting under instructions from the National Council on the Arts (an advisory committee of elected officials, academics, producers, and a few artists) vetoed grants already unanimously approved by a peer review panel and destined for Karen Finley, John Fleck, Holly Hughes, and Tim Miller. Frohmeyer

said he was bowing to the "political realities." In 1993, after going to court, the NEA Four were awarded money equal to the grants they were denied. However, the NEA by then had stopped giving any grants to individuals. The result has been a distinct lessening of NEA support for experimental, risky, and edgy art. See Phelan (1991) for a fuller exposition of what happened and its consequences.

2. The Critical Art Ensemble, a performance group specializing in connecting art and the sciences, was scheduled to participate in a 2004 Mass MOCA (the Massachusetts Museum of Contemporary Art) show, The Interventionists: Art in the Social Sphere. CAE's installation was Free Range Grain, dealing with genetically modified crops. The installation was designed to address the question, "How can artists and the pubic become engaged in complex sciences like biotechnology, sociology, and anthropology?" Free Range Grain never opened. According to Rebecca Schneider and Jon McKenzie: "On the morning of 11 May, two weeks before the opening of The Interventionist show, Steve Kurtz awoke to find that his wife had passed away in the night. If the death of a loved one was not tragic enough, Kurtz's 911 call to EMS set off a long and troubling set of events. Soon Kurtz found himself surrounded by regional terrorism investigators, FBI agents, and the federal Joint Terrorism Task Force. Their suspicion: possession of illegal biological agents. [...] News images showed agents in HAZMAT suits going in and out of the house, the street in front closed off with police tape. The Kurtz residence in Buffalo, New York, doubles as a studio for Critical Art Ensemble. As CAE's recent work has focused on the biotech industries, the main floor of his house contained laboratory equipment, petri dishes, and biological samples. Reportedly, it was these scientific art materials that led authorities to contact federal officials, who detained Kurtz and later arraigned him before a federal grand jury, even though state investigators declared his house safe and the suspected organisms harmless" (2004:6). Eventually the domestic terrorism charges were dropped. But as of this writing, Kurtz is still charged with mail and wire fraud because of purchasing the bacterium serratia marcescens for use by Kurtz in his artwork.

Bibliography

Artaud, Antonin. "No More Masterpieces," in *The Theatre and Its Double* (New York: Grove Press, 1958): 74-83.
Erlanger, Steven, "A Nation Challenged: Voices of Opposition," *New York Times* 22 (September 2001): section B, 12.
Kaprow, Allan. "The Real Experiment," *Artforum* XXII no. 4 (1983): 36-43.
Lentricchia, Frank and Jody McAuliffe. *Crimes of Art and Terror* (Chicago: University of Chicago Press, 2003): 100-3.
Phelan, Peggy. "Money Talks, Again," *TDR* 35, 3 (1991): 131-41.
Schneider, Rebecca and Jon McKenzie. "Keep Your EYES on the FRONT and WATCH YOUR BACK," *TDR* 48, 4 (2004): 5-10.
Spinola, Julia. "Monstrous Art," *Frankfurter Allgemeine Zeitung*, English edition, 25 (September 2001).

4

Encounters with Censorship[1]

NGŨGĨ WA THIONG'O

It was a debate about censorship that made me turn to writing. I was sixteen, in the last year of my primary education, and I had just been introduced to Charles Dickens and Robert Louis Stevenson by one of our teachers. I came from a rural community in colonial Kenya, so books were a rare sight in our lives. For me and my friends who were used to oral stories around the fireside in the evenings, it was quite a discovery that people could actually tell stories through writing—such interesting stories, too. One did not have to wait for the evening to hear them; one could read them, as I most certainly did, at any time of the day and night and even under the desk during a dull lesson. For me these writers were a special category of beings. I wanted to join their company, and outside the classroom I shared my secret desire with one of the students with whom I also shared books that came my way. "Why not?" was his response. It was then that the debate began.

I believed that one needed a license to write—that if one wrote without some kind of written permission, one would be arrested and most certainly be thrown into prison. If teachers needed training and a certificate to teach, why would writers not need the same? But my friend had a different view and said that one did not need a license to write—that there was no way one could be imprisoned for writing books. The exchange took place in 1954; later the following year, he and I went to different schools—he to a teacher training college and I to secondary school—and as far as I was concerned that was the end of our unresolved debate. But my friend never forgot the exchange, and his first act in his first year was to write a story he called a book to prove to me that one did not need a license to write.

That was in colonial Kenya, then seething under a state of emergency declared by the British colonial state in 1952 in its fight again the Mau Mau guerrilla struggle for independence. As part of that antinationalist fight, the British had banned songs, dances, books, and newspapers they deemed to be on the side of the independence movement. Although this did not crop up in the debate between my friend and me, my own concerns may have been derived from that environment of censorship. My friend never went beyond the first chapter of his self-proclaimed book, but he had made his point. He

had not asked for anybody's permission to write his unfinished book, and he did go on to finish his teacher training program and to become a licensed teacher. Most importantly, he was not arrested and imprisoned.

I recalled that debate when at the midnight hour of December 31, 1977, the police of an independent Kenya came for me, their first act raiding my home library. They collected any books with the titles that bore the words *socialism* or *politics*. But what seemed to make them happy was their seizure of typed copies of the play *Ngaahika Ndeenda* [I Will Marry When I Want], whose license to be performed at Kamoriithu Community Education and Cultural Center in Limuru had been withdrawn by the state six weeks earlier. The debate kept resurfacing in my mind when at Kamoto Maximum Security Prison I was stripped of my name and of any rights to books and writing material. All letters—incoming and outgoing—had to go through a prison censor.

In prison, under those circumstances, I could not help but reflect on censorship and the free circulation of ideas, revisiting, if you like, the debate my friend and I had engaged in twenty-five years before. We did not give it the name *censorship*, but our exchange had been about the basic issue that underlies the question of censorship: the right to freely express and receive ideas.

Censorship is an act of regulating the shape, form, and content of ideas by a centralized religious or secular authority with powers to initiate and to carry out punitive measures in the name of the moral welfare of a group, a community, or the nation. It involves the subjection of intellectual value to moral worth in the tradition of one of the rulers of one of the German states in the nineteenth century who, at the University of Jena, proclaimed that what he wanted from the university were not educated men but obedient subjects. Quite often the centralized authority is the one that defines the moral worth, in turn becoming the sole judge of the correct relation of the offending ideas and practices to authorized moral value. The end clearly is to control the conduct and opinions of a community through a regulation of their intellectual diet—especially of political beliefs and ideologies—to bring about conformity to an established norm. Censorship becomes the means of containing an opposing view, especially one that seems to challenge an existing view of the desirable moral order.

This is well illustrated in *Galileo*, a play in which Bertolt Brecht[1] dramatizes the struggle between the polemic and the Copernican systems. Galileo Galilei, who with the newly invented telescope was able to prove the truth of the Copernican system that the earth is not the fixed center of the universe, returned to Florence, Italy, with the belief that once the Pope and the defenders of the old system looked through the telescope, they would be able to see the truth for themselves and hopefully would abandon their old belief in the immutability of the earth. Some of the experts looked and argued fervently against what they saw. Others refused to look through the telescope. Galileo pleaded, "Gentlemen, I beseech you in all humility to trust the evidence of

your eyes."[2] It is one of his friends who later enlightened Galileo, showing him that censorship has more in common with the fear of truth than the defense of the truth:

> Galileo, I see you setting on a fearful road. It is a night of disaster when a man sees the truth. How could those in power leave at large a man who knows the truth, even though it be about the most distant of stars? Do you think the pope will hearken to your truth when you say that he is in error? Do you think that he will write in his diary: January 1610—Heaven abolished?[3]

We tend to think of censorship too often in terms of the secular powers of the erstwhile communist regimes and right-wing dictatorships of the twentieth century, but in fact religious institutions and orthodoxies have been historically the censorious sites of those intellectual diets deemed harmful to the faith and morality of their adherents. The *Index Librorum Prohibitorium* [Index of Censorship] of the Catholic Church initiated in 1559 by Pope Paul IV, with its list of prohibited texts, became the model of those lists so beloved of colonial and postcolonial powers.[4]

Censorship, whether carried out by religious or secular institutions, has as its immediate and main object the prevention of the consumption of an intellectual product in the form of words, exhibitions, or performances, which is why lists of the forbidden become the principal form in which censorship expresses itself. This is also the form that conjures up images of a group of men sitting down in half-lit corridors of power with scissors or pencils in their hands ready to rule out and to cut out the undesirable word in a newspaper or the undesirable image on celluloid. This form is replete with absurdities and comical contradictions satirized in James Thurber's story of the land of Wonderful O, where the letter O is banned from the alphabet. One can see the consequent disaster: good and god become *gd*. Orange becomes range.[5]

In her paper *The Stage and the State*, Ruth Underhill told of the censorship of parts of Shakespeare's *Richard II* in the reign of Queen Elizabeth I.[6] All plays of the time had to be approved by a court-appointed master of the revels. Three editions of *Richard II* were published without the scene in which Richard II abdicates the throne; this phenomenon was not dissimilar to Shakespeare being censored in the reign of Haille Sellassie of Ethiopia. In a production of *Julius Caesar*, it was not Brutus who stabbed Caesar; it was Caesar who stabbed Brutus. For how could a monarch with claims to divinity die in the hands of a common mortal?

Some of the absurdities arise from the fact that the censors cannot possibly have the time and the stamina to read all the books and watch all the videos being produced. In H. Kamuzu Banda's Malawi, the censorship board became the main underground distributors of forbidden videos.[7] The

members sometimes took home the more alluring videos to show and titillate a trusted few; of course, the trusted few had their own trusted few. Later the board imploded under the weight of its own contradictions. To simplify its tasks, a censorship board may often be guided by key words here or there that become the signal for putting a certain work on a prohibited list. This can result in a censorship board prohibiting a book actually favorable to the regime. The South African apartheid regime once banned Anne Sewell's book *Black Beauty*, the story of a horse, because of the implication that the color black could be beautiful. There the word *black* was the signal. The Kenyan government, for instance, simplified its task by simply outlawing all books published in Peking, China. So in the Eighties people were absurdly sentenced to long prison terms when caught with a text by Albert Einstein if it had publishing origins in China—Peking in particular—but the same work was presumed harmless if published by any of the Western publishing houses. The works of Karl Marx, Vladimir Lenin, Fidel Castro, and Mao tse Tung, published by Harvard University Press for example, were safe to read, but the same texts became revolutionary and subversive if they carried a Chinese imprint. The police who raided my home library were looking for a Chinese imprint of those books that bore the title of political and socialism and liberation.

When in 1986 my novel *Matigari* came out and people started talking about the hero as a seeker of truth and justice, the Moi regime, thinking that people were talking about a real live character, sent police to arrest Matigari, the main character. Later they banned the book.[8,9,10]

The absurdity also can come from the victims of censorship. There is Brecht's poem on the subject of burning books that satirizes such a situation. The poem tells of a certain regime that commanded that all books with harmful knowledge be burned publicly. But one of the best writers, moreover—one whose works had always been critical of the regime—was dismayed to that find his books were not on the list of those to be burned.

> He rushed to his desk
> On wings of wrath, and wrote a letter to those in power
> Burn me, he wrote with flying pen, burn me!
> Haven't my books[11]

Always reported the truth? And here you are Treating me like a liar! I command you: burn me!

In its attempts to prevent the consumption of the intellectual product, censorship can go beyond this legalistic form of lists of books to be banned and burned. Censorship can reach out to the means of realizing the intellectual product. A regime, an authority, can bar access to the performance space, for instance. This can take crude forms. In 1982 the Kenya regime literally locked

out performers of the Kamorootho from the National Theater at the University of Nairobi, and later it sent three truckloads of armed police to raze to the ground the open-air theater built by the villagers after outlawing the group of performers. But barring access to the performance space also can take the less crude form of withdrawing public funds for the arts. Rudy Giuliani, former mayor of New York City, exemplified this form when he threatened to withdraw funding for the Brooklyn Museum because he objected to certain items in an exhibition. A regime also can bar access to the means of literary production—pen and paper, for instance. I experienced this at Kamoto Maximum Security Prison, where I ended up writing my novel *Devil on the Cross*[12] on toilet paper. But outside the prison walls, such as where publishing houses are controlled by the state, the allocation of paper can determine the line of intellectual production. It happened in many of the community regimes of the East and in many publishing bureaus of the colonial regimes in Kenya, Zimbabwe, and South Africa, where the colonial state only funded the production of books by Africans only if they shied away from politics.

Now one of the most important means of production of knowledge is language, and the suppression and devaluation of languages is one of the surest ways of preventing the realization of the product of intellect. In fascist Spain, nonspanish languages were driven underground. About two years ago I was invited to give a few lectures in the Basque Country, where I was told the most harrowing stories of parents teaching their children the languages forbidden by Francisco Franco's fascist regime—often risking their own lives to do so. When Africans were carted from Africa to America and the Caribbean islands, the first act of the intellectual suppression was the repression of African languages. The same happened in colonial Africa. The books and newspapers banned in Kenya at the time I was having that debate with my friend were only those written in African languages. In postcolonial Kenya, the same hostility to African languages continues, and part of the reason I was detained was that I wrote in an African language. Only a couple of weeks ago the Kenya regime threatened to ban the only two radio stations that broadcast in African languages, and it is only the fear of losing money from Western donors that has stayed the hand of the regime.

The intellectual production in the world today is dominated by a handful of European languages that are best exemplified in the operations of the United Nations. Part of my joy in being at New York University (NYU) was their willingness to house and to fund a journal in the Gikuyu language, *Mutiiri*. They also supported the recent and first-ever conference on writing in African languages, which was held in Asmara, Eritrea, in January 2000. Out of this meeting came the Asmara Declaration, in which African scholars and writers from the different parts of the continent affirmed their belief that African languages have the right, the duty, and the responsibility to speak for the continent.

But we should not forget the political and economic environment, which often means that a given community and social class is unable to produce ideas either because of the economic restraints or because of the political environment of repression of democracy.

Let me now touch on one more form in which a given regime can affect adversely the production of knowledge: controlling the body of the producer. This is often a byproduct of the climate of political repression in general. Throughout history, intellectuals have been hounded into prison, exile, or death. We can think of the better-known cases of the execution of Socrates in ancient Athens, the crucifixion of Jesus Christ, and the burning of nonconformist intellectuals during the Roman inquisition; less-known cases include the killing of writers in apartheid South Africa and in Idi Amin's Uganda. I cannot think of a single country in the history of ideas where intellectuals have not escaped prison or death by flight to other countries. Even Plato had to flee to Egypt. Aristotle fled Athens, saying that he was not going to let Athens offend twice against philosophy. Jesus and Mohammed also took flight to other countries. Controlling the body of the producer is not only an attempt to prevent further realization of the intellectual production on the part of the affected intellectual but also an exemplary warning to the population as a whole. The affected intellectual is used as an example of what would happen to other rebels against the authorized norm.

One could argue that there has always been a struggle between forms of censorship and forms of a restless search for knowledge. The biblical story of Adam and Eve in the Garden of Eden in some ways exemplifies this struggle. Note that the forbidden fruit is literally one that grows on the tree of knowledge. In that case Eve must choose between authorized bliss in the Garden of Eden and the risky business of knowing. The development of ideas begins with the desire to know and try out that which has not been tried before. Development of the human society—at least the intellectual part of it—begins with the desire to bite the forbidden fruit, and this desire and willingness to do so has always been a part of the makeup of those at the frontiers of knowledge.

Among the books that slipped through the prison censor at Kamoto Maximum Prison was Aristotle's *Metaphysics,* and in it I came across a statement that I held onto in my prison days. Aristotle argued that the investigation of truth was both hard and easy. An indication of this was the fact no one was able to attain the truth adequately while on the other hand we do not collectively fail but every one says something true about the nature of truth and I quote him, "while individually we contribute little or nothing to the truth, by the union of all, a considerable amount is amassed."[13] He goes on to say that we should be grateful not only to those with whose views we do agree but also to those with more superficial views, "for these also contribute something by developing before us the power of thought." This must be one of the earliest defenses of diversity and tolerance of contradictory views and positions. Walt

Whitman accepts[14] as part of his reality that he contradicts himself. Mao tse Tung[15] once talked of a hundred thoughts contending so that a hundred flowers could bloom.

I love the image of the flower. It is expressive of the beauty of diversity but also the essential equality on which diversity must be founded, for no flower is really more of a flower than another flower on account of its different color, shape, or size. A flower is also a product of a process—the roots, trunks, branches—but it is also the beginning of a new process; it is the flowers that carry the seeds of a new tomorrow.

Given the nature of development as a struggle between what has been and what will be, I believe that there will always be forms of censorship as the old tries to conserve what is—particularly through the instrument of the state as centralized authority—and the new trying to reform what is already there. So there will always be a struggle between the tendency toward reformation. Although censorship may not end, it must surely be put on the defensive for it to justify itself on the bar of reason, necessity, democracy, and that principle so well enshrined in Article 19 of the Universal Declaration of Human Rights.

> Every man and woman has the right to freedom of opinion and expression, including freedom to hold opinions without interference and to seek, to receive, and to impact information and ideas through any media regardless of frontiers.[16]

I believe that art as an embodiment of the possible is essentially at variance with censorship and that universities exist to produce not obedient subjects but seekers of truth. The creation of the Department of Art and Public Policy at NYU is therefore a most hopeful sign, and it should institutionalize the struggle for the opening of the frontiers of the possible in the enhancement of human freedom in equality and diversity.

My friend was right after all: One must never need a license to think, and we all have to work for a world in which no ones needs a license to think, write, and circulate ideas.

Notes

1. Brecht, Bertolt. 1961. The Life of Galileo in Bertolt Brecht Plays, trans. Desmond/Vesey. London Methuen & Co. Ltd.
2. Brecht, Galileo, scene 4, 265.
3. Brecht, Galileo, scene 3, 257.
4. The Catholic Church. 1559–1966. Index Libronum Prohibitorium.
5. Thurber, James. 1957. The Wonderful O. New York Simon and Schuster.
6. Underhill, Ruth. 1995. "Stage and State The Censorship of Richard II." Individual Studies. [Electronic text], Department of English, University of Victoria.
7. H. Kamuzu Banda's Malawi 1958-1993 President for Life, Government of Malawi (1971-1993), President, Government of Malawi (06 Jul 1996-21 May 1994), Foreign Minister, Government of Malawi (1964-1993), Prime Minister, Nyasaland (01 Feb 1963-06 Jul 1966), Leader, Malawi Congress Party (1958-1994).

8. Thiong'o, Ngugi Wa. 1989. Matagari. New Hampshire, CT: Heinemann Publishing.
9. The Moi Regime, Daniel Torroitich arap Moi (born September 2, 1924) was the President of Kenya from 1978 until 2002.
10. Thiong'o, Ngugi Wa. 1989. Malagari.
11. Brecht, Bertolt. 1998. "The Burning of the Books," Bertolt Brecht Poems 1913-1956, ed. John Willet and Ralph Manheim with the co-operation of Erich Fried, trans. John Willet. New York Routledge p. 294.
12. Thiong'o, Ngugi Wa. 1982. Devil on The Cross. New Hampshire, CT: Heinemann Publishing.
13. Aristotle. 1971. Metaphysics (Book II, Chapter 1, 1), Oxford Clarendon Press.
14. Whitman quote—general knowledge.
15. When Mao tse Tung addressed a session of the Supreme State Conference in Beijing, the Chinese Communist Party (CCP) chairman called for a relaxation of constraints upon the nation's intellectuals. Moreover, Mao called on the intellectuals themselves to engage in open criticism of the Party. This became known as the Hundred Flowers campaign.
16. United Naions, The Universal Declaration of Human Rights, Article 19, 15.

Address to the Students of the Tisch School for the Arts, New York University, September 14, 2001

E. L. DOCTOROW

Given the death and devastation visited on this city, this country, by malign, religiously brainwashed nihilists—the shock we feel, the suspicion that this is the true beginning of the twenty-first century and that our modern life as a Western democratic republic has made a sharp turn in the direction of the unknowable—perhaps it may seem as if our theme this morning, our discussion of art and its importance, is rendered quaint or even ridiculous. What is the point of sitting alone in a room and writing. Why are actors on a stage of any importance. What is any art but playtime, indulgence, mere embellishment on the deadly business of life, when the voices of singers can be stopped in their throats by the sickening thunder of collapsing skyscrapers?

But as I think about it, the catastrophe renders our theme acutely, even urgently, relevant. My friend and colleague Don De Lillo has said that whereas writing used to change the world, the agent of change in our time is terrorism. I am not sure I agree with that. I think the terror of our times comes of writing—that as between terrorists and writers, we have in effect a conflict between the old writing and the new writing and between the writing of the ancients—the sacred texts that still powerfully endow their fundamentalist interpreters in some parts of the world with a license to kill in the name of God—and the newer writing of the post-Enlightenment societies of the Western democracies whose authors are multiple and without holy credential.

So I will talk here about the role of art in a democracy, which is the theme of this conference, and will come around, if I can, to show you how everything connects.

When an American novelist sits down to write a book she does not contemplate the role of art in a democracy. I am sure the role of art in a democracy was never a thought in the mind of Jackson Pollack as he did his drip painting in his studio in Easthampton, or of Tennessee Williams while he was writing *Streetcar Named Desire*. In our democracy, art happens as an act of person differentiation and is usually created without undue consciousness of its social

51

consequences or responsibilities, though these may be made clear to the artist when the work is done and reviled by critics or condemned for indecency by autocratic municipal officials, is taken off the shelves of high school libraries, or leads to reduced or canceled federal and corporate arts endowment budgets. But this is not to say art becomes aware finally only of injustices done to itself. The novelists, the playwright, the painter all live in the composition: The composition does the thinking and will be aware of its social consequences or programmatic intentions to the degree that the author or artist is not. In a democracy a work of art can be brought into being by nothing more than a private excitement in the mind of the artist, a word or two, something he sees in the street, a musical phrase, but just as likely by a presiding anger in his breast or the sorrowful burden of his knowledge of the past. The writer of the most personalist story, a roman a clef of her own family life or marriage, can be at bottom protesting the large social structures of the society or the terrible injustice of our brutal ordinary human inadequacy. But whatever social value that may emerge from the finished piece, it cannot be inflicted by dictat but must come of it, organically, as the finished being grows from its DNA.

That, at any rate, is the prevailing belief in our literacy world. We see the public value of our work as an outcome of its aesthetic integrity. Our attitude is expressed succinctly by the naturalized American poet W. H. Auden, who said by way of examples that a writer's politics are more of a danger to him that his cupidity.

Yet for all of this the role of art in a democracy is identical to the role of art in a theocracy or in a secular dictatorship. It is true that in a theocratic or secular dictatorship, artistic strategies may take a different form to avoid suppression and punishment of the artist. A severe impingement on the artist's freedom may draw the poem or the novel or the painting into the realm of, say, parable or allegory that is in its very nature disguised polemic. Also, what makes a work of art ruinously didactic in one society may not in another. The dramatist or the poet, living in the torment of an intolerable despotism, may be engaged quite consciously in an act of political protest that is by its nature something like a sermon. But I make the claim nevertheless that the role of art in a democracy where the artist is tolerated, sometimes celebrated, though never revered is the same as its role where there is no freedom of expression, where the censors prevail and heresy is a legal concept, or where the artist is routinely exiled, tortured, or silenced for good. I say this because of the inevitable conflict between the prevailing fortress-like institutional truths of any society and the loose cannon of personal witness. Artists or any medium can never be counted on to say the right thing. That can even be true of a film director. It is the radical nature of their calling that artists by definition are on the outside of all institutions, even of those that support them. If they are to be artists they cannot feel a responsibility to condone or to defend the hypocrisy or murderousness of any institution, be it government, religion, or family.

And so all through history poets and writers have been objects of societal suspicion. Plato, when he projected his ideal Republic, decreed that poets were to be outlawed. Writers in Elizabethan times lived in the shadow of the Tower. However beneficent and enlightened the society may be, there is an eternal argument between the accepted agreed on communal truths and the artist's act of witness, which must always have a whiff about it of the disruptive. That is why you will find some literary critics who see themselves as guardians of the prevailing communal truths of the society though they disguise their role with the vocabulary of literary criticism.

The artist in any era reasserts the authority of the single mind to make and remake the world. This can be more than an embarrassment even in a democratic state—it can be alarming. The writer, as a representative artist, is recognized to have discovered the secret every politician is born knowing: that good and evil are construed, there is no outrage, no monstrousness that cannot be made reasonable and logical and virtuous, and by the same token no shining act that cannot be turned to disgrace—with language. The novelist, the poet, and the dramatist all know that reality is malleable and accept any construction placed on it. This is exactly what governance knows worldwide. That is why though the artist in a democracy may be blessedly free, the role of art in a democracy is finally no different in kind from the role of art under any other form of government.

The idea of the individual artist is a relatively new phenomenon in history. In the ancient world the story was a communal creation. Just as the cathedral was the work of nameless artisans, so were the ruling stories passed along anonymously without written language. Instead, they were spoken and honed and shaped from mouth to mouth until the group wisdom shone through in its clearest manifestation. *Beowulf* may be a throbbing poem to you, but to its contemporary listeners it was a means of education. It was created to instruct the princes of the society, the chiefs to be, how to conduct themselves, the courage they were expected to display in battle, and the generosity in the form of shared booty they were to show to their followers. The Hebrew Bible is clearly a redacted communal creation though attributed by the very religious in part to Moses. Muhammad, too, is attributed with authorship—his words were written down by others—and Jesus's words and actions and fate are reported on by the gospeler-reporters. The sacred texts of all the religions have been communally amended, rewritten, commented on, and interpreted by rabbis, by priests, by imams, and by monks to transform religious apprehension to churches, unmediated awe into dogma, inchoate feeling to sacrament, and brute expression to ethical commandment. But it is as if in ancient times only society's prophets could hold such an esteemed title as author, whereas in the history of civilization the right of authorship has slowly devolved from God and His prophets and priest to everyone.

And so we arrive at my text for this talk, a line from Ralph Waldo Emerson's essay on Goethe: "In a writer's eye," says Emerson, "anything which can be thought can be written; the writer is the faculty of reporting, and the universe is the possibility of being reported." That is such an American thing to say, is it not? Though we should remember that the idea of this universe as something to report comes of an early time in American letters when the word universe did not evoke thoughts of The Big Bang, but only meant everything. To report the universe in any case is a brazen intention, suggesting a kind of Gnosticism, in fact, that asserts the supreme authority of the lonely unenslaved mind. All the alarm stirred in the breasts of censors and lord high chamberlains rings in Emerson's line—it is the source of the wariness in which the writer is held all over the world. Even in the institution known as the family at ground level, without our own homes—there in nothing to make family members more nervous than the discovery that one of them is a writer.

Now perhaps I will be forgiven for speaking explicitly about my own field: fiction. Because its practice evokes the ancient way of knowing, via the story, it stands outside the principles of our empirical age wherein facts reign supreme, and the project of modernism—the application of science and technology to human problems—is the source of such benefits of health and well-being and prosperity of which the ancient world of the pre-Enlightenment only dreamed. The way modernism works is by means of expertise and the organization of human thought via disciplines, each of which has it own vocabulary and its own discourse. And supposedly there is a strict demarcation between fact and fiction. But let us turn for a moment again to the very ancient times to which I have alluded when by necessity no distinction was made—between fact and fiction, between religious perception and scientific discourse, between utilitarian communication and poetry—when all these functions of language we now divide and distinguish according to the situation we are in were indivisible. As in Homer. As in Genesis. When I was an undergraduate this concept was called the holophrastic theory of language. The image provided was of a star, with the points representing where we are today—cognitive language, scientific language, emotive language, poetic language, utilitarian language—and the center of the star symbolizing that earlier linguistically imploded time when myth was science and science was belief and belief was poetry, when the sun was Zeus's chariot driving across the sky, and when a volcano served for the Lord's travel directions—a pillar of fire by night and a pillar of cloud by day. It was the time when stories were the only system of knowledge; they were all people had, the very first means of knowing, when act of telling a story was itself a presumption of truth. The storyteller of old got a spot near the fire because the story he told defined the powers to which the listener was subject and suggested how to live with them. A story was as valuable as a club or a sharpened bone. It bound the present to the past and the visible with the

invisible, and it helped to compose the community necessary for the continuing life of its members.

You see what I am getting at: The practice of fiction reverts to that ancient system of knowledge. It proposes total discourse that antedates all the special vocabularies of modern intelligence. In the sense that it stands outside the modernist project and outside the system of expertise that structures the intellectual life of society, we have another reason for society to distrust it or to dismiss it or to censor it. In the society of specialists, the novelist is something else. As a generalist he is an outsider. Fiction is a megadiscipline that employs reportage, confession, history, myth, legend, superstition, science, religion, philosophy, and the intuitive knowledge that resides in the combination of words. It excludes no data; everything is acceptable and equally appropriate, from the laws of physics to the mutterings of poor mad people in the street. And though universities give degrees in creative writing and dramatic writing, the truth is that a good writer is his own certification; his degree is granted finally by his muse.

Henry James in his essay "The Art of Fiction" proposed a little parable to suggest how fiction happens and the sources of its genius as a system of knowledge. He said that if a young woman who had lived a sheltered life walked past an army barracks and heard a fragment of soldiers' conversation, she could, if she were a novelist, go home and write a credible novel about army life. There is always a moment of revelation to instigate a novel. It involves the working of our linguistic minds on the world of things in themselves, a phenomenological coupling of ascribed meaning with the unmeant; perception is shot through with memory, dream imagery imprints on our day life, and the sentence forms with such synaptic speed that the act of writing, when it is going well, seems no more than the dutiful secretarial response to a silent dictation.

When such geniuses as Sir Francis Bacon and Galileo Galilei insisted on putting claims of knowledge to the test with observation and experiment, storytelling as the prime means of understanding the world was so reduced in authority that only children and fundamentalists continued to believe that stories are, by the fact of their being told, true.

So the storytellers—the novelists, dramatists, and filmmakers—are at their best built to question the residual communal stories that govern our lives; they are a potential affront to our religious texts, our national myths, and our political orthodoxies in producing their alternative work from no authority granted by anyone but themselves, while at the same time they suggest to the modernist sensibility the atavism of thought, their living presence as throwbacks demonstrating that the modern mind is still structured for primitive storytelling. The writers steal from both camps their language and propose to make epiphanies. They are by nature transgressive. How can they be otherwise if anything they think can be written and the universe is the possibility of being reported?

A debate has occurred in recent years in the academy as to whether or not a work of art can be autonomous—that is, truly separable from the prevailing powers of the society in which it is composed, whether it can express finally something that does not endorse and, whatever its apparent content, reaffirm the sociopolitical matrix of its creation. But if it is true of art to be compromised by the social circumstance of its creation—if it is true of Sophocles and William Shakespeare and Miguel de Cervantes—then it must be true of Isaac Newton, Karl Marx, Charles Darwin, and Søren Kierkegaard as well; it must be true of all human thought, whatever its form. It is true as any tautology is true. Great art is great exactly in the genius of its ambiguity, in its bipolarity, in the immanence of denial within its assertion. There is always a no inside the yes and a yes inside the no. Though it will always enact the perpetual crisis of human consciousness and will announce indisputably the author's feet of clay, it will flash forth a light from its own time and place across borders and through the ages. In Herman Melville's *Moby Dick,* we are never in one place alone at any given minute but in two—in the present that is the past, on the sea that is the soul, in the soul that is the eternality of Noah's flood, and in the novel that is God's ineffable realm. And you will remember how much Shakespeare is in Melville's book: in soliloquy, in scene, in iteration of Shakespeare's hierarchy of characters that gives comedy to the lower so as to bring the one at the top (i.e., Ahab, the embodiment of the universal fate) into tragic distinction. For we must not forget the conversation that goes on among works of art, with every book being an answer to an earlier book, with every painting answering another painting, and with the artists of every genre responding not only to the life around them but also to the work that has gone on before. And then they cross over, composers responding to poetry, artists responding to music, film writers responding to novels, and so on. The practice of the arts engenders a multiplicity of voices, and that multiplicity assures the creation of a self-revising consensual reality that inches forward over the generations to a dream of truth. Art in all its forms is a preventive to the coagulation of simplistic belief, the constriction of freedom that attaches instinctively to all society's institution which by their inertia would inflict on the national mind a closure of thought—which means an end to possibility and an end to the variable genius of human character and the full expression of human capacity.

It is inconceivable in an absolutist society such as a theocracy, that is as country run by religious dictat, or in a fascist or communist dictatorship—it is inconceivable in any society where the answers are already given, and the rules of life are inflexible, and the authority for all thought is the ruling modality...that free expression and the multiplicity of witness can be anything but an abomination, a danger to the states, or an affront to God ... the Fuhrer, or the God having done all the writing that was necessary for anyone, forever.

Now perhaps you think what I have said here is a sort of grandiose bit of idealization of the artist's place in the scheme of things. But if you as a young

person have your own private ambitions as a writer or composer or actor, I imagine you sitting quietly at a table somewhere and writing in a notebook or nursing a beer and working on a scene you are going to do, and I can say to you that all human history has brought you to this movement and contrived to pour that beer into your glass. Wars have been fought, orthodoxies have been thrown off, human consciousness has gone through revolutions, and human beings have been reconceived in freedom. The right to write stories is now a common right, and it is the genius of a modern society to understand that it has come as far as it has because the writing—the creating—is no longer the prerogative solely of the gods and their prophets and priests. All authors are mortal, every author has a name, and every story, including yours, has to make it on its own.

Naturally not all art is great; very little of it is. But the few monumental oeuvres that change our thinking, our seeing—such as work by Gustav Mahler, Pablo Picasso, Franz Kafka, and Samuel Beckett—rise from the chatter of what is temporal, secondary, imitative, foolish, and easily forgettable. There would have been no Shakespeare without the community of Elizabethan dramatists and poets, many of them second rate, to impinge on his anxiety and to propel him to his expression. And lest you think that this discussion here has been theoretic and starry eyed, let me assure you that though we are not driven to insanely murderous terrorist acts by misreading our ancient mythological writers, we have our own characteristic problems: The dynamic of conservative political philosophy in America today has brought about combination of all the forms of communication—the media, film and television, radio, cable, the Internet, newspapers, and book publishing—into fewer and larger corporate hands. How can the multiple voices that are our societal genius be heard and how will the new ideas get through if the intellectual vapidness of these behemoths prevails?

It is also possible, now, that in the understandable need to protect ourselves from terrorism we will harden to our own democratic traditions and will become overly sensitive to one another's errant voices or opinions, installing measures in the name of national security that compromise our freedom. What all this means, in other words, is that if you do not write your stories, someone else will be sure to write them for you.

The pragmatist philosopher John Dewey once defined "democracy as neither a form of government nor social expediency, but a metaphysic of the relation of man and his experience in nature." That means we temporalize human affairs; we do not look not up for some applied celestial accreditation but look forward, ground level along endless journey, and work in the freedom of human consciousness through any authoritarianism—whether religious, government, or corporate—that would constrict our thought, our art.

So drink up and get to work. We have heard this week not from a warring nation but a political culture justifying itself with ancient imperatives.

But people who commit evil will always offer citations. From within their malevolent acts they feel not guilt but righteousness; the ethics of their faith are turned inside out, and God becomes the justification for what in fact is human deviltry.

We will of course oppose this dangerous theocratic narrative with the visible strengths of our country: our federal form of government, our military, and our economic resources. But these would be as nothing without the Emersonian idea that goes to the heart of who we are: "In a writer's eyes," he said, "anything which can be thought can be written; the writer is the faculty of reporting, and the universe is the possibility of being reported." Just remember that, and you will be all right.

6
Responsible Looking

DEBORAH WILLIS

Who am I? What am I? These are the initial questions which young people ask as s/he begins to realize that a relationship indeed does exist between the individual and society.[1]

Kellie Jones

… Our art and our culture does not reside in artifacts, does not reside on objects, but resides within our attitudes, our ideas, our value systems.[2]

David Avalos

For many artists in Africa, Asia, and Latin America, being politically alert is simply part of being a world citizen.[3]

Holland Cotter

In the last few years I have been rethinking how art is taught in the academy. As a scholar of African American photographic imagery, I have consistently focused my research on body politics, race, gender, and the politics of visual culture: the central questions of visual theory and art history. Today it is difficult to find one meaning in a photograph. The well-used cliché "A picture is worth a thousand words" seems outdated in today's society. For me, photography is participatory and active.

I initiated conversations with friends about their syllabi and the inclusiveness of their required reading lists. As we exchanged syllabi about a range of topics from thinking about exhibitions to issues in performance art, I began to notice recurring themes in my own course outlines. For some time I have assembled materials focusing on challenging images in an effort to encourage students to make informed choices in creating works of art. In teaching visual

culture, I often examine images of "uplift," stereotypes, and political images in art and popular culture. I ask my students to critique photographs in the media, picture books, journals, newspapers, public photographic repositories, and private family albums. By teaching courses in visual culture, I try to encourage students to embrace a more diverse way of viewing photographic history.

In reviewing my syllabi for this essay, I was reminded of a remark a friend made when asked if he was an artist. He responded, "No, I see myself as a participant in a democratic society." A young Palestinian artist said, "What does that mean?" I do not recall my friend's response, but that self-description remained with me for a long time. I was curious about how I felt when asked that question. Autobiography is essential to my teaching. Biography is useful in exploring cultural values, traditions, and perceptions. As a photographer, educator, and curator, I have used photography to tell stories about family life and in the past have asked students and artists to use the photograph in a narrative form to explore personal memories. I believe that in teaching photography one can teach and explore the significance of self, family, and society.

In her essay "The Citizen Artist," Aida Mancillas also pondered the question. She wrote, "When people in the community where I live ask me what I do (who I am), I tell them that I am an artist. Sometimes I am pressed for a bit more. My own preference is the term 'community artist ...'" In and out of the classroom, I try to answer the question. I struggle with an answer, which shifts from time to time, but often I find myself saying, "Well, my work combines thinking about art and how to look at images and then applying those ideas to inform our communities." I often walk away wondering if I answered correctly. Sometime in 1999 the Maryland Institute College of Art (MICA) initiated a program in training artist–citizens to empower communities through the arts. Ken Krafchek, founder and director of the Community Arts Partnerships, believes that "understanding oneself in relationship to others makes each student a better artist and citizen."[4] It is affirming as a professor in the arts to see the number of programs such as MICA's thriving in the academy. The arts and citizen partnership fostered relationships over the past five years, and this strategy has been adopted in other programs such as Chicago's Columbia College Office of Community Arts Partnership, Cooper Union Saturday/Outreach and CAP Programs, Xavier University of Louisiana Community Arts Partnership, California State University Reciprocal University for the Arts Project, and the Native American Youth Outreach Program Institute of American Indian Arts.

As Kellie Jones argues,

> In this search for a personal identity, it soon becomes clear that the mirror of the outside world plays a crucial role in the manner in which one sees him/herself reflected by others. Certain questions pose themselves

in this tense process: Does that mirror image—a perfect metaphor for art—flash back a recognized semblance or rather some skewed, partially coherent, stereotypical mask? Is this resulting image a construction of the viewed him/herself or of the viewer? What states of recognition has each deployed in their own interrogation of identity?[5]

This questioning has led me to incorporate these ideas in my teaching and to have students think critically about their role as artists in today's society. I ask them what they think about photographic imagery, specifically the ways one looks at and interprets photographs and how identity and representation are constructed in photographs of the racialized and gendered body. As a lifelong student of photography, I have always had a strong interest in questioning and reading images. In the past, the photographic image was considered as powerful as the written word. Even today because of the power of persuasive advertising campaigns, a buying public believe the messages presented as "real" and not constructed. I want my students to challenge what they think they know and to be able to hold informed discussions about their roles as art makers.

This essay explores themes investigated in my courses taught at New York University's (NYU) Tisch School of the Arts. The courses combined historical, contemporary, and theoretical approaches to visual culture and addressed the problematic construction of social, political, and aesthetic images, the gendered body, the construction of beauty, and how technology is used in telling the visual story. The introductory epigraphs offer a framework within which to situate this discussion. In creating an atmosphere for teaching about reading photographic images about the construction of race, beauty, and identity, I had to reconsider the learning process. As bell hooks writes in her introduction to *Teaching to Transgress*, "The professor must genuinely value everyone's presence. There must be an ongoing recognition that everyone influences the classroom dynamic, that everyone contributes. These contributions are resources ... Often before this process can begin there has to be some deconstruction of the traditional notion that only the professor is responsible for classroom dynamics."[3] That exchange is what I value in my classes. Each week a student is responsible to lead the discussion with four key questions found in the readings. I encourage them to explore the cultural, artistic, and political uses of photography so that they will be able to incorporate their findings in the so-called real world. My intent is to help students construct an informed perspective as they examine and interpret diverse historical and contemporary experiences. For example, Graham Clarke observed that the "portrait photograph is the site of a complex series of interactions—aesthetic, cultural, ideological, sociological and psychological."[4] If we as consumers of images are to understand the power of the portrait photograph, we must begin to ask critical questions regarding the visualization of gender, race, identity, and sexuality in art. In historicizing these courses, I ask my students to analyze a photograph

to explore or to decode, or both, the photograph's hidden references, which reflect the political, ideological, and aesthetic interests of the photographer, subject, reader–consumer, curator, or editor and therefore bring attention to parallels in visual and written discourse. Often photography serves a particular social need—for example, the Farm Security Administration and images of the civil rights movement, historically in photographs of brutalized and lynched black men and women in the South and demonstrated recently in the images of tortured Iraqi prisoners.

In creating assigned readings or photographic projects about the social responsibility of the photographic image, I often received varied responses. Students have utilized photography, text, and memory to address issues of sexual and cultural politics in their work. They have made critical visual steps in constructing the ways in which to comment and view contemporary photography, looking at the diverse visual stories beyond the stereotypes and the visual construction of the story. Stuart Hall asserts, "Within racialized forms of 'looking', profound differences of history, culture and experience have often been reduced to a handful of stereotypical features, which are 'read' as if they represent a truth of nature, somehow indelibly inscribed on the body. They are assumed to be 'real' because they can be *seen*—difference, visible to the naked eye."[5] Hall's reading of the different ways of looking is helpful in shaping classroom discussions about visual images. Within the past ten years we have witnessed a tremendous amount of writing on the politics of representation by theorists, cultural studies scholars, historians, artists, literary critics, and photographers. Scholars and artists alike are reinterpreting, historicizing, and creating works and alternative readings in visual culture, the body, and critical race theory. In the following sections, I describe the course descriptions, required readings, and a synopsis of a few student papers. Each semester guest lecturers were invited to discuss their work.

One visitor to the classroom was Caroline Koebel, who teaches in the Department of Media Study at the University of Buffalo, State University of New York. Her experimental project, "I Want to Have Your Baby," used interviews of subjects from around the world and also with NYU students in film, video, installation, performance, net art, curating, and writing. Her artwork confronts the problematics of female being-in-the-world and the expression of subjectivities at odds with commercial culture. Her works have been shown across the United States as well as in such places as Brazil, Ireland, and Thailand. I want to have your Baby: a peace activist action repopulating the world with humane beings. Students critically viewed this project and thought about how they would populate society. Some of the students decided to imagine whose baby they desired and how that baby would change the world. A few of the students observed the tape and decided not to have a baby by a popular singer or activist. The exchange was humorous and enlightening.

I now highlight a few papers and discussions generated by the students. Some are in response to guest lecturers, photographers, art historians, critics, filmmakers, and other visual and performance artists.

The Course: the Photo Artist and Society—Can the Subject Survive the Lens?

This interdisciplinary course explored methods used by photographers, artists, historians, and critical thinkers in addressing visual culture—that is, photography, video, and film. The course was open to juniors, seniors, and graduate students. The course centered the student within the contemporaneous world of image making with an emphasis on photography, digital technology, and interactive modes of artworks such as installations. Lectures included discussions focusing on documentary photography, installation, paintings, snapshots, and advertising images. The course provided perspectives in criticism in museum and popular culture, and it looked at the visualization of gender, race, identity, and sexuality in art. It introduced a diverse body of students to an interdisciplinary and globally based approach to reading historical and contemporary images. It offered the students an opportunity to analyze and interpret images from a more informed position. It was a text-based and image-based course designed to equip students with critical thinking skills. The seminar had a strong research component for the graduate students from Africana Studies and the Art program in the School of Education.

Some questions designed in this course of instruction included:

- Can the subject survive the lens?
- How does the unfashionable body differ from the fashionable body?
- How are gendered body images presented?
- How is photography structured as memory?

The students looked at images from art expositions and world fairs, West and South African and Australian art, museum exhibitions, advertising, electronic imagery, art, and documentary photography. They devised a visual taxonomy in which to assist them in the analysis of both cultural and fine art images. The seminar also had a web-based component, which enabled students to view images from artists' websites around the world, as well as museum exhibitions.

A Sampling of Course Evaluations for Surviving the Lens

1. Please tell us about your experience in this class. What was the best and most useful about the class? What was the least useful? What was most difficult and frustrating? What are you most aware of having learned?

Student 1: This was a dynamic class in both its curriculum and in the energy of the class discussion largely due to the clarity of the instructor's

vision and in her capacity to balance keeping us on course. I have learned about the balancing act of negotiating one's body in space, the way it functions as subject and object, and my responsibility as an art professional to preserve my subject's humanity even as I render it in 2-D.

Student 2: I had a very productive experience in this class. Approaching images from a variety of angles was extremely useful to critiquing image culture and understand its process. It was useful to engage in dialogues with the professor and other students regarding their approaches to image taking and making and receiving. It was sometimes difficult to balance out these discussions with discussions in the reading materials, which often offered different forms of analysis and explanations. I am aware of having learned the power dynamics at play in image creation and participation and some of the history behind the reading of images and their production. It is interesting to consider these histories as they have been formulized in difference academic cultures from historiography to within the art field and when the disciplines interact or they relate to society.

Student 3: This class was truly amazing! It was extremely thought provoking in terms of notions of photographer and subject, the bias of the artist, the subjectiveness of each situation, artists' intent, stereotypes, media, etc. There was nothing that I could see as not useful. The most difficult thing perhaps was preparing for the presentations.

Student 4: Introduced to new material. Issues concerning identity, representation, power and powerlessness. No difficulty or frustration. Actually the only problem is that the class is too short.

Student 5: It was a wonderful experience to have class discussions on various subjects. Good to hear many different opinions from students. The class overall allowed me to look at photography and its subjects in deeper sense.

Student 6: Deb was the best part of the class. The conception and subject matter use for the class was refreshing, enlightening, and relevant for all photographers. Class was too big. Became enlightened about my own practice.

Student 7: The varied course material was intriguing.

Student 8: The class was a very positive experience; everyone was very supportive of one another and open to new ideas. I've learned to view

images in a different way that through the context of subject, viewer, artist, etc., not just solely through photographer.

Student 9: I really enjoyed this class. Deb presented very interesting and pertinent topics that were relevant to my work and use of visual language.

Student 10: I really loved this class. Having a mix of people outside of photo was new and interesting. The discussions were so good [that] I wanted to continue them in the next class.

Student 11: I really liked how open Deb was to the class ideas and thoughts. I also like how it was multimedia and not just books and slides.

2. Evaluate your own performance. What did you do well? What was your biggest problem?

Student 1: I believe I did well. I engaged in discussions regularly, posing interesting questions, and I added insight into different South African perspectives. My biggest problem was not opening up earlier in the semester.

Student 2: My biggest problem was time. Having an extra hour per class meeting would have been helpful. My own misunderstanding of certain dates for reading materials occasionally made me prepared for discussions that weren't engaged in or unprepared for those that were. Differentiating between popular opinions and art theory would have been helpful also. I think I succeeded in more finely tuning my critical eye. I had an enjoyable and productive time merging my Africana studies and sociology backgrounds with this class. I also felt the opportunity to use my abilities in order to produce some ideas that were new, at least to myself, and to merge some texts that would not otherwise have been joined.

Student 3: I was able to think through issues of representation and identity previously unconsidered.

Student 4: It was nice to have a final project which allowed me to explore more my vision and my subjects, most[ly] my family members. I had a problem speaking out in class, but it was a great experience for me to hear from others.

Student 5: I talked too much. I learned [a lot] huge and missed too many classes.

Student 6: Had problems conversing with other students.

Student 7: I completed the readings, did the projects, and participated in class. I sometimes had trouble articulating my ideas in discussions.

Student 8: I thought I did well. I was pretty involved in class discussions, and I put in a lot of hours on my assignments.

Student 9: I tried to push myself to be involved in the group discussions, but sometimes I go too into it and carried away.

Student 10: I consistently contributed to class discussions, although this may have been my biggest problem as well. I have strong opinions. Nonetheless, I think my perspective fueled responses and greater participation. There was a multiplicity of voices in this class.

3. What suggestions do you have for this course in the future?

Student 1: Definitely, continue offering it! The only thing I can think of is having students do their own projects a little earlier on, so that the whole class could appreciate each other's work.

Student 2: I suggest a few more historical readings to give more of a context to the production of images. More theory would have been nice for me.

Student 3: Perhaps it should be a two-semester class. The information is critical and hard to cover all of it in one semester.

Student 4: Make it smaller.

Student 5: More guest lecturers.

Student 6: More readings.

Student 7: To have to develop the final projects for the website specifically.

A Summary of Final Projects

Final projects and presentations included photo-based projects, written essays, a website on the course designed by one photo & imaging student, and a jazz performance in class by two Gallatin students. All themes focused on issues related to race, memory, identity, and community. An edited synopsis of each essay appears below.

Male Gallatin Music Student

This student wrote an original piece and introduced the music with the following narrative:

A fellow musician/idol, a mid-fifties aged African American man, told me a story about Miles Davis he had heard. Miles had once asserted that he could tell upon hearing a musician play whether he was white or black. In the nineteen-eighties he was asked the same question, yet this time responded, "Man, I don't know if I can tell anymore." Being complimented with this story was *the* highest vindication for me! I had transcended the borders of being a white kid play black music, my sound and left my social identity behind and I had found the artistic identity I had been striving for much of my life. Other compliments I have received from African American friends have fun in a similar vein. "I swear you're off the chain," and "You know what's happening. You put your back into it." Reinforced my search for an identity in blackness on the one hand and reinforced my yearning for self on the other. How could I be true to myself and tradition without playing into stereotypes of what "black" creative expression is. Was my physicality the way I play, Or, was it a construction of blackness, or was it an attempt to break constructions of whiteness? Where was my expression? Where was I comfortable?

Male Gallatin Student's Performance Titled "Memory and Melody"

He introduced the music with the following narrative:

These compositions are an aural scrapbook of events, hopes, and dreams of past and future; hope is a memory of something yet to happen; sleeping dreams are memories of what we forgot we knew these songs are an attempt to document places I have been or feelings I have known. Just as a smell or photograph can transport our minds to previously experienced planes, so can a melody or tone. Yet as we revisit these situations in our minds, we find that due to our present circumstances, the scenery may have changed memory, like music, is always in the constantly flowing present.

Who's Next? Surviving Media Representations of the Militant Lens? (Female Gallatin Student)

War hysteria has become so exaggerated by media coverage that it becomes difficult to trace the effects that have led up to the conflicts. Racial profiling has occurred, becoming a military tool with the promise to defeat an enemy, and moreover, can be visualized. My concerns are not particularly with the

war and its victims but with those who are victimized by racial or cultural profiling before, during, and post war. The question many Americans should be asking is not who is next but rather who is now? What is becoming of those who are scapegoats of Immigration and Naturalization Services (INS) and of those who have brought the Department of Homeland Security into existence just by their physical vulnerability of being labeled *other*. Can one who becomes a victim of national fears survive this militant lens the media carries?

Dissolving Categories: New Female Media and Aboriginal
Art (Photo & Imaging Student)

From the time of colonization, indigenous Australians were assimilated into white Australian society. The Europeans tried to dissolve their aboriginal heritage and replace it with their idea of what a culture should be. However, at the same time aboriginals were distinguished as being aboriginal and celebrated as such. The white Australians still had an infatuation with aboriginal Australians' different way of life. White Australians want aboriginals to remain close to their heritage and background to carry on the primitive way of life. Aborigines who have been disposed from their lands and are now living in urban environments are confounded with a serious issue. They are expected to hold on to their true aboriginality without being influenced by their urban environments. How can the Western world expect the existing aboriginal society to function with Western ideals and backgrounds? To create a link between traditional and authentic in regards to aboriginal art is unjustifiable. The nontraditional work should not be reduced to a lower status or as unauthentic. The artists are using their inherent rights of self-expression and their creativity to get their ideas across.

Moving beyond the Museum: Applying Visual Art to a Female Black
Radical Imagination (Africana Studies Graduate Student)

Despite understanding the importance of psychic space as a landscape for African diasporic rebellion, scholarship does little to promote visual art as a critical element of this realm. My project thus seeks to explore the possibilities of applying visual art as a tool of the black radical ideas. My thesis casts a more forward looking glance. By presupposing that visual art is indeed a viable tool for the black radical imagination, I turn my attention to the ways black masses might gain access to visual art and visual literacy. Since art museums function as the primary facilitators of public relationships to works of art, this project centers on the potential roles of visual art, as mediated by major art museums, within the black radical imagination. Accordingly, I hope to address the following questions:

1. If art museums are the most prevalent spaces in which visual art can be experienced and understood, how might they affect the development of visual art as a resource for the black radical imagination?
2. Art museums have long been identified as elitist institutions, but how do their class structures come to bear on African American engagement with black visual culture?
3. Are there aspects of its fundamental construction that prevent an art museum, any art museum, from serving a broad-based black public?
4. If visual art is indeed a viable tool in the black radical tradition and museums do not foster the kind of relationship with art necessary to leverage it as such, what are the alternatives? How else might art be presented to black masses?

Girl Culture: A Response (Female Photo & Imaging Student)

This photographic project is a response to a book entitled *Girl Culture* by photographer Lauren Greenfield, a book that ultimately detailed the demise of morals and integrity in aspiring young women. In these eight photographs, I have attempted to give women an alternative voice to the one Greenfield presented. I have photographed women who, despite defining their identity through stereotypical female roles (e.g., secretary, stripper, anorexic) are successful, empowered, and proud. Women such as these do not measure the value of their lives through their physical appearance but rather through their accomplishments. Although all of these women admit they are not free from the tyranny of the ideal female form, this does not keep them from lavishing the female identity they have created for themselves. I hope that above all else this project gives proof that women can be strong, intelligent, and beautiful—balance that comprises, in my eyes, what it means to be a woman.

Queens Boheme: Pictures from New York City's Last Beer Garden (Male Photo & Imaging Student)

In December 2001, on returning from the Czech Republic, I took up residence in Astoria, Queens, and began frequenting the bar at Bohemian Hall. A cultural enclave for the neighborhood, the bar, dance hall, and beer garden is a social club of sorts as well as a meeting place and events center for members of the benevolent society of Czechoslovaks. These pictures were taken over the course of a year and a half or so. Most of the people in them are regulars at the bar—people from the neighborhood. They are not all Czech by any means; many are immigrants from Eastern Europe or Russia. But a camaraderie is present there, usually found somewhere at the bottom of a beer or three. This does not document a certain place or people; rather it is a smaller piece of a larger whole. This could be anywhere and probably is most everywhere.

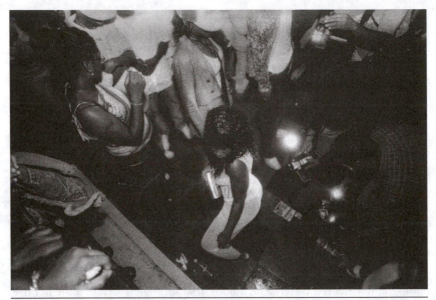

Figure 6.1 Untitled (Aerial Shot of Woman Dancing) from Jabba Strikes Back, Emerald Lounge, Bronx, NY, 2003. Gelatin silver print.

Memories of People I Have Never Met (Female Photo & Imaging Student)

Photography appeals to two important aspects of the human psyche: memory and desire. A photograph is always of something that has already occurred (i.e., it is in the past); therefore, it relates to memory. Photographs relate to our desire to look at or to capture the image of a person or a moment. American culture is highly shaped by images: advertisements, television, film, magazines, and books. When I look back, I am amazed by how much images of certain celebrities and historical figures factor into my own experience. The images of people I have never met factor into the formation of my own personal culture. For this project, I decided to draw and write about some of the famous personalities who had an impact on my life prior to coming to college. I looked for their images on the Internet and then drew quick sketches from those images. Drawing the images made my interaction with the image more personal, as well as reflective of my interaction with that image.

Girl Culture: Style and Fashion (Female Photo & Imaging Student)

For my project, I studied the idea of how much style and fashion have become so important in determining first impressions and even levels of coolness. After studying Lauren Greenfield's project *Girl Culture*, I began asking myself what was missing from the book for me. Where had Greenfield neglected to photograph a girl I could identify with? The answer I came up with was style. Living in New York especially, we are surrounded by people who give

Figure 6.2 Untitled (Corset) from Women Wear White, Men Wear Black Affair, Tropical Reflections, Brooklyn, NY, 2004. Gelatin silver print.

a glimpse into who they are by the clothes they wear. Clothing has become a sign of what group you consider yourself a part of and even a hint of whom you might like to be approached by. I feel that fashion has begun to play a bigger role in attraction as well. Especially when hints of androgyny came into play with the movement of the mod scene, it became about the clothing and haircuts and to a certain extent a uniform of style. When there is a club full of young people dressed similarly with the same dyed black haircut the actual looks becomes lost.

One of the biggest influences on peoples' choices of style is music—from hip hop to mod to the pop princesses we see every day. The music people listen to usually comes through in what they are wearing and how they put themselves together. These photographs are styles I created based on the models that wear them and from what I see in the street every day. Fashion to me personally is extremely important and becomes what I see first before a person's physical beauty. That is what I hope to show in these photos: Even though the models look interesting on their own, the aura created in the images comes solely from the style.

Surviving the Spectator (Female College of Arts and Sciences Student)

Toward the end of one of the bloodiest centuries in human memory, the United Nations Security Council set up the first international war crimes tribunal since Nuremberg in May 1993, only fifty years after the world had declared

Figure 6.3 In the center of GFS Ballroom, Hyattsville, MD, 2003. Lambda print.

"never again." The International Criminal Tribunals for the former Yugoslavia and for Rwanda as well as the formation of the International Criminal Court reflect the inability of countries and the world to prevent violence and war from, among other things, ravaging the human imagination. As this is being written the United States has, as it is well known, occupied Iraq and has placed thousands of individuals into prisons as suspected terrorists. What has gotten much less attention is the devastation occurring in the Democratic Republic of Congo. More than three million people have died since 1998 in this ongoing war for power and the country's vast resources. Women and children are being raped and killed every day in this war and throughout the world. Is the twenty-first century going to be bloodier than its predecessor? As globalization has been a hot topic for some time, a critique of some of the mediums through which Western culture is spread—and the culture itself—must be performed to touch on the issues of hypersexualization, hyperviolence, and hyperreality—or the disappearance of reality, to reference Baudrillard—being transmitted through space. Are these going to be the global norms? Are these attempts at the ultimate regulation of the body? In the collection of discussions and images to follow in this paper, I hope to come closer to understanding some of the interconnectedness issues of contemporary society with a focus on the normalization of dehumanization and the potential routes for the further destruction of the individual body. Accepting deception or remaining apathetic to the forces of social control is inviting a loss of personal identity and of liberty. To start to piece together to forces of social domination and

submission, I start by examining the need for deception and control in the first place. This touches on how personal beliefs must be silenced to maintain the morally atrocious practices of global powers (i.e., multinational corporations and governments), focusing on the United States.

Conclusion

Like many artists working today, the student papers and discussions in all of the classes responded to social and aesthetic issues beyond the sometimes-insular photographic community. They commented on the body, politics, culture, and history from personal and the larger society. In reinterpreting and analyzing the works discussed, each student was open to new readings of materials and to imagining challenging ideas about art and the politics of looking. Some challenged the guest lecturers openly during class visits and in the reaction papers. The themes that emerged from the papers and shared concerns of the students include global concerns about war imagery, abuse, racial profiling, identity, community, spirituality, and sexuality. Although the approaches to each paper varied, this group shares cultural and ideological affinities. Each of the student papers presented was provocative and sensitive visual reference in response to the class discussions. Photographic media participates in a pervasive, diverse, and influential manner in contemporary society. As a means of considering the relevant issues of photography, the students were able to derive from a series of weekly lectures a broader understanding of the visual experience. We explored through slides, film, video, and readings the power relations of imagery and the role of the spectator and image maker. The classes offered a challenging perspective in the field of photography and visual culture and a close reading of photographic images suggested a restructuring of preconceived or previously taught perceptions. I believe that the courses stimulated discussions in and outside the classroom and advanced critical writing in photography.

Required Text

Practices of Looking: An Introduction to Visual Culture by Marita Sturken and Lisa Cartwright.

Talking Visions: Multicultural Feminism in a Transnational Age ed. Ella Shohat. "naked without shame: a counter-hegemonic body politic" by bell hooks and "We Wear the Mask" by Coco Fusco.

The Film Art of Isaac Julien True Confessions pp. 57-61 by Kobena Mercer and Isaac Julien Center for Curatorial Studies, Bard College, Annandale on the Hudson, NY, 2000.

The Black Female Body: A Photographic History by Deborah Willis and Carla Williams, "World Fairs and Expositions," Temple University Press. 2001.

Lorna Simpson, (Whitney Museum of American Art), Phaidon, 2002 (essay by Kellie Jones).

Fatimah Rony, The Third Eye: Race, Cinema and Ethnographic Spectacle, Duke, 1994, "Conclusion."

Ed. Kimberly Pinder, Race-ing Art History: Critical Readings in Race and Art History, Routledge, 2002, Essays by Oukwi Enwezor and Kimberly Pinder.

Elizabeth Edwards, Raw Histories: Photographs, Anthropology and Museums, Berg, 2001. (Chapter on Museums).

Lisa Gail Collins, The Art of History, African American Women Artists Engage in the Past, Rutgers, 2002 (Chapter on Memory)

Ed. Marianne Hirsch, The Familial Gaze. Univ. Press of New England, Essays by Willis, Abel and Chong.

Catherine Lutz and Jane Collins, Reading National Geographic, Univ. of Chicago, 1993, Chapter 4.

The Visual Culture Reader, ed. Nicholas Mirzoeff (Routledge, 1998).

_____. Chap. 2, "Studying Visual Culture" by Irit Rogoff pp. 14-26.

_____. Chap. 12, "Visual Stories" by Ann Reynolds, pp. 133-147.

Family Frames: Photography, Narrative and Post Memory by Marianne Hirsch (Harvard University Press, 1997) "Resisting Images," pp. 189-216.

Miscast: Negotiating the Presence of the Bushmen, ed. Pippa Skotnes (University of Capetown Press, 1996) "With Camera and Gun in Southern Africa Inventing the Image of Bushmen c. 1880-1935" by Paul S. Landau, pp. 128-141.

The Passionate Camera: Photography and Bodies of Desire, ed. Deborah Bright (Routledge, 1998).

_____. "Looking at a photography, looking for a history" by David Deitcher pp. 22-36.

. "Not just a passing fancy: notes on butch" by Alisa Solomon, pp. 263-275.

Photography: A Critical Introduction, ed. Liz Wells (Routledge, 1998).

_____. The photograph as testament- Case Study: Images Migrant Mother.

_____. Photography and commodity culture- Case Study: Benetton—The context of the image, pp. 202-215.

What can a woman do with a camera: photography for women, eds. Jo Spence + Joan Solomon, (Scarlett Press, 1995).

_____. "Anne Hickmott "Taking the pictures," pp. 167-181.

. "Maggie Murray "Documentary photography." pp. 111-118.

_____. "Clarissa Sligh "Home Truths," pp. 61-66.

Criticizing Photographs: An Introduction to Understanding Images, by Terry Barrett (Mayfield Publishing, 1996).

_____. "Evaluating photographs," pp. 108-113.

_____. "Writing and Talking about photographs," pp. 157-171.

Videos

Frantz Fanon: Black Skin, White Mask by Isaac Julien.
The Darker Side of Black by Isaac Julien
The Life and Times of Sara Baartman by Zola Maseko
A Stranger with a Camera, Elizabeth Barret.
Morgan and Marvin Smith: For Posterity's Sake
The Couple in the Cage: A Guatinaui Odyssey by Coco Fusco
A Question of Color by Kathe Sandler
Advertising and the End of the World
Seeing is Believing
Kim's Story
PBS: Art 21
Kiss the Boys and Make Them Die by Margaret Stratton (30 min. video)
Chuck Close: Portrait in Progress. (57 min. video)
American Photography (selected excerpts from the documentary)
Kiss it up to God by Caran Hartsfield (29 min. video)

Notes

1. Kellie Jones, *Interrogating Identity* (New York: Grey Art Gallery & Study Center, New York University, 1991), 6.
2. David Avalis, Oral History interview conducted by Margarita Nieto (an Diego, CA, 16 June & 5 July 1998).
3. Holland Cotter, "Fanciful to Figurative to Wryly Inscrutable," *New York Times*, 8 July 2005, Sec. E, p. 29.
4. The Wallace Foundation, *Successful Strategies for Developing Artists and Youth-Partners* (Chicago, 2003), 8.

5. Kellie Jones, *Interrogating Identity Op. Cit.*
6. bell hooks, *Teaching to Transgress* (New York: Routledge, 1994), 8.
7. Graham Clarke, *The Photograph* (Oxford: Oxford University Press, 1997), 102.
8. Stuart Hall and Mark Sealy, *Different: A Historical Context* (London: Phaidon, 2001), 4.

Bibliography

Clarke, Graham. *The Photograph*. Oxford: Oxford University Press (1997): 102.

Cotter, Holland, "Fanciful to Figurative to Wryly Inscrutable," *New York Times*, 8 July 2005, Sec. E, p. 29.

Hall, Stewart and Mark Sealy. *Different: A Historical Context*. London, New York : Phaidon (2001): 4.

hooks, bell. *Teaching to Transgress*. New York, London: Routledge (1994): 8.

Jones, Kellie. *Interrogating Identity*. New York: Grey Art Gallery & Study Center, New York University, 1991, p. 16.

The Wallace Foundation. *Successful Strategies for Developing Artists and Youth-Partners*. Chicago (2003): 8.

7

A Praise of Doubt

GAIL SEGAL

Anyone moving about New York City during the days following the collapse of the World Trade Center has images and sounds—even smells—seared to memory: among the available sensations, an acrid metallic odor, helicopters whirring overhead, sirens zipping down the southbound avenues. The wider cross streets of lower Manhattan—Canal, Houston, and 14th—were marked by numerous checkpoints monitored by National Guard and police.

The checkpoints made it impossible for anyone to traverse without proof of residence. City governance wanted only people who lived in a downtown neighborhood to have access to that neighborhood. This was for an obvious reason: keeping roads clear for rescue teams, firefighters, Red Cross workers, and any suppliers making provisions. A number of residential buildings downtown had to be evacuated. High-rises housing New York University faculty and students were among them, and the displaced lived in temporary lodging all over the city, and for many weeks. At some point in the aftermath residents were allowed to retrieve needed possessions from the otherwise quarantined buildings.

On one occasion a young woman was stopped by a guardsman. He requested appropriate identification before she would be allowed to make her way across Houston Street, and in response she offered her university photo identification. The guardsman returned it. He needed to see verification of her address. Startled, she indicated she had none. He coached her along, saying it could be an envelope, or letter, even a postcard.

Among the unforgettable impressions in personal memory is a young woman squatting on Houston Street, emptying contents of her backpack in search of one paper scrap documenting her address. The task, while urgent, was simple: simple because her bulging backpack was occupied primarily by one object—a button-eyed, stuffed teddy bear that lay beside her on the sidewalk as she rummaged through the pack.

Evacuation from lower Manhattan had occurred, for the most part, with more speed than efficiency. The emergency of that morning tore through the seal of everyday possibility, and now, anything being possible, people grabbed what they could and fled.

The teddy bear was established as a staple within the category of transitional objects fifty years earlier, almost to date, in the first printing of D. W. Winnicott's findings on the relationship between mothers and infants.[1] In his essay probing the use of these objects and other transitional phenomena, Winnicott made clear that it is not the object that is transitional but the phase during which the object is used. The object represents the transition while also facilitating it, making possible, as researched by Winnicott, the passage from the "state of being merged with the mother to a state of being in relation to the mother as something outside or separate."[2]

Whatever trace of this phenomenology existed between the young woman and teddy bear, the significance from my perspective was immediate and symbolic. There on the corner of Houston Street, a street characterized during the days following the attack as "the dividing line, the place where the world begins to end"[3] laid an object representing a transition—a transition set in motion by a tragic American event. In the weeks and months after the attack, the media focused perhaps too liberally on the extraordinary nature of the event at the expense of reminding U.S. citizens that previous acts of terrorism had occurred, and with regularity, in many other parts of the world. However, the assault on America that blue-sky September morning proved unprecedented in its emblematic scope with the event's visual drama, captured on television worldwide, replayed again and again, as fundamental assumptions by which Americans carried out the daily tasks of living collapsed.

The assumption that we might move about freely and safely in work and play underwent radical revision. Added to this, the event upturned any premise that the world's sole remaining, albeit self-identified, superpower could assert that power and influence without being challenged on its own turf. Even dark faith in the Hobbesian notion that man lives in a state of nature and acts in his own self-interest expressed in America's national and international polity had to be excavated and recast, extracting from self-interest the will to survive. Many of America's citizens, complacent from the giddiness and bloat of 1990s prosperity and naive to the quality of hate that prompted the attacks, were, in the days and months to follow, stunned, caught out, grief stricken, and scared. In short, America suffered a loss of innocence that propelled her citizens into unknown territory. Something had changed, and changed terribly.

Homeostasis as an adaptive strategy of the human organism is an accepted scientific fact. The water-based content of human physiology allows for movement and flow to sites of disturbance in an effort to maintain equilibrium. The pernicious, invasive, and proliferating nature of cancer as a disease derives from the capacity of its anaplastic cells to thrive for a given time below the radar screen of disturbance. Other intruders—the common cold, mosquito bites, viral flu, or chicken pox—meet with equal and persistent response until the body has been normalized.

The brain, too, prefers to run on idle. As early as 1920, scientists mapping the mind's activity demonstrated its effort toward recovery in response to stimulations of varying degrees.[4] More recently neuroscientist Antonio Damasio summarized it simply by declaring the brain to be "the captive audience of the body," avid in its work "to achieve homeostasis."[5]

The colossal disturbance created by the events of September 11, 2001, measured high on the emotional and physical Richter scale and in many instances registered as trauma, particularly for those emotionally or physically near the attacks. The urge to normalize was, needless to say, very strong. *Strong* prevailed as descriptive terminology in speeches delivered to the American people after the attacks, but not in a context characterizing homeostasis.[6] President George W. Bush rallied patriotic sensibilities, invoking the strength of Americans as a resource for resuming our daily lives. The word *freedom* received more play than *strength,* freedom being the exercise of human liberties—particularly democratic, preeminently American—that, according to our national leadership, motivated the attacks. America was targeted for attack because "we're the brightest beacon for freedom and opportunity in the world."[7]

Provisions during times of transition require finesse, as Winnicott discovered in researching the early phase of child-rearing.[8] The transition imposed on the American people, prompted by September 11—encouraging as it did a reassessment of America's identity at home and abroad and embedded as it was in a mire of reactions to such a great disturbance—required finesse enhanced by qualities of leadership.

Reinforcing America's positive self-image, reasserting America's predominance, galvanizing Americans to seek justice, merging national purpose and identity with God, and encouraging Americans to go on spending—these were the messages coming from the White House to relieve national anxiety and to reestablish equanimity.[9] In commentaries and speeches responding to the September 11 attacks the president exploited an attachment to an American idea and self-image outdated by the very fact of the attacks and, in so doing, abandoned the opportunity to situate the event in a context of even modest complexity, eclipsing possible gains in insight and understanding—never mind the new agencies of thought and action transition often inspires. The language of indignation, pride, invulnerability, and retribution prevailed. And although such rhetoric may seem to provide immediate solace it can, in response to any crisis, effect a sealing over of the shards of disturbance—shards that are sure to show up elsewhere if the slow work of digesting the experience has been foreshortened or undermined. In particular the intoxication with the language and idea of war introduced hours after the attacks marked the most egregious example of rhetorical obstruction to avenues of safe passage for a country stripped of innocence on the verge of taking up the difficult struggle toward a more sober national and international perspective.[10,11]

"They hate our freedoms, our freedom of speech, our freedom of religion, our freedom to vote, our freedom to disagree with one another," Bush said, explaining again to Americans the cause of al-Qaeda's hate.[12] Publicized disagreement, pluralism in the public arena as conceived by the founding fathers, was in comparatively short supply in the days to follow, as were reminders to the American people that the U.S. government authorized the presence of American tanks and troops in proximity to Muslim holy sights as protection for Saudi Arabian oil reserves, a particularly sore reality for the leadership of al-Qaeda.[13] All levels of our own publicly elected leadership might have been more bold, seizing the small gap in America's self-image pried open by September 11, to counter arrogance and self-satisfaction—dividends from a decade of uncontested international political and economic power—with reflection and insight. The effects of longterm poverty and humiliation, for example, might have been timely topics of discourse along with the militancy of educated Muslims, galvanized to martyrdom by a conviction of rightness in resisting the spread of values in stark conflict with their own. Of course the collective urge toward homeostasis—to get back to normal and resume the daily inventory of tasks and pleasures after the initial crisis—made such messages burdensome and unpopular. But even a beginning drama student would recognize this as a prelude to a deadly struggle for power.

In the world of Monty Brogan, protagonist of the fiction film *25th Hour,* power is known as sway.[14] Sway will get you courtside seats to a New York Nicks game at Madison Square Garden the day of the game or a first look at offerings from the most prestigious fashion houses. For ten years Monty exercises sway, accumulated, deal by deal, from selling narcotics to a wide range of users from all economic strata and ages. His confidence and success earns him the company of beautiful Naturelle and the spacious brownstone apartment where they live together in Brooklyn. Friends also enjoy benefits of Monty's sway, overlooking his means for ends, free from waiting in long lines at nightclubs, no longer needing reservations for a seat in a five-star restaurant. Even his father, the widowed owner of an Irish pub, has walked through the door of privilege, accepting his son's financial subsidy to avoid foreclosure. Monty's exercise of power dead-ends one afternoon when officers from the Drug Enforcement Agency arrive and discover his earnings and wares burrowed into the foam padding of his leather sofa. The high life as he knows it becomes unhinged.

25th Hour charts the last day of freedom in Monty's life before a seven-year prison sentence begins. With its site-specific locations of Brooklyn and Manhattan, the screenplay adapted by David Benioff from his novel was conceived and written well before the events of September 11. Director Spike Lee, personalizing the narrative, situated the story events in time against a backdrop of post-September 11 imagery and realities. The convergence of place with this particular time forges a collision between a real national tragedy and the

fictionalized misfortune of a drug dealer lurched into the strictures of the law. Contextualizing it in this way—setting a personal, domestic story in the larger world—invites the audience to experience and review Monty's circumstance against that broader landscape, a landscape all too fresh in the mind of the viewer, like an injury still swollen and discolored.

At the Sundance Film Festival in January 2002, directors, film critics, and producers gathered as panel members to discuss politics in film. The panelists expressed views ranging from a belief in the political nature of all films to the more demanding criteria that movies may be ideological but that the assignation of *political* belongs only to works about politics or with political dimension.[15] One or two panelists seemed impatient with the lack of response by narrative filmmakers to the events of September 11, and in counterpoint, audience members expressed the possibility that time needed to digest the experience might be guarded more carefully as a condition for generating story material of substance.

In the case of *25th Hour*, the story material existed. Fortunately for Spike Lee, the screenplay's parameters and themes withstood any challenge imposed by the gravity of September 11, despite the absence of causal links between the plot's forward movement and post-September 11 facts or circumstances. It is rather that every word or action can be heard and seen against the reality of a national tragedy and its dark mood. The reminders are there and recurrent: American flags, memorial sites of flowers and candles, commemorations to firefighters, and the cavern of Ground Zero. The two elements—one real, one fabricated—inform one another inescapably, the way a mountain thrust onto a landscape will shift proportion of the hillside houses and lake below.

The influence of September 11 on the film's atmosphere and tone is argued into fact as early as the opening credit sequence. Thirteen static images of blue night deliver forms of shape and light viewed at various angles, emerging over time as cityscape. Closer shots are followed by long views, then longer. Eventually they are recognizable: two towers of light rise vertically above Manhattan, with the Empire State Building seen to the north, the Statue of Liberty lit to the south. The sequence gathers force with a dirge-like score by Terrence Blanchard that is ancient and foreboding. As the sequence ends on a Manhattan skyline viewed from Brooklyn, the two Towers of Light fall into an invisible ash at the ground.

For Monty every fabrication of his world collapses. Intended parallels between his fictionalized illegal activities and American circumstances prior to September 11 end here. Yet it goes without saying that unchecked or unchallenged exercise of power fosters myopia, obfuscating the true measure of any given circumstance, perpetuating a vital disconnect from real world possibility and the ensuing consequences—as happened with Monty. In his case the work of rummaging through past and present searching for a scrap of genuine

identity as his last day of freedom clocks forward is what affords the viewer the discomfiting proximity to a person on the verge of change.

The rupture of attachment to limitless license and privilege provoked by Monty's arrest has its yield.[16] On the day before incarceration begins, Monty exists in a heightened state of dread. Certain aspects of his future are known; other aspects of his future are feared but unknown. Dread, in and of itself, acts as a disturbance, and Monty strains to avoid it, hiding out in the more tolerable terrain of nostalgia, suicidal fantasy, and blame.[17] In the celebrated "F—k you" sequence, Monty's mirrored reflection in the men's room of his father's pub scapegoats every imaginable subculture in a litany of hate: Koreans, Russians, Upper East Siders, Corrupt Cops, Black Brothers, Hasidim, Sheiks, Pakistanis, Indians, Dominicans, Haitians, Panhandlers, Priests, Islams, the Catholic Church, Wall Street, Enron. None are excused before individualizing his rant with attacks against President Bush and Dick Cheney, Jesus Christ, Osama bin Laden, and finally those close to him: Jakob, Frank, Naturelle, and his father. Monty's father waits for him at a table where they have their last dinner together. "I should have stopped drinking after your mother died," his father tells him earlier, trying to take some responsibility for Monty's fate. But Monty refuses, excusing himself from the table. By the time his reflection exhausts the pool of hate for others, including his father, he is left only with himself. The last "F—k you" is reserved for Monty. Even self-loathing seems more palatable than dread.

> ...for as so often happens in the modern world—
> and how much restlessness, envy and self-
> contempt it causes—there was no one-to-one
> correspondence between his social or economic
> position and his private mental life.

Anxiety is defined as a queasiness or apprehension about future uncertainties. Dread is the terror of real possibilities.[18] The September 11 attacks on Washington, D.C., and New York City enlarged exponentially the realm of possibilities from which Americans and Europeans might imagine a future. Subsequent bombings by al-Qaeda operatives in Madrid and London keep that imagining fluid and alive, converting potential to probability.

Dread of the probable is Monty Brogan's fate, and the recurring imposition of dread despite efforts to avoid it creates sympathetic exchange between *25th Hour's* narrative exigencies and the post-September 11 background against which they occur. The collision of Monty's plight with the fact of the larger world has its effect in a particularly haunting scene between his friends Frank and Jakob, who are foils to Monty and sufficiently differentiated one from the other. Any disturbance propelling Monty into transition impacts the lives of those close to him, tugging them into transition by association, and this applies

to Frank and Jakob foremost. Frank works as a high-rolling Wall Street trader at the top of his game. He fears nothing. A relentless drive for power and money acts as adhesive between Frank and Monty in the years before the astringent of arrest and prison forces a rift. The gulf widening between them is part of what gets played in dramatic terms, culminating in the film's final confrontation, a favor of violence Monty provokes for the sake of his own salvation.

Jakob, vastly underemployed by work and life, is, as Frank accuses, a "rich, Jewish kid on a trust fund," teaching English in the private Catholic school. His current anxiety is his sexual obsession with a sixteen-year-old female student. It is precisely Jakob's lack of callousness and guile that motivates Monty to place into his care the one truly trusted and cherished aspect of his life, Doyle, a dog he rescued from the streets years before.[19]

The two friends convene in Frank's slick downtown apartment in the early evening, a prelude to the all-night bash at a local club toasting Monty's last splurge of freedom. Jakob arrives. Frank opens two beers, and the men walk toward a wide window expanse. With their backs to the viewer, the camera rises over their shoulders to reveal the nightscape of Ground Zero through the window below (Figure 7.1). The focus shifts onto the site just as Jakob, looking down, sighs with heaviness, "Jesus Christ." Frank sits on the sill; the focus returns to the two men, and this is how the conversation plays to its finish: Frank and Jakob side by side, between them the blue night, the blurred pit of machinery and rubble, Blanchard's musical score simmering underneath (Figure 7.2).

It is one long five-minute take. The extent of exchange about the site lasts for only a minute. Jakob reveals his cautiousness, Frank his spirit of stubborn

Figure 7.1 Frank (Barry Pepper) and Jakob (Philip Seymour Hoffman) stare at the rubbled remains of the World Trade Towers from an adjacent high-rise in Spike Lee's 2002 film "25th Hour" (Touchstone Pictures) photographed by Rodrigo Prieto. Reproduced with permission.

Figure 7.2 Still from Spike Lee's 2002 film "25th Hour" (Touchstone Pictures) photographed by Rodrigo Prieto. Reproduced with permission.

refusal, exposing, as well, his view that market value—money worth —and intrinsic value are synonymous.

> Jakob: The *New York Times* says the air's bad down here.
>
> Frank: Well, f—k the *Times;* I read the *Post* (pause). EPA says it's fine.
>
> Jakob: Somebody's lying.
>
> Frank: Yea.
>
> Jakob: You gonna move?
>
> Frank: F—k that man, as much good money as I pay for this place, hell no … bin Laden can drop another one right next door, I ain't movin'.

It is Jakob who turns the conversation to Monty with, "What are we going to say to him?" The center section of the scene earns tension from Frank's impatience with Jakob against his own pose as an arbiter of brutal reality. For sure, dread is not yet credentialed in Frank's emotional vocabulary. The more inclined toward the sentimentality Jakob becomes the greater Frank's urgency to force feed him hard facts:

> Monty's life is over—he's got three choices, and none of them look good. One, he can run. Two, he can catch the bullet train, and the third choice

he can go to prison and that's it. After tonight, bye bye Monty ... You'll never see him again. It's over after tonight, Jake; wake the f—k up.

As the exchange grows testy the music swells underneath, building to a startling percussion when Frank walks out of frame, leaving Jakob slack-jawed next to the window. Jakob turns toward the desecration as the camera moves forward, the focus leaving him for a vehicle, spot-lit, crawling over the site below. The shot ends.

A series of mostly static, mostly graphic, blue-night images of Ground Zero form the coda of the scene with Frank's imperative "Wake the f—k up" hanging in the air alongside beautiful and evocative Arab voices singing from within the musical score. Not only frame, but also content of the frame, maintain stasis, limiting motion to the occasional thereby drawing each moving object, with painterly precision, into the viewer's focus. An American flag flaps in the night air, a single crane rolls across the blue ground, a truck carting off debris inches up the West Side Highway, and lastly, seen first at a distance, and then in closer range, four men in white rake across flat ground, coated with ash, for human remains (Figure 7.3).

Spike Lee's audacity as a filmmaker has long been on record. Real circumstances and locations—present or historic—are insinuated into story material film after film even as he spins them into new form. To merge in the mind of the viewer the dreaded reality of Monty Brogan's future with precise visual details of the aftermath of September 11 marks one of the more striking examples of his boldness. Any dramatic scene carries the potential for a variety of effects corralled, shaped, limited, and honed by the director's vision. Here, for

Figure 7.3 Workmen rake through the rubble at the site of Ground Zero in an image seen from Frank's apartment window in Spike Lee's 2002 film "25th Hour" (Touchstone Pictures) photographed by Rodrigo Prieto. Reproduced with permission.

example, the scene could have easily begged a comparison between a known victim, a real human loss, and the fictionalized ne'er-do-well Monty Brogan, "paid in full by the addictions of other people,"[20] whining about seven years of incarceration when twenty might be more fitting. But Spike Lee is bold and competent, and directing is precisely that—directing the audience toward certain effects. The hoped-for effects in this case earn support from a variety of techniques, among them Rodrigo Prieto's camera work, which frames characters here and throughout against fields more graphic than sensual, limiting color and shape. The result is a theatricality that in turn endows the world with elevated proportion not unlike the effect of formal diction in classical Greek drama (Figures 7.4, 7.5, and 7.6).

Figure 7.4 Monty Brogan (Ed Norton), Frank Slaughtery (Barry Pepper) and Jakob Elinsky (Philip Seymour Hoffman) are framed against flat planes of color and striking graphic shapes in Spike Lee's 2002 film "25th Hour" (Touchstone Pictures) photographed by Rodrigo Prieto. Reproduced with permission.

Figure 7.5 Still from Spike Lee's 2002 film "25th Hour" (Touchstone Pictures) photographed by Rodrigo Prieto. Reproduced with permission.

Figure 7.6 Still from Spike Lee's 2002 film "25th Hour" (Touchstone Pictures) photographed by Rodrigo Prieto. Reproduced with permission.

The intensity of the scene escalates as connection between personal dread and national cataclysm occurs through carefully staged mise en scène. Here, resonance with Greek drama is nearly audible given the preoccupation of each with domestic strife in tandem with conflicts fueled by ideas sprung from the soil of a democratic society. If the pale shadow of Greece falls over this scene, it is cast most widely by interaction between story and technique as a means for encouraging viewers to regard Monty's predicament, suffering as he does from an emotional crisis so deeply human, with a tragic feeling even when his fate does not merit the claim of tragedy.

Despite, or perhaps because of, the dramatic seriousness and intensity, one can imagine Spike Lee taking great pleasure in directing this scene, thrilled by the found location—an apartment with its wide window view of Ground Zero—never mind the force of talent available in actors Barry Pepper and Philip Seymour Hoffman as well as the gifted services of Rodrigo Prieto and composer Terrence Blanchard. It is known through Lee's commentary that producers challenged the scene's presence in the final cut of the film and that he fought for it against their concerns about possible audience sensitivity to vivid reminders so soon after the event.[21,22] This challenge notwithstanding, the director's judgment prevailed, and any pleasure in the making went without sacrifice. The work of Winnicott comes to mind again: his assertion of the direct development from transitional objects and phenomena to creative playing and from playing to shared playing and from this to cultural experience.[23] Widening the focus beyond the story's dual claims, one personal and domestic, the other public and historic, to the artist navigating through the application of technique, a response to each already promises in the largest sense, if

not safe passage for a transition, at least the ticket bought, cargo packed. Who can ever, in any case, anticipate the weather? The very act of making, of creative enterprise, provides, if not an antidote, at least a homeopathic tincture for the treatment of dread.

The film *25th Hour* does not answer the problem of dread outright, but then it is not the burden of art to offer solutions so much as to place problems in a context of appropriate complexity. Humanizing a felonious criminal against the bruised landscape of post-September 11 might be considered more radical than bold given what it nudges the viewer toward as thoughts come to mind of suicide pilots careening precious, precious cargo into two towers, the Pentagon, and a field in Pennsylvania. But the film sustains its complexity, and with various strategies. Flashbacks, for example, cut into the film exert their influence as reminders of Monty's less than noble habits and experiences. And yet they appear without crafted overtures or warning, as triggered memories, merging Monty's past and present—or more precisely, baptizing the past in the present, the way any memory is transformed by the occasion of remembering.

The director also manipulates various techniques—camera, lighting, staging, performance, sound design, and editing—toward competing effects. They argue with one another even in the same scene. The theatricality imposed on the film by its camera—for example, limiting clutter in the visual field—exists in tension with the naturalism guiding casting and performance. Explicitly found locations, rather than set constructions, are treated abstractly through lighting and camera angle. The nightclub, populated densely with accurate attention to physical type and wardrobe, has in the camera's moving eye a maze-like geography and added to it a blue light flooding the dance floor, merging dancers in a sea of perspiration. Editing paces the film percussively, like a clock ticking with a steady and decisive beat, interrupted intermittently by double or triple cutting, a technique instantly replaying an action and accelerating pace as it expands the viewer's experience of a given moment. This handling of associated parts toward a taut conversion of opposites protects the film, finally, from the permanence of fixed vision or myth. It keeps the tone pliable, its point of view fickle, flirting with conviction but not residing there.[24] Through the strata of applied techniques—geographic plates rumbling against one another—a dynamic film world is formed.

The "fault line," the plane of critical action, earns its complexity through writing. In *25th Hour* interaction is staged among a collective of characters who represent on the viewer's behalf strong and conflicting positions, even as their respective positions modify or change within the story's progress. Monty's humanizing never goes without the fierce friction of opposition from other players, added to by obstacles from the law on one side and the Eastern European mafia on the other in whose employ Monty has made his financial killing and whose leadership he protects from the Drug Enforcement Agency.

Added pressure is applied to this plurality of voices by Monty's emotional unraveling. The impending prison term works on him as an emetic, displacing the more immediate impulses of suicide, blame, and loathing with regret, and ultimately the fleshed-out imaginings of dread emerge. More brutal a reality than even he can tolerate, Frank glosses the dark visions Monty describes for his future and tries to console. Monty refuses; one last favor is what he asks of Frank. In the gray light of dawn, Frank will be called on to pummel Monty's face so that his boyish beauty will not arouse or provoke inmates in prison. Here Frank wins the ticket to his own dread, though his dread is not conditioned by external possibilities so much as internal ones. The animal drive he so cherishes and with pride can be excited into bashing the face of his closest friend. Not more than an hour later, Monty, face swollen and bloody, rides north along the Hudson River to his destination. In the driver's seat is his father, who offers escape: "Give me the word," he says, "and I'll make a left turn, take the GW Bridge and go west." This is followed by the father's vivid, powerful, and extended fantasy of freedom. Again Monty refuses. He does, finally, what he deems necessary, divesting all appurtenances of his former life, including his dog, including his face, so that in the throws of this dreadful circumstance he might tolerate, if not accept, the terms of transition.

Even without the echo of Spike Lee's earlier work the question lingers. Does Monty do the right thing? He submits, however reluctantly, to the legal system, to that deliberative ethic of crime and punishment architected to preserve civilized society. Insuring maximum liberty and justice for America's citizens requires restriction of and penalty for certain actions deemed criminal. But is that system fair? The intention is justice, but what of its practice? The Rockefeller Laws, enacted in 1973, delivered mandatory sentences to first-time, small-scale offenders. A punishing burden to New York's African American and Latino populations, the laws proved to be a massive failure socially and economically and have since been revised, but not early enough to favorably effect Monty Brogan.[25]

So picture this: guards are moving out of the space looking back over their shoulders, laughing. You are miles from home. Door closes. Boom. I got some big f—king guy's knee in my back. I'll give it a go, but there's too many of them. Someone takes a pipe out from underneath a mattress and starts beating me in the face. Not to hurt me, just to crush my teeth so I can give 'em head all night so they don't have to worry about me biting. Let's say I make it through 7 years minus 84 days for good behavior. What then? What kinds of skills do I have? I can't get a job in the straight world. I can't go back to doing this – 15 years to life for a second pinch. I'll be a 38 year-old ex-con with government issued dentures.

Just reparations in legal terms have consequences beyond the years of sentencing. This is Monty's argument to Frank the night before incarceration begins. Should the social system shoulder the burden of reintegrating ex-convicts into society? Is it in the government's best interest to provide skill training or education or to simply punish, enacting a quid pro quo in response to the dereliction of law-abiding practices?

Does Monty do the right thing—for himself, for his family and friends, for the society in which he lives, for his country? The film's stance seems equivocal. Monty's refusal to expose his "business associates" to officers of the Drug Enforcement Agency earns him a harsher sentencing. Might it have been more right, even at greater personal risk, to deliver names of his suppliers? The prolonged, visualized fantasy of Monty's future makes a striking case for deliverance into life as a fugitive. Images of relocation, changed identity, decent work, marriage, children, and grandchildren unspool, narrated by the voice of the father who dreams in Monty's behalf of a life of responsible citizenship as a true patriarch in a country that depends on legacy for its continuance. This weighs substantially against Monty's ultimate choice. Practical and expedient, his choice involves the least number of family and friends in compromised conduct or pain while also exercising a measure of self-preservation. Monty does what he deems necessary. Ultimately, the rightness of his decision is not conclusive.

This inconclusiveness allows for stretching a fraction further and, briefly, the scope of this essay by drawing into full light the motion of mind that tolerates, perhaps even on occasion embraces, the skepticism and bewilderment associated with doubt. It is not convenient or efficient in times of transition—particularly at moments of national emergency, when dread is activated and desire for assurance, for normalcy is pitched at extreme—to endure questioning voices. Who will volitionally challenge the compass of a boat while tossed by ferocious storm winds on a violent sea? But the practice of doubting may bring, in the latter case, passengers and crew into conversation lending any action taken with regard to the boat's direction greater substance, bearing, and consensus. If Monty chooses to go to prison even against other alternatives, one in particular made plausible and attractive by his father, then his choice has suffered the weight of doubt's scrutiny and carries significant viability, meaning literally that it gives him more life.[26]

In the current climate of American politics and culture with strongly held opinions dominating every forum of idea exchange, the transition beckoning America depends on a willingness to question and with regularity, one's individual assumptions, judgments, and convictions. To submit one's views to a public discourse that includes a wider circle than the like-minded, this is to engage the machinery of the cumbersome democratic process, never mind the obvious personal dividends of clarifying thought and educating belief. The

practice of doubt invigorates any open society, animating the debate necessary to sustain its health and welfare. Even as Americans catch from time to time a whiff of dread, aroused by one terrible circumstance after another, it is incumbent on its citizenry, for the survival of freedoms so cherished by our national leadership, to doubt with purpose and enthusiasm the certitudes claimed and actions taken by that leadership whose power and influence guard our present and determine our future.[27]

Dramatists give measure and example, propelled as they are toward complexity, in service—as they must be—to the friction generated by a plurality of voices. They frame personal and pubic dilemmas in contexts that include the disenfranchised, the despicable or outcast, subverting bigotry and intolerance by drawing characters into the widest human fold. From time to time they risk not just ideological but political subject matter, setting narrative against charged social realties, providing an occasion to exercise the muscle of doubt: a muscle that ensures not just strength but also its scarcer counterpart, suppleness. To this end Americans might entertain the possibility that it is not just homage or continued reference to the founding fathers that is needed at the current stage of development in our democratic experiment but also the evocation and example of the "good enough mother," described and commended by Winnicott as good enough precisely because of a capacity to allow for gradual disillusionment. Disillusionment, whether we like it or not, is the necessary tariff for embarking on any transition that moves from obsession with supremacy and status toward a broader participation in objective reality, as happens in the fictional life of Monty Brogan.

In the nonfiction of our daily lives, the pending objective reality counts among its urgencies energy shortages, environmental hazards, global warming, shrinking water supplies, HIV/AIDS and other diseases, alarming increases in childhood obesity, as well as extreme divisions between those who have and those who have nearly nothing. I am careful to itemize conditions that affect the widest human community subjecting the very concept of national identity, in dire need of reevaluation in any case, to the critique afforded by a discipline of doubt. Here the artist navigating the terrain between subjective experience and objective reality provides a searchlight. In this light the culture's transitional objects and phenomena – objects and practices we cling to in times of crisis or transition – might be more thoroughly scrutinized. Pursuit and grasp of difficult realities might serve to expose habits of wishful thinking fueled by hope for personal comfort or gain. In this light, expressions of doubt, the sine qua non of any democratic society, earn a place of privilege, safeguarding our humanity as we engage the serious work of settling on a compass point to guide our passage.

Notes

1. D. W. Winnicott, "Transitional Objects and Transitional Phenomena," *Playing and Reality* (London: Tavistock Publication, 1971), 4-5.
2. Ibid. 3.
3. Adam Gopnik, "The City and the Pillars," New Yorker, September 2001, 36.
4. Walter B.Cannon, *The Wisdom of the Body*, 2d. ed. (New York: W.W. Norton & Company, 1963).
5. Antonio Damasio, MD, "Emotion and the Human Brain" (The James Arthur Lecture, The American Museum of Natural History, New York, NY, March 5, 2002).
6. President George W. Bush, "Speech to America" (Washington, DC, Televised September 11, 2001); "Speech to Congress" (Washington DC, Televised September 20, 2001); "Address to America on the Occasion of the U.S. Air Strikes" (Washington, DC, Televised October 7, 2001); "Speech at the Pentagon Memorial Service" (Washington, DC, Televised October 11, 2001); "Speech to the Firemen and Police" (Atlanta, GA, November 8, 2001); "Speech to the General Assembly of the United Nations" (New York, NY, Televised November 10, 2001). The speeches of President Bush delivered during the weeks after the attacks make for interesting reading. Among the phrases referring to America's strength are "strong spirit," "strong of heart," and "as long as America is determined and strong, this will not be an age of terror."
7. Bush, "Speech to America." In the President's speech given to the American people on the evening of September 11 his claim of causality ends with emphatic reassurance, "and no one will keep that light from shining."
8. Winnicott, Playing and Reality, 1-25. The transition preoccupying Winnicott depends on the "good enough mother" (10) who is not necessarily the birth mother but is the one, in any case, who ushers the child from omnipotence, subjectivity, and primary identification toward the real world with its frustrations and compromises. Included in her role is to oversee creative play, which is a transitional phenomenon. Success in infant care, Winnicott confides, depends on the fact of devotion, not on cleverness or intellectual enlightenment.
9. Bush, "Speech to America;" "Speech to Congress;" "Address to America on the Occasion of the U.S. Air Strikes;" "Speech at the Pentagon Memorial Service;" "Speech to the Firemen and Police;" Speech to the General Assembly of the United Nations."
10. The easy compatibility of freedom and war has a counterpoint in John Madison's 1795 writing: "No nation can preserve its freedom in the midst of continual warfare." George Washington in his farewell address also issued certain warnings: "Overgrown military establishments are inauspicious to liberty and are to be regarded as particularly hostile to republican liberty."
11. Privileging al-Qaeda's criminal action on September 11, 2001, as "acts of war" seems now in hindsight a convenient strategy executed by the administration to win support for longer-range plans in Iraq.
12. Bush, "Speech to Congress."
13. John R. Bradley, "US Troops Quit Saudi Arabia," *News.Telegraph*, (2003), http://www.telegraph.co.uk/news/main,jhtml?xml=/news/2003/08/28/wsaud28.xml. In April 2003, in response to pressure from leaders of Saudi Arabia, the Bush Administration determined it would halt military operations in Saudi Arabia.
14. *25th Hour*, DVD, directed by Spike Lee. (2002; Touchstone Pictures and 40 Acres and a Mule Filmworks Release; 2003). The film includes no verbal reference to sway. The book by David Benioff, from which the screenplay was adapted, includes discussion and description. An effort to incorporate it into the film is evidenced by deleted scenes included in the special features on the 1HX DVD release in 2003. The examples cited here are from this source.
15. Roger Ebert, Chris Eyre, John Kilik, Barbara Kopple, Emanuel Levy, Mira Nair, Bingham Ray, Robert Redford, and Amy Taubin "Politics and Film" panel discussion moderated by Emanuel Levy, Sundance Film Festival, January 2002. Film critic Emanuel Levy suggested that all films are political. Amy Taubin offered intelligent counterpoint limiting the definition of political films. Roger Ebert expressed dismay over the absence of political films at the 2002 festival and in general over the lack of films responding to September 11.

16. Winicott, Playing and Reality, 30n. Considering the need for power through the lens of Winnicott's research leads to his writings on omnipotence, an experience he described as essential to a child's early relationship with the mother. This undergoes transition, and if appropriately navigated by the mother, the child's need for omnipotence is replaced by confidence for engaging with the real or external world.

17. President George W. Bush, "State of the Union Address" (Washington, DC, Televised January 29, 2002). Scapegoating was in wide release after the attacks of September 11. Among the examples is the punishing phrase axis of evil, an attribution that has had lasting presence and consequence.

18. The American Heritage Dictionary, ed. Joseph P. Pickett (Boston: Houghton Mifflin, 2000)

19. If Monty has a transitional object it is surely his dog, Doyle, who represents, as Monty claims, "the one good thing I ever did," affirming his humanness, an affirmation the viewing audience depend on to counter the bitter aftertaste of his crime.

20. 25th Hour, DVD. Frank, speaking to Naturelle at the nightclub, accuses her of complicity in Monty's life as a drug dealer.

21. 25th Hour, DVD. Director's Commentary. Spike Lee's authority over the final cut of this and other films preserves his insularity and protection from the censorship of industry producers.

22. The Barbarian Invasions, DVD, directed by Denys Arcand (2002; Miramax and Cinemaginaire Pyramide Productions, 2003). Canadian filmmaker Arcand also avoids censorship of provocative visual imagery in his post-September 11 film The Barbarian Invasions. A security guard in a hospital watches a bank of video monitors while having a bowl of soup. The stupefied expression on the guard's face is in response to one monitor tuned to a television station that replays the collision of the second plane into the tower of the World Trade Center as the first tower burns. In the background, a history scholar offers voice-over commentary. On the occasion of the film's screening at the New York Film Festival, September 2002, one audience member during the question-and-answer session reproached the director harshly for the inclusion of such provocative imagery. Arcand expressed understanding of the particular difficulty for New York City audiences but felt it important to include in the final version of the film.

The film shares terrain with 25th Hour, as a world crafted with elements of high finance and narcotics while also dramatizing a relationship between father and son, though in this instance it is the father's fate that provides gravity for the film world's orbit. The father, a leftist and academic, has been diagnosed with cancer. Father and son, a hedge-fund expert living in London, reunite in a hospital in Canada where the father convalesces. The son uses money for power and despite his deep-seated, long-lived disdain for his father's sexual liberties exercised at his mother's expense, he pays for his father to have premium care and comfort which includes doses of heroin for pain. A young and attractive junkie, who happens also to be the daughter of one of the father's ex-lovers, provides the heroin. Cancer is the disturbance and by the time it surfaces as symptoms it is too late. The transition it foments belongs first to the father. He'll be leaving for the great beyond, and not for a limited term. The son and junkie are pulled against their strong wills into the tide of it. The calling of dread is exacerbated in the father's case by his mental distress over his life's worth: "You need to succeed at something in your life, even if its on your own terms. I'm sure it must allow one to die with peace of mind. Me. I'm a total failure. At least if I'd learned something. I haven't found a meaning. I have to keep searching…"

Like 25th Hour, the transition imposed on the protagonist takes place against the weight of the social and historical setting in which it occurs, a post-September 11 world. Both films avoid causal links in plot construction. Without location specific realities and props of Manhattan, The Barbarian Invasions is obliged to conceive other means for drawing the two worlds. This occurs quite organically through the intellectual banter of the father and his friends. One strength of the film as a medium for experience is its capacity to usher into drama various views of human history without sacrificing the value given by the domestic story for connection and intimacy. These views are given voice through a lively cast of characters in comments laced with dark humor and irony, qualities that may have been easier for Canadian writers to access after September 11 given geographic distance and greater objectivity afforded by a national border. The father's brooding pessimism prompts this offering to a hospital worker from his death bed: "Contrary to what

people think, the twentieth century wasn't particularly bloody. It's generally agreed that wars have caused one hundred million deaths... not all that impressive if you think that in the sixteenth century, without bombs or gas chambers the Spanish and Portuguese managed to wipe out one hundred and fifty million Natives in Latin America. That's a lot of work, Sister, one hundred and fifty million people. With axes! ...it was quite an achievement. So much so that the English, Dutch, French and eventually the Americans followed their example and went onto butcher another fifty million. Two hundred million dead... and there's not the tiniest Holocaust museum. The history of mankind, Sister, is a history of horrors!"

Or this later in the film:

Pierre: Intelligence is not an individual trait, but a collective national and intermittent phenomenon. Think of Athens 416 BC...

Alessandro: Firenze 1504

Pierre: Philadelphia, USA 1776-1787.

Remy: (the dying father) I was born in Chicoutimi Canada in 1950.

Diane: It's a miracle you're not dumber than you are.

Pierre: In 1950 everyone was dumb, in Athens and in Chicoutimi. Intelligence has disappeared. And I don't want to be pessimistic, but it can take eons to come back.

Alessandro: From the death of Tacitus to the birth of Dante was what, eleven centuries?

23. Winnicott, Playing and Reality. Winnicott expands by saying, "The creativity we are studying belongs to the approach of the individual to external reality." (68)"Playing is inherently exciting and precarious. The characteristic derives not form instinctual arousal but from the precariousness that belongs to the interplay in the child's mind of that which is subjective and that which is objectively perceived." (52). "And on the basis of playing is built the whole of experience or existence. We experience life in the area of transitional phenomena. I have used the term cultural experience as an extension of the idea of transitional phenomena. I am thinking of something that is the common pool of humanity, into which groups and individuals may contribute, and from which we may all draw. If we have somewhere to put what we find. "(99, emphasis in the original).

24. Walter Murch, film editor and sound designer, speaks eloquently about the process of generating tension and complexity through the manipulation of various techniques in an interview with Joy Katz printed in Parnassus Poetry in Review: The Movie Issue 22 (1997): 124-53.

25. Michael Cooper, "New York State Votes to Reduce Drug Sentences," The New York Times, December 8, 2004. New York legislators voted finally to reduce mandatory prison sentences for drug crimes in the state.

26. The practice of doubt has enjoyed some favor of late with the production of Jonathan Patrick Shanley's Pulitzer Prize winning play by that name and in writings by Fanny Howe to include a sequence prose poem, also titled "Doubt" (from Gone) and also by her an exquisite essay of intuitions on the subject of bewilderment in her book length collection The Wedding Dress. Most relevant to this essay is the English writer McEwan's probing novel Saturday, which after the July 7, 2005, bombings in London seems eerily prescient. Published in spring 2005, the book shares ground with 25th Hour (and The Barbarian Invasions), though it digs further into post-September 11 realities and sensibilities given its advantage of time-distance from the event at the occasion of its writing. The novel has as another advantage. Its form allows description, which includes in this case the meandering thoughts of protagonist, Henry Perowne, a neurosurgeon living in London, husband and father to two grown children whose experience of dread is not circumstance specific, at least not initially. It exists rather like a mild, air-borne toxin inhaled from time to time, causing elevations in body temperature. It hangs over him otherwise as a post-September 11 emission. In Saturday, it is not just the author who generates plurality in the various voices of his fiction but also Henry himself – the protagonist who reveals a capacity for doubt. In speaking about the war in Iraq he hears himself vacillating in point of view from one conversation to another and summarily admits, "I honestly think I might be wrong." This is prelude to a demonstration of doubt as a catalyst for widened perspective. Henry, despite self-absorption and passivity, actually manages to recognize the state of humiliation experienced by another person – a man diseased, outcast, with little hope or possibility for the future – who in the plotted circumstance of the novel happens also to be a perpetrator of violent crime and against Henry and his family. Not just

this, but Henry is also able to see, witness as he is to the perpetrator for a sufficient period of time, that the man, even in his powerlessness and humiliation, has human and redeeming qualities of which Henry himself is grossly deficient. This inches the purview of doubt from healthy citizenship in a pluralistic society to the insight and decency necessary for the planet's survival. Not just Henry, but the perpetrator, too, is given more life.

27. During the first term in office, President Bush overhauled a number of U.S. regulations, a practice well within the authority of the White House and without oversight. Many of the modified regulations advantaged leaders of business and industry. Report of the after-the-fact changes appeared in *The New York Times* (August 14, 2004) along with a graph indicating that the cost to industry through imposed regulations was lower under the Bush administration than any administration since 1987, when records were first kept of these costs. A considerable number of the revised regulations involved workplace hazards. Suffice it to say that occupational safety (e.g., tuberculosis protection for hospital workers, black lung protection for coal miners, sufficient sleep for truck drivers) has been compromised and with little notice. The dependency on newsgathering media goes without saying. For a discussion of the relationship between news media and its "consumers" is Richard Posner's article in *The New York Times* Book Review, Sunday, July 31st, 2005. His assertion that "people don't like doubt...they prefer newspapers that support their existing beliefs" reinforces the concerns explored in this essay."

Bibliography

Books:

Auden, W. H. *Collected Poems*. Edited by Edward Mendelson. 2nd ed. New York: Vintage International Edition, 1991.

Berlin, Isaiah *Four Essays on Liberty*. London: Oxford University Press, 1969.

Cannon, Walter B. *The Wisdome of the Body*. 2nd ed. New York: W. W. Norton and Company, Inc., 1963.

Colvin, Sidney, Editor. *Letters of John Keats to his Family and Friends*. London: Macmillan and Co, 1891.

Emerson, Ralph Waldo. *Self-Reliance and Other Essays*. New York: Dover Thrift Edition, 1993.

Emerson, Ralph Waldo. Editor, Brooks Atkinson. *The Essential Writings of Ralph Waldo Emerson*. New York: Modern Library Classics, 2000.

Hamilton, Alexander. James Madison and John Jay. *The Federalist Papers*. New York: Penguin Classics, 1987.

Hecht, Jennifer Michael. *Doubt: A History*. San Francisco: HarperCollins Publisher, 2004.

Howe, Fanny. *Gone*. Berkeley: University of California Press, 2003.

Howe, Fanny. *The Wedding Dress: Meditations on Word and Life*. Berkeley: University of California Press, 2003.

Lee, Spike and Ralph Wiley. *By Any Means Necessary: The Trials and Tribulations of the Making of Malcolm X*. New York: Hyperion, 1992.

McEwan, Ian. *Saturday*. New York: Random House, Inc., 2005.

Shanley, John Patrick. *Doubt: A Parable*. New York: Theater Communications Group, 2005.

Tillich, Paul. *The Courage To Be*. 2nd ed. New Haven: Yale University Press, 1952.

Winnicott, D. W. *Playing and Reality*. London: Tavistock Publications, 1971.

Articles:

Brinkley, Joel. "Bush Overhauls U.S. Regulations." *The New York Times* 14 (August 2004).

Cooper, Michael. "New York State Votes to Reduce Drug Sentences." *The New York Times* 8 (December 2004).

Gopnik, Adam. "The City and the Pillars." *The New Yorker* 24 (September 2001).

Hoffmann, Stanley. "On the War." *The New York Review of Books* Vol. 48, No. 17, 1 (November 2001).

Jose Alfonso Feito, "Allowing Not-Knowing: Shared Inquiry and the Invitation to Wonder." Saint Mary's College of California, 2005.

Judt, Tony. "America and the War." *The New York Review of Books*, Vol. 48, No. 18, 15 (November 2001).

Judt, Tony. "The New World Order." *The New York Review of Books*, Vol. 52, No. 12, 14 (July 2005).

Podhoretz, Norman. "How to Win WW IV." *Commentary* (February 2002).
Podhoretz, Norman. "WW IV: How it Started, What it Means and Why We Have to Win. *Commentary* (September 2004).
Podhoretz, Norman. "The War Against WW IV." *Commentary* (February, 2005).
Posner, Richard. *The New York Times Book Review*. 31 (July 2005).
Rosen, Gary. "Bush and the Realists." *Commentary* (September 2005).

Speeches:

Bush, George W. Speech to America. 11 (September 2001).
_____. Speech to Congress. 20 (September 2001).
_____. Television Address to America. 7 (October 2001).
_____. Speech at Pentagon Memorial Service. 11 (October 2001).
_____. Speech to Atlanta Firemen and Police. 8 (November 2001).
_____. Speech to UN General Assembly. 10 (November 2001).
Speeches printed in full at: http://www.whitehouse.gov/news/releases/
Damasio, Dr. Antonio. "From Emotion to Conciousness." The Museum of Natural History in New York City 5 (March 2002).
Obama, Barack. Remarks made at a book signing for *Dreams From My Father: A Story of Race and Inheritance*. 14 (November 2004).

Films:

The Barbarian Invasions. Written and directed by Denys Arcand. 2002.
Do the Right Thing. Written and directed by Spike Lee. 1989.
25th Hour. Written by David Benioff and directed by Spike Lee. 2002.

8

Screening Citizens

TOBY MILLER

We live in a country that produces virtually nothing anybody else wants to buy, apart from culture. The United States now mostly sells feelings, ideas, money, health, movies, laws, games, religion, and risk—niche forms of collective identity, otherwise known as culture. In 2000, U.S. services exported US$295 billion, and 86 million private-sector service jobs generated an US$80 billion surplus in balance of payments (Office of the US Trade Representative, 2001). The significance of this for the nation's image elsewhere is of course immense, whereas the domestic correlatives are important in terms of wealth, job creation, and ideology.

This chapter is directed toward people who are preparing to work as cultural producers in the audiovisual sector of the United States. It is meant to help them think through how the culture industries are perceived and what is at stake in citizenship terms. I address three issues in particular. The first is the nature of culture and how it blends ideas about custom and society with ideas of meaning and textuality. This sets the scene for the remainder of the chapter. The second issue is the way the debate about the audiovisual industries within the United States has been about discipline and about seeking to control residents—in other words, the impact on the social order and everyday conduct of the culture industries, most notably film and television. I explain the history to this pattern, noting that it is a distinctly U.S. phenomenon of social control, whereby issues of inequality are displaced onto notions of behavior and popular culture is said to pervert audiences. Entering minds hypodermically, these texts can enable and imperil learning, driving viewers to violence through aggressive and misogynistic images and narratives. We can see this discourse at work in a variety of sites, including laboratories, clinics, prisons, schools, newspapers, psychology journals, television stations' research and publicity departments, everyday talk, program-classification regulations, conference papers, parliamentary debates, and state-of-our-youth or state-of-our-civil-society moral panics. It is spectacularly embodied in the U.S. media's theatricality after school shootings, when violent images (not hyper-Protestantism, straight white masculinity, a risk society, or easy access to firearms) are held responsible for creating violent people. There is minimal address of issues

97

beyond behavior that should be on the agenda, such as the operation and representation of capitalism, of gender, of race, and of sexuality. Instead, the focus is on a psychological model of media effects.

The third issue concerns the work the U.S. government does to support the film and television industry and how this brings into question the idea that these sectors are genuinely laissez-faire zones of consumer choice as opposed to big government. The dominant discourse maintains that there is no state responsibility for popular culture, because it is the outcome of a pure market, where the desires of consumers drive the output of producers. The First Amendment to the U.S. Constitution is said to keep government away from screen drama, whereas the entrepreneurial abilities of the culture industries make them successful. Again, this is monumentally misleading: The state is a major participant in that success. I demonstrate that the invisible hand of government is massively implicated in the funding, the politics, and the ideology of U.S. film drama to stimulate the industry and to create domestic and international habits of mind that will direct audiences toward particular forms of citizenship and consumption.

Young artists enter a world of misleading discussions about the citizenship implications of what they do, all the way from the psychological blame placed on the popular—and displaced from social unrest and inequality—on to the role of the state in U.S. entertainment. My aim, then, is to disclose the real conditions of existence of moral panics about the culture industries and the real conditions of existence of Hollywood success. The first section of the chapter alerts future cultural producers to what *culture* signifies, both historically and today. The second section explains how their work is perceived in dominant critical discourse, and the third section disabuses them of a foundational myth of popular culture. These last two sections engage crucial citizenship questions: One addresses the behavioral-effects debate found in households, legislatures, and newspapers, and the other addresses how the industry and the state obfuscate the basis for Hollywood's hegemony. Thinking through these issues will make new cultural professionals more aware and alive to the vital cultural-justice questions that surround their chosen field.

Culture

It should come as no surprise that cultural texts lead to questions of social control and the role of government. Consider the history of the very word *culture*. It derives from the Latin *colare,* which implied tending and developing agriculture as part of subsistence. With the emergence of capitalism's division of labor, culture came both to embody instrumentalism and to abjure it, via the industrialization of farming on the one hand and the cultivation of individual taste on the other. In keeping with this distinction, culture has usually been understood in two registers: via the social sciences and the humanities—truth versus beauty. This was a heuristic distinction in the sixteenth

century, but it became substantive over time. Eighteenth-century German, French, and Spanish dictionaries bear witness to a metaphorical shift into spiritual cultivation. The spread of literacy and printing saw customs and laws passed on, governed, and adjudicated through the written word. Cultural texts supplemented and supplanted physical force as a guarantor of authority. With the Industrial Revolution, populations became urban dwellers—food was imported, and cultures developed textual forms that could be exchanged. Consumer society developed through horse racing, opera, art exhibits, masquerades, and balls. The impact was indexed in cultural labor: the *poligrafi* of fifteenth-century Venice and the hacks of eighteenth-century London generated immensely popular and influential conduct books, works of instruction on everyday life that marked the textualization of custom and the emergence of new occupational identities (Williams 1983: 38; Benhabib 2002: 2; de Pedro 1999: 61-62, 78 n. 1; Briggs and Burke 2003: 10, 38, 60, 57).

Culture became a marker of differences and similarities in taste and status within groups, as explored interpretatively and methodically. In the humanities, theater, film, television, radio, art, craft, writing, music, dance, and games are judged by criteria of quality and meaning, as practiced critically and historically. For their part, the social sciences focus on the languages, religions, customs, times, and spaces of different groups, as explored ethnographically or statistically. So whereas the humanities articulate differences within populations through symbolic norms—for example, which class has the cultural capital to appreciate high culture and which does not—the social sciences articulate differences between populations through social norms—for example, which people cultivate agriculture in keeping with spirituality and which do not (Wallerstein, 1989). This bifurcation also has a representational impact, whereby the "cultural component of the capitalist economy" is "its socio-psychological superstructure" (Schumpeter 1975: 121).

But the canons of judgment and analysis that once flowed from the humanities–social sciences distinction—and kept aesthetic tropes somewhat distinct from social norms—have collapsed in on each other: "Whoever speaks of culture speaks of administration as well, whether this is his intention or not" (Adorno 1996: 93). Art and custom have become resources for markets and nations: reactions to the crisis of belonging and to economic necessity. As a consequence, culture is more than textual signs or everyday practices. It also provides the legitimizing ground on which particular groups—such as African Americans, gays and lesbians, the hearing impaired, or evangelical Protestants—claim resources and seek inclusion in national narratives. And culture is crucial to both advanced and developing economies (Yúdice 2002: 40 and 1990; Martín-Barbero 2003: 40).

This intermingling has implications for both aesthetic and social hierarchies. Culture comes to "regulate and structure ... individual and collective lives" (Parekh 2000: 143) in competitive ways that harness art and collective

meaning for governmental and commercial purposes. Culture is understood as a means to growth via cultural citizenship, through a paradox—that universal, and marketable, value is placed on the specificity of different cultural backgrounds. For example, the Spanish minister for culture addressed Sao Paolo's 2004 World Cultural Forum with a message that was equally about economic development and the preservation of aesthetic and customary identity. And Taiwan's premier brokered an administrative reorganization of government that same year as a mix of economic efficiency and cultural citizenship (quoted in "Foro Cultural," 2004 and "Yu," 2004). This simultaneously instrumental and moral tendency is especially important in the United States, albeit in a rather different way. For the United States is virtually alone among wealthy countries in the widespread view of its citizens that their culture is superior to others and in the successful sale of that culture around the world (Pew Research Center for the People & the Press, 2003; Miller *et al.*, 2001 and 2005). The United States has blended preeminence in the two cultural registers, exporting both popular prescriptions for entertainment—the humanities side—and economic prescriptions for labor—the social sciences side. The rest of this chapter focuses on two aspects of that cultural register: anxieties about social control and state support for screen drama.

The Audiovisual As a Site of Discipline

Concerns about how the public reacts to the arts can be traced back a very long way indeed. There was concern about public stimulation of the passions by popular romances and plays (i.e., the liturgy of the devil) in sixteenth- and seventeenth-century Western Europe about and the capacity of typography to disrupt ecclesiastical authority via heresy, sedition, or immorality. When books proliferated across Western Europe in the mid-eighteenth century, people began to skim through them, generating anxious critiques that a plenitude of text was producing a surface form of reading that lacked profundity and erudition (Briggs and Burke 2003: 2-3, 18, 49, 64). In their modern form, such preoccupations derive most directly from the emergent social sciences from the nineteenth and twentieth centuries, which sought to understand and control the crowd in a suddenly urbanized and educated Western Europe and the United States that raised the prospect of a long-feared "ochlocracy" of "the worthless mob" (Pufendorf 2000: 144). Elite theorists from both right and left, notably Vilfredo Pareto (1976), Gaetano Mosca (1939), Gustave Le Bon (1899), and Robert Michels (1915), argued that newly literate publics were vulnerable to manipulation by demagogues. Irrationality en masse was seen as the antithesis of citizenship (Murdock 2005: 177). In the United States, these concerns were manifest at the heart of numerous campaigns against public sex and its representation, most notably the nineteenth-century Comstock Law. The law was named after the noted post office moralist Anthony Comstock, who ran the New York Society for the Suppression of Vice and was especially exercised

by "evil reading." Throughout the history of media regulation since that time, both governments and courts have policed sexual material based on its alleged impact on audiences, all the way from the uptake of Britain's 1868 *Regina v. Hicklin* decision about vulnerable youth through to the U.S. Supreme Court's 1978 *Federal Communication Commission v. Pacifica* decision (Heins 2002: 9, 29-32). In the early twentieth century, opera, plays by William Shakespeare, and romance fiction were censored for their immodest impact on the young. Such tendencies moved into high gear with the Payne Fund Studies of the 1930s, which inaugurated mass social science panic about young Yanquis at the cinema (May and Shuttleworth, 1933; Dale, 1933; Blumer, 1933; Blumer and Hauser, 1933; Forman, 1933; Mitchell, 1929). These pioneering scholars boldly set out to gauge emotional reactions by assessing "galvanic skin response" (Wartella 1996: 173). Their example has led to seven more decades of obsessive attempts to correlate youthful consumption of popular culture with antisocial conduct.

Essentially, academic experts across the United States have decreed media audiences to be passive consumers (Butsch 2000: 3), thanks to the missions of literary criticism—distinguishing the cultivated from others—and psychology—distinguishing the socially competent from others. Tests of beauty and truth found popular culture wanting. The notion of the suddenly enfranchised being bamboozled by the unscrupulously fluent has recurred ever since. It inevitably leads to an emphasis on the number and conduct of audiences to audiovisual entertainment: where they came from, how many there were, and what they did as a consequence of being present. These audiences are conceived as empirical entities that can be known via research instruments derived from sociology, demography, psychology, communication studies, and marketing. Such concerns are coupled with a secondary concentration on content: What were audiences watching when they …? And so texts, too, are conceived as empirical entities that can be known via research instruments derived from these disciplines. Massive public funding, miles of newspaper columns, and hours of ecclesiastical rhetoric have been devoted to such questions instead of to gun laws, gun technology, masculinity, poverty, and state violence.

Although the media play a part in the theory of democracy, as sources of public knowledge of political–economic processes and expressive sites of public opinion, this is overdetermined by powerful processes of professorial negativity. These worries draw on academic, religious, governmental, and familial iconophobia and the sense that large groups of people lie beyond the control of the state and the ruling class and may be led astray. Even that brief moment of supposed social cohesion in the 1950s was clouded by the media—congressional hearings into juvenile delinquency heard again and again from social scientists, police, parents, and others that the emergent mass media were dividing families, were diverting offspring from their elders' values (Gilbert 1986: 3), or were mindlessly creating what ethnomethodologist Harold Garfinkel called

a "cultural dope" who "produces the stable features of the society by acting in compliance with pre-established and legitimate alternatives of action that the common culture provides" (1992: 68). Bob Dylan recalls that during the early '60s in Greenwich Village, "sociologists were saying that TV had deadly intentions and was destroying the minds and imaginations of the young—that their attention span was being dragged down." The other dominant site of knowledge was the "psychology professor, a good performer, but originality not his long suit" (2004: 55, 67).

Why this anxiety? Because new communication technologies and genres offer forms of mastery that threaten, however peripherally, the established order. Each such innovation has brought with it a raft of marketing techniques and concerns about supposedly unprecedented and unholy new risks that, often unwittingly, reference earlier panics: silent and then sound film from the 1920s, radio in the 1930s, comic books of the 1940s and '50s, pop music and television from the 1950s and '60s, satanic rock and video cassette recorders during the 1970s and '80s, and rap music, video games, and the Internet since the 1990s (Kline 1993: 57; Mazzarella 2003: 228). Whenever new communications technologies emerge, their audiences, or consumers, are identified as both pioneers and victims, simultaneously endowed by manufacturers and critics with immense power and immense vulnerability. This was true of 1920s "Radio Boys," seeking out signals from afar, and 1990s "Girl-Power" avatars, seeking out subjectivities from afar. They are held to be the first to know and the last to understand the media—the grand paradox of youth, latterly on display in the "digital sublime" of technological determinism but as always with the super-added valence of a future citizenship in peril (Mosco 2004: 80). The satirical paper the *Onion* cleverly criticized the interdependent phenomena of academic panic and commodification via its faux 2005 study of the impact on U.S. children of seeing Janet Jackson's breast in a Super Bowl broadcast the year before ("U.S. Children," 2005).

The moral panic over *Grand Theft Auto: San Andreas* in 2005, because of its hidden sexual material, is just the latest in a long line of such inquiries. As politicians, grant givers, and jeremiad-wielding pundits call for more and more research to prove that the screen makes people stupid, violent, unpatriotic, and apathetic—or the opposite—academics line up at the trough to indulge their contempt for popular culture and ordinary life and their rent-seeking urge for public money—hence the reliably cliché-laden Senator Hilary Clinton announcing that games are "stealing the innocence of our children" (quoted in "Chasing" 2005: 53), and communications and psychology faculty duly seeking the research funds made available in response. Each massively costly laboratory test of media effects, based on, as the refrain goes, "a large university in the mid-West," is countered by a similar experiment with conflicting results. When the *Economist* magazine asks of video gaming, "Is it a new medium on a par with film and music, a valuable educational tool, a form

of harmless fun or a digital menace that turns children into violent zombies?" ("Chasing," 2005) it is using the same binary oppositions as critics of theater centuries earlier.

For young workers entering the field of cultural production, knowing how these forms of social control are exercised—how the media themselves, religion, and government focus on popular texts rather than material inequality—is vital. In addition to dealing with this powerful world of media-effects rhetoric, young workers in the culture industries must engage a second dominant discourse: the canard that our popular culture succeeds because it is entirely separate from state influences. Consider this history.

Hollywood Citizens

The United States has a vast array of state, regional, and city film commissions coordinated by Film U.S., hidden subsidies to the film industry via reduced local taxes, free provision of police services, and the blocking of public wayfares, Small Business Administration financing through loans and support of independents, and State and Commerce Department briefings and plenipotentiary representation. Having originated in the late 1940s, by 2000 the number of publicly funded U.S. film and television commissions stood at 205, although some have been defunded with the budgetary crises of the second George W. Bush era. In 2002 there were fifty-six municipal film offices across California alone (Wasko 2003: 38; Stevens 2000: 797-804; Center for Entertainment Industry Data and Research, 2002; Jones 2002: 41). Their work represents a major subsidy. For example, hotel and sales tax rebates are almost universal across the country, and such services even extend in some cases to constructing studio sites, as in North Carolina. The New York City Office of Film, Theatre, and Broadcasting (2000) offers exemption from sales tax on production consumables, rentals, and purchases. The Minnesota Film Board (2000) has a Minnesota Film Jobs Fund that gives a 5 percent rebate on wages, not to mention paying producers' first-class airfares and providing free accommodation for them and tax-free accommodation for their workers as well as tax-avoidance schemes. The California Film Commission (2000) reimburses public personnel costs and permit and equipment fees. The Californian State Government offers a Film California First Program that covers everything from free services to a major wage tax credit and was due to begin a new tax credit in 2004, until this was overturned at the appropriations stage due to the state's deficit (Hozic, 1999; Directors Guild of America, 2000; "Americans," 2001; Wicker 2003: 493; Pietrolungo and Tinkham, 2002-03; Rettig, 1998; Ross and Walker, 2000).

Miami is a stunning example of such public subvention. It has become the third-largest audiovisual production hub in the United States after Los Angeles and New York. This was achieved not by happenstance but through very deliberate policy. The Miami Beach Enterprise Zone offers incentives to

businesses expanding or relocating there that include property tax credits, tax credits on wages paid to enterprise zone residents, and sales tax refunds. The Façade Renovation Grant program provides matching grants to qualifying businesses for the rehabilitation of storefronts and the correction of interior code violations. As a consequence of this promotional activity, the Miami culture industries generated about US$2 billion in 1997 and boasted a workforce of 10,000 employees (García, 1998; Martín, 1998). By 2000, volume had increased to US$2.5 billion. Other Miami counties are also renewing their initiatives to woo the audiovisual sector. To diminish the difficulties that producers and film companies encounter with the complicated bureaucracy of the numerous municipalities in the area, which have their own regulations, Miami-Dade's Film Commission led an initiative to draw more film and television business to South Florida (Miller and Yúdice 2002: 80).

Away from these local initiatives, the story of public assistance is even more profound, from infrastructural to textual interventions. Federally, Congress considered legislation in 1991 to limit foreign ownership of the culture industries to 50 percent, a xenophobia that retreated along with the Japanese economy. The House of Representatives continues to contemplate a bill from 2000 to provide subvention to low-budget films; new production-wage tax investments incentives and research-and-development tax credits regularly come before Congress; and there is now a Congressional Entertainment Industry Taskforce dedicated to retaining cultural industry jobs in the United States. The domestic Export-Import Bank Film Production Guarantee Program of 2001 is only the latest incarnation of the state off screen (Steinbock 1995: 21; Blankstein, 2001; Goldman, 2000; "Congress to Address," 2001; Boryskavich and Bowler 2002: 35).

Internationally, negotiations on so-called video piracy have seen Chinese offenders face beheading, even as the United States claims to be watching human rights there as part of most-favored nation treatment. Protests by Indonesian filmmakers against Hollywood that draw the support of their government see Washington threaten retaliation via a vast array of industrial sanctions. The delegation to Hanoi in the mid-1990s of members of Congress who had fought in the American War in Vietnam ushered in film scouts, multiplex salespeople, and Hollywood films on television. And the United States pressured South Korea to drop its screen quotas as part of 1998–99 negotiations on a Bilateral Investment Treaty ("Commerce Secretary," 2001; Robinson 2000: 51; Devine 1999: xvii; Kim 2000: 362). Copyright limitations prevent the free flow of information, and foreign funds have often been raised through overseas tax shelters (Acheson and Maule, 1991; Guback, 1984, 1985, and 1987). Nearly 20 percent of the US$15 billion expended on Hollywood production in 2000 was, for example, German, based on tax subsidies and lax listing rules on its high-technology Neuer Markt—in 2001, the figure amounted to US$2 billion (Zwick, 2000; Kirschbaum, 2001; European Audiovisual Observatory

2003: 5; Crayford, 2002). In 2005, U.S. cable television companies might have politely received callers from U.S. film commissions seeking their business, but they were planning production in Canada, based on funds derived from annual rebate incentives for "the dentists of Hamburg." Once more, we find public funding at the heart of this putatively private endeavor.

No wonder *Canadian Business* magazine refers to "Hollywood's welfare bums" (Chidley, 2000). Even *Time*'s European business correspondent (Ledbetter, 2002) acknowledges the world-historical extent of cultural protectionism in the United States, which applies across the entertainment spectrum—what William I. Greenwald half a century ago memorably named "the virtual embargo'" (1952: 48; also see Slotin, 2002). Unions and leftist groups doubt the efficacy of additional, local corporate welfare as a counter to foreign corporate welfare, since the media giants that utilized such subsidies are international in their operation. Activists favor rooting out all such policies (Cooper, 2000)—almost a link to the neoclassical ideal—in the name of saving Hollywood from "rustbelt" status thanks to the North American Free Trade Agreement (Bacon, 1999; see also Talcin, n.d.). For their employers, competition is an end rather than a means, as in other forms of capitalism.

As for propaganda, in the embarrassingly macho language of U.S. political science the media represent "soft power" to match the "hard power" of the military and the economy (Nye, 2002-03). The state has a long history of direct participation in production (Hearon, 1938) and control, starting with screening Hollywood films on ships bringing migrants through to sending "films to leper colonies in the Canal Zone and in the Philippines" (Hays 1927: 50). During the First World War, films from the Central Powers were banned across the United States. Immediately afterward, the Department of the Interior recruited the industry to its policy of "Americanization" of immigrants (Walsh 1997: 10) and Paramount-Famous-Lasky executive Sidney R. Kent proudly referred to films as "silent propaganda" (1927: 208). In 1927, the fan magazine *Film Fun* printed an unsigned article by someone who had migrated from Paraguay:

Hizzoner, Uncle Sam, tells us it takes five years for a furriner [sic] to become Americanized. Hizzoner is looking up the wrong street; any furriner [sic] who goes to the movies in Europe can become an American in almost no time ...

... When I got to America they told us we would have to go to Ellis Island the next day. I wanted to get into the swim right away ...

... They turned me loose. I knew just what to do. The movies I had seen had taught me all about America. I bought a gun the second day, a horse

the third, and the Woolworth building the fourth; the man who sold it to me was such a nice fellow, I'd like to meet him again some day.

So you see, it really doesn't take long to become Yankeeized when one has seen the cinema.

("A Yank," 1927)

In the 1920s and '30s, Hollywood lobbyists regarded the U.S. Departments of State and Commerce as its message boys. The State Department undertook market research and shared business intelligence. The Commerce Department pressured other countries to permit cinema free access and favorable terms of trade. The Motion Picture Export Association of America (MPEAA) referred to itself as the little State Department in the 1940s, so isomorphic were its methods and ideology with U.S. policy and politics. This was also the era when the industry's self-regulating production code appended to its bizarre litany of sexual anxieties two items requested by the "other" State Department: selling the American way of life around the world and, as we have seen, avoiding negative representations of "a foreign country with which we have cordial relations" (Powdermaker 1950: 36).

During the Second World War, the United States opened an Office of the Coordinator of Inter-American Affairs. Its most visible program was the Motion Picture Division, headed by John Hay Whitney, former coproducer of *Gone with the Wind* (Victor Fleming, 1939) and future secret agent and front man for the Central Intelligence Agency's news service, Forum World Features (Stonor Saunders 1999: 311-12), who brought in public relations specialists and noted filmmakers like Luis Buñuel to analyze the propaganda value of German and Japanese films. Whitney was especially interested in their construction of ethnic stereotypes. He sought to formulate a program for revising Hollywood movies, which were obstacles to gaining solidarity from Latin Americans for the U.S. war efforts, and was responsible for getting Hollywood to distribute *Simón Bolívar* (Miguel Contreras Torres, 1942) and to produce *Saludos Amigos* (Norman Ferguson and Wilfred Jackson, 1943) and *The Three Caballeros* (Norman Ferguson, 1944). Some production costs were borne by the Office of the Coordinator of Inter-American Affairs in exchange for free prints to be distributed in U.S. embassies and consulates in Latin America. Whitney even accompanied Walt Disney and the star of his film, Donald Duck, who made a guest appearance in Rio de Janeiro, and the office had a film reshot because it showed Mexican children shoeless in the street, while the successful integration of Brazilian comic-book and cartoon characters into Disney products at this time paved the way for post-war success in opening the Brazilian market to extensive Disney merchandise (Kahn 1981: 145; Powdermaker 1950: 71; Reis 2001: 89-90).

When the U.S. military invaded Europe in 1944 and 1945, they closed Axis films, shuttered their industry, and insisted on the release of U.S. movies. The quid pro quo for the Marshall Plan was the abolition of customs restrictions, among which were limits on film imports (Trumpbour 2002: 63, 3-4, 62, 98; Pauwels and Losien 2003: 293). In the case of Japan, the occupation immediately changed the face of cinema. When theaters reopened for the first time after the United States dropped its atomic bombs, all films and posters with war themes were removed. Previously censored Hollywood texts were on screens. The occupying troops immediately established the Information Dissemination Section, which soon after became the Civilian Information and Education Section, in its Psychological Warfare Branch to imbue the local population with guilt and to "teach American values" through movies (High 2003: 503-04).

Meanwhile, with the cold war under way, the Central Intelligence Agency's Psychological Warfare Workshop employed future Watergate criminal E. Howard Hunt, who clandestinely funded the rights purchase and production of *Animal Farm* (Joy Batchelor and John Halas, 1954) and *1984* (Michael Anderson, 1956) (Cohen, 2003). On a more routine basis, the U.S. Information Service, located all over the world as part of cold-war expansion, had a lending library of films as a key part of its public diplomacy (Lazarsfeld 1950: xi).

Film producer Walter Wanger (1950) trumpeted the meshing of what he called "Donald Duck and Diplomacy" as "a Marshall Plan for ideas ... a veritable celluloid Athens" (444) that meant the state needed Hollywood "more than ... the H bomb" (446)—this from the man who had hailed Mussolini as "a marvelous man" in 1936 (Trumpbour 2002: 37). Motion Picture Association of America/Motion Picture Export Association of America head Eric Johnston, fresh from his prior post as secretary of commerce, sought to dispatch "messengers from a free country." President Harry Truman agreed, referring to movies as "ambassadors of goodwill" (quoted in Johnston, 1950; also see Hozic 2001: 77). And when the advent of a new international division of cultural labor threatened Hollywood jobs because production moved offshore, union official H. O'Neil Shanks spoke in these terms to the 1961 Congress House Education and Labor Subcommittee on the Impact of Imports and Exports on American Employment:

Apart from the fact that thousands of job opportunities for motion picture technicians, musicians, and players are being "exported" to other countries at the expense of American citizens residing in the State of California, the State of New York, and in other States because of **runaway production** this unfortunate trend ... threatens to destroy a valuable national asset in the field of world-wide mass communications, which is vital to our national interest and security. If **Hollywood** is thus permitted to become "obsolete as a production center" and the United States

voluntarily surrenders its position of world leadership in the field of the-
atrical motion pictures, the chance to present a more favorable Ameri-
can image on the movie screens of non-Communist countries in reply to
the cold war attacks of our Soviet adversaries will be lost forever.

(Ulich and Simmons 2001: 359-60)

The Legislative Research Service prepared a report for the Subcommittee
on International Organizations and Movements of the House Committee
on Foreign Affairs in 1964 with a title that made the point bluntly: *The U.S.
Ideological Effort: Government Agencies and Programs.* It explained that "the
U.S. ideological effort has become more important than ever" because "the
Communist movement is working actively to bring ... underdeveloped lands
under Communist control" (1964: 1). The report included John F. Kennedy's
instruction that the U.S. Information Agency use film and television inter alia
to propagandize (9) and noted that at that date, the government paid for 226
film centers in 106 countries with 7,541 projectors (19). Four decades later,
union officials soberly intoned, "Although the Cold War is no longer a reason
to protect cultural identity, today U.S.-produced pictures are still a conduit
through which our values, such as democracy and freedom, are promoted"
(Ulich and Simmers 2001: 365). The U.S. Department of Commerce produces
materials today on media globalization for Congress that run lines about both
economic development and ideological influence, problematizing claims that
Hollywood is pure free enterprise and that the U.S. government is uninter-
ested in blending trade with cultural change. This is laissez-faire?

Most pertinently, the new hybrid of SiliWood blends together northern
Californian technology, Hollywood methods, and military funding. The
interactivity underpinning this hybrid has evolved through the articulation
since the mid-1980s of southern and northern California semiconductor and
computer manufacture and systems and software development, which was a
massively military-inflected and -supported industry until after the cold war,
to Hollywood screen content. Disused aircraft-production hangars were sym-
bolically converted into entertainment sites (Aksoy and Robins, 1992; Scott
1998a and 1998b: 31; Porter, 1998; Bureau of Labor Statistics 2000: 205; Vogel
1998: 33; International Labour Office, 2000; Sedgwick, 2002; Raco, 1999;
Waters, 1999; Goodman, 2001).

The links are ongoing. Steven Spielberg is a recipient of the Defense
Department's Medal for Distinguished Public Service; Silicon Graphics fever-
ishly designs material for use by the empire in both its military and cultural
aspects; and virtual-reality research veers between soldierly and audience
applications, much of it subsidized by the Federal Technology Reinvestment
Project and Advanced Technology Program. This has further submerged kill-
ing machines from public scrutiny, even as they surface superficially, doubling

as Hollywood props. This link was clearly evident in the way the film industry sprang into militaristic action in concert with Pentagon preferences after September 11, 2001, and even became a consultant on possible terrorist attacks (Directors Guild of America, 2000; Hozic 2001: 140-41, 148-51; Grover, 2001; McClintock, 2002; Gorman, 2002; Calvo and Welkos, 2002; "Americans," 2001). The University of Southern California's Institute for Creative Technologies uses military money and Hollywood directors to test out homicidal technologies and narrative scenarios. And with the National Aeronautics and Space Administration struggling to renovate its image, who better to invite to lunch than Hollywood producers, so they would script new texts featuring the agency as a benign, exciting entity? Why not form a White House–Hollywood Committee while you are at it to ensure coordination between the nations we bomb and the messages we export? The Motion Picture Association of America even argues before Congress that this is a key initiative against terrorism, since copying funds transnational extrapolitical violence ("Hollywood Reaches," 2002; Chambers, 2002; Valenti, 2003).

Lastly, with the Republican Party effectively owned by minerals and manufacturing and mistrustful of film's putative liberalism, the culture industries have their bidding done by purchasing Democrat lobbyists. In return for campaign funds, the Democratic Party obeys the will of the studios via protectionist legislation such as the Consumer Broadband and Digital Television Promotion Act and various anticounterfeiting amendments to attack file sharing and the use of multiple platforms for watching films (Koerner, 2003). Caught amid conflicting pressures of expansion, stability, and political legitimacy (Streeter 1996: 264), Hollywood studios have poured donations into the campaign coffers of politicians who support copyright extensions, ratification of the World Intellectual Property Organization Treaty, and antipiracy technologies (see Table 8.1).

Table 8.1 Cinema, Television, and Music Industry Contributions to U.S. Political Parties

Year	Total	Individuals	PACs	Soft Money	Democrat	Republican
2002	$39,910,667	$7,923,442	$4,327,202	$27,660,023	78%	22%
2000	$37,936,084	$15,228,134	$3,976,294	$18,731,656	64%	36%
1998	$16,430,185	$6,921,670	$3,398,946	$6,109,569	62%	38%
1996	$19,597,100	$7,778,591	$3,195,514	$8,622,995	62%	37%
1994	$9,744,657	$4,804,969	$2,604,878	$2,334,810	71%	29%
1992	$13,722,121	$7,880,176	$2,809,985	$3,031,960	74%	26%
1990	$5,755,469	$3,381,999	$2,373,470	N/A	74%	26%

Source: Adapted from opensecrets.org.

In summary, for all its rhetoric of pure competition, the U.S. government has devoted massive resources to generate and to sustain private-sector film in the interests of ideology and money, and the audiovisual sector has responded in commercial and ideological kind.

Conclusion

The U.S. public sector is deeply implicated in both the ideological and the monetary workings of film and television, even as the critical apparatus of U.S. lobby groups, academia, and the state is obsessed with behavioral and laissez-faire shibboleths. While the real politics is operating at the level of massive subsidies and propaganda, the symbolic politics is deflecting attention from the violence and selfishness unleashed by U.S. capitalism by embarking on endless, unresolvable, financially rewarding debates about media audiences. If we are to encourage a truly active cultural citizenship, then cultural producers need to know where the money is made and where the deals are done in audiovisual popular culture; they need to be able to question the obsessive chronicling of behavior in the face of popular culture; and they need to contest the hidden role of the state in promulgating the domination of U.S. entertainment. Otherwise, what is a film school for?

Bibliography

Acheson, Keith and Christopher Maule. "Shadows Behind the Scenes: Political Exchange and the Film Industry." *Millennium Journal of International Studies* 20 (1991) no. 2: 287-307.

Adorno, Theodor W. *The Culture Industry: Selected Essays on Mass Culture*. Trans. Gordon Finlayson, Nicholas Walker, Anson G. Rabinach, Wes Blomster, and Thomas Y. Levin. Ed. J. M. Bernstein. London: Routledge, 1996.

Aksoy, Asu and Kevin Robins. "Hollywood for the Twenty-First Century: Global Competition for Critical Mass in Image Markets." *Cambridge Journal of Economics* 16 (1992) no. 1: 1-22.

"Americans Go On-Line with Anti-Canuck Views." *Toronto Star* 14 (February 2001).

Bacon, David. "Is Free Trade Making Hollywood a Rustbelt?" *Labournet* 19 (November 1999).

Benhabib, Seyla. *The Claims of Culture: Equality and Diversity in the Global Era*. Princeton: Princeton University Press, 2002.

Blankstein, Andrew. "Company Town: Lawmaker Urges Stop to Runaway Production." *Los Angeles Times* 31 (January 2001).

Blumer, Herbert. *Movies and Conduct*. New York: Macmillan, 1933.

Blumer, Herbert and Philip M. Hauser. *Movies, Delinquency and Crime*. New York: Macmillan, 1933.

Boryskavich, Krista and Aaron Bowler. "Hollywood North: Tax Incentives and the Film Industry in Canada." *Asper Review of International Business and Trade Law* 2 (2002): 25-42.

Briggs, Asa and Peter Burke. *A Social History of the Media: From Gutenberg to the Internet*. Cambridge: Polity Press, 2003.

Bureau of Labor Statistics. *Career Guide to Industries 2000-01* (2000).

Butsch, Richard. *The Making of American Audiences: From Stage to Television, 1750-1990*. Cambridge: Cambridge University Press, 2000.

California Film Commission. www.filmcafirst.ca.gov, accessed 2000.

Calvo, Dana and Robert W. Welkos. "Hollywood Shakes Off Fear of Terror Images." *Los Angeles Times* 20 (May 2002): 1.

Center for Entertainment Industry Data and Research. *The Migration of Feature Film Production from the U.S. to Canada and Beyond: Year 2001 Production Report* (2002).

Chambers, David. "Will Hollywood Go to War?" *Transnational Broadcasting Studies* 8 (2002).

"Chasing the Dream." *Economist* 6 (August 2005): 53-55.

Chidley, Joe. "Hollywood's Welfare Bums." *Canadian Business* 3 (April 2000): 11-12.

Cohen, Karl. "The Cartoon That Came in From the Cold." *Guardian* 7 (March 2003).

"Commerce Secretary Mineta Releases Report on the Impact of the Migration of U.S. Film and Television Production." *US Department of Commerce Press Release*, 18 (January 2001).

"Congress to Address Runaway Production." International Cinematographers Guild. www.cameraguild.com/news/global/congress_runaway.htm, accessed 2001.

Cooper, Marc. "Runaway Shops." *Nation* 3 (April 2000): 28.

Crayford, Peter. "The Revolt on Planet Hollywood." *Australian Financial Review* 13 (July 2002): 45.

Dale, Edgar. *The Content of Motion Pictures.* New York: Macmillan, 1933.

Devine, Jeremy M. *Vietnam at 24 Frames a Second.* Austin: University of Texas Press, 1999.

Directors Guild of America. "DGA Commends Action by Governor Gray Davis to Fight Runaway Production." Press Release 18 (May 2000).

Dylan, Bob. *Chronicles: Volume One.* New York: Simon & Schuster, 2004.

European Audiovisual Observatory. *Focus 2003: World Film Market Trends/Tendances du marché mondial du film* (2003).

Forman, Henry James. *Our Movie Made Children.* New York: Macmillan, 1933.

"Foro Cultural: Ministra Espanola dice que la cultura es pilar para el desarollo." *Spanish Newswire Services* 30 (June 2004).

García, Beatrice E. "Entertainment Industry Survey is Off the Mark." *Miami Herald* 5 (December 1998): 1C.

Garfinkel, Harold. *Studies in Ethnomethodology.* Cambridge: Polity Press, 1992.

Gilbert, J. *America's Reaction to the Juvenile Delinquent in the 1950s.* New York: Oxford University Press, 1986.

Goldman, Michael. "The Politics of Post: Lobbying Congress for HD Relief." *Millimeter* 1 (May 2000).

Goodman, William C. "Employment in Services Industries Affected by Recessions and Expansions." *Monthly Labor Review* 124 (2001) no. 10: 3-11.

Gorman, Steve. "ABC to Launch Controversial Wartime "Reality" Show." *Reuters* 20 (February 2002).

Greenwald, William I. "The Control of Foreign Trade: A Half-Century of Film Trade with Great Britain." *Journal of Business of the University of Chicago* 25 (1952) no. 1: 39-49.

Grover, Ronald. "Power Lunch." *Business Week* 21 (September 2001).

Guback, Thomas H. "International Circulation of U. S. Theatrical Films and Television Programming." *World Communications: A Handbook.* Ed. George Gerbner and Marsha Siefert. New York: Longman (1984): 153-63.

Guback, Thomas H. "Hollywood"s International Markets." *The American Film Industry.* Ed. Tino Balio. Madison: University of Wisconsin Press (1985): 463-86.

Guback, Thomas H. "Government Support to the Film Industry in the United States." *Current Research in Film: Audiences, Economics and Law vol. 3.* Ed. Bruce A. Austin. Norwood: Ablex (1987): 88-104.

Hays, Will. "Supervision from Within." *The Story of the Films as told by Leaders of the Industry to the Students of the Graduate School of Business Administration George F. Baker Foundation Harvard University.* Ed. Joseph P. Kennedy. Chicago: A W. Shaw Company (1927): 29-54.

Hearon, Fanning. "The Motion-Picture Program and Policy of the United States Government." *Journal of Educational Sociology* 12 (1938) no. 3: 147-62.

Heins, Marjorie. *Not in Front of the Children: "Indecency," Censorship, and the Innocence of Youth.* New York: Hill and Wang, 2002.

High, Peter B. *The Imperial Screen: Japanese Film Culture in the Fifteen Years' War, 1931-1945.* Madison: University of Wisconsin Press, 2003.

"Hollywood Reaches Out to NASA at L.A. Power Lunch." *Reuters* 24 (September 2002).

Hozic, Aida A. "Uncle Sam Goes to Siliwood: Of Landscapes, Spielberg and Hegemony." *Review of International Political Economy* 6 (1999) no. 3: 289-312.

Hozic, Aida A. *Hollyworld: Space, Power, and Fantasy in the American Economy.* Ithaca: Cornell University Press, 2001.

International Labour Office. *Sectoral Activities Programme: Media; Culture; Graphical.* Geneva, 2000.

Johnston, Eric. "Messengers from a Free Country." *Saturday Review of Literature* 4 (March 1950): 9-12.

Jones, Martha. *Motion Picture Production in Canada: Requested by Assembly Member Dario Frommer, Chair of the Select Committee on the Future of California"s Film Industry.* California Research Bureau, California State Library, 2002.

Kahn, E. J., Jr. *Jock. The Life and Times of John Hay Whitney.* Garden City: Doubleday, 1981.

Kent, Sidney R. "Distributing the Product." *The Story of the Films as told by Leaders of the Industry to the Students of the Graduate School of Business Administration George F. Baker Foundation Harvard University.* Ed. Joseph P. Kennedy. Chicago: A. W. Shaw Company (1927): 203-32.

Kim, Carolyn Hyun-Kyung. "Building the Korean Film Industry"s Competitiveness." *Pacific Rim Law and Policy Journal* 9 (2000): 353-77.

Kirschbaum, Erik. "Germany Thriving Centre for European Film." *Reuters* 16 (February 2001).

Kline, Stephen. *Out of the Garden: Toys, TV, and Children's Culture in the Age of Marketing.* London: Verso, 1993.

Koerner, Brendan I. "Hollywood and Whine." *Washington Monthly* (January-February 2003).

Lazarsfeld, Paul F. "Foreword." *Hollywood Looks at its Audience.* Leo A. Handel. Urbana: University of Illinois Press (1950): ix-xiv.

Le Bon, Gustave. *Psychologie des Foules.* Paris: Alcan, 1899.

Ledbetter, James. "The Culture Blockade." *The Nation* 4 (November 2002): 37.

Legislative Research Service, Library of Congress. *The U.S. Ideological Effort: Government Agencies and Programs: Study Prepared for the Subcommittee on International Organizations and Movements of the Committee on Foreign Affairs.* Washington, DC, 1964.

McClintock, Pamela. "H'Wood Steps Up War Effort." *Variety* 3-9 (June 2002): 3.

Martín, Lydia. "Studio Miami: How Does an Entertainment Capital Rise from the Ground Up? Cash, Connections and Cool." *Miami Herald* 13 (December 1998): 11.

Martín-Barbero, Jesús. "Proyectos de Modernidad en América Latina." *Metapolítica* 29 (2003): 35-51.

May, Mark A. and Frank K. Shuttleworth. *The Social Conduct and Attitudes of Movie Fans.* New York: Macmillan, 1933.

Mazzarella, Sharon R. "Constructing Youth: Media, Youth, and the Politics of Representation." *A Companion to Media Studies.* Ed. Angharad N. Valdivia. Malden: Blackwell (2003): 227-46.

Michels, Robert. *Political Parties: A Sociological Study of the Oligarchical Tendencies of Modern Democracy.* Trans. Eden and Cedar Paul. London: Jarrold & Sons, 1915.

Miller, Toby and George Yúdice. *Cultural Policy.* London: Sage, 2002.

Miller, Toby, Geoffrey Lawrence, Jim McKay, and David Rowe. *Globalization and Sport: Playing the World.* London: Sage, 2001.

Miller, Toby, Nitin Govil, John McMurria, Richard Maxwell, and Ting Wang. *Global Hollywood 2.* London: British Film Institute, 2005.

Minnesota Film Board. www.mnfilm.org, accessed 2000.

Mitchell, Alice Miller. *Children and the Movies.* Chicago: University of Chicago Press, 1929.

Mosca, Gaetano. *The Ruling Class.* Trans. Hannah D. Kahn. Ed. Arthur Livingston. New York: McGraw-Hill, 1939.

Mosco, Vincent. *The Digital Sublime: Myth, Power, and Cyberspace.* Cambridge, Mass.: MIT Press, 2004.

Murdock, Graham. "Public Broadcasting and Democratic Culture: Consumers, Citizens, and Communards." *A Companion to Television.* Ed. Janet Wasko. Malden: Blackwell (2005): 174-98.

New York City Office of Film, Theatre and Broadcasting. www.ci.nyc.ny.cs/html/filmcom, accessed 2000.

Nye, Joseph S., Jr. "Limits of American Power." *Political Science Quarterly* 117 (2002-03) no. 4: 545-59.

Office of the United States Trade Representative. *The President's 2000 Annual Report on the Trade Agreements Program.* Washington, 2001.

Parekh, Bhikhu. *Rethinking Multiculturalism: Cultural Diversity and Political Theory.* Basingstoke: Palgrave, 2000.

Pareto, Vilfredo. *Sociological Writings.* Trans. Derick Mirfin. Ed. S. E. Finer. Oxford: Basil Blackwell, 1976.

Pauwels, Caroline and Jan Loisen. "The WTO and the Audiovisual Sector: Economic Free Trade vs Cultural Horse Trading?" *European Journal of Communication* 18 (2003) no. 3: 291-313.

de Pedro, Jesús Prieto. "Democracy and Cultural Difference in the Spanish Constitution of 1978." *Democracy and Ethnography: Constructing Identities in Multicultural Liberal States.* Ed. Carol J. Greenhouse with Roshanak Kheshti. Albany: State University of New York Press (1999): 61-80.

Pew Research Center for the People & the Press. *Views of a Changing World June 2003* (2003).

Pietrolungo, Kathryn E. and Brian Tinkham. "Global Rule One: SAG's Answer to Runaway Production." *Southwestern Journal of Law and Trade in the Americas* 9 (2002-03): 357-90.

Porter, Michael E. "Clusters and the New Economics of Competition." *Harvard Business Review* (November-December 1998): 77-90.

Powdermaker, Hortense. *Hollywood: The Dream Factory: An Anthropologist Looks at the Movie-Makers.* Boston: Little, Brown and Company, 1950.

Pufendorf, Samuel. *On the Duty of Man and Citizen According to Natural Law.* Trans. Michael Silverthorne. Ed. James Tully. Cambridge: Cambridge University Press, 2000.

Raco, Mike. "Competition, Collaboration and the New Industrial Districts: Examining the Institutional Turn in Local Economic Development." *Urban Studies* (May 1999): 951-70.

Reis, Raul. "Brazil: Love it and Hate it: Brazilians' Ambiguous Relationships with Disney." *Dazzled by Disney? The Global Disney Audiences Project.* Ed. Janet Wasko, Mark Phillips and Eileen R. Meehan. London: Leicester University Press (2001): 88-101.

Rettig, Ellen. "Lights, Camera, Tax Incentives?" *Indianapolis Business Journal* 28 (September 1998): 3.

Robinson, Jim. "Reel Renaissance." *Business Mexico* 10 (2000) no. 4: 51-55.

Ross, Bob and Kevin Walker. "Hollywood on the Bay." *Tampa Tribune* 10 (October 2000): 1.

Schumpeter, Joseph A. *Capitalism, Socialism and Democracy.* New York: HarperPerennial, 1975.

Scott, Allen J. "From Silicon Valley to Hollywood: Growth and Development of the Multimedia Industry in California." *Regional Innovation Systems: The Role of Governances in a Globalized World.* Ed. Hans-Joachim Braczyk, Philip Cooke, and Martin Heidenreich. London: UCL Press (1998a): 136-62.

Scott, Allen J. "Multimedia and Digital Visual Effects: An Emerging Local Labor Market." *Monthly Labor Review* 121 (1998b) no. 3: 30-38.

Sedgwick, John. "Product Differentiation at the Movies: Hollywood, 1946 to 1965." *Journal of Economic History* 62 (2002) no. 3: 676-705.

Slotin, Ian. "Free Speech and the *Visage Culturel*: Canadian and American Perspectives on Pop Culture Discrimination." *Yale Law Journal* 111 (2002) no. 8: 2289-319.

Steinbock, Dan. *Triumph and Erosion in the American Media and Entertainment Industries.* Westport: Quorum, 1995.

Stevens, Tracy, ed. *International Motion Picture Almanac,* 71st ed. La Jolla: Quigley, 2000.

Stonor Saunders, Frances. *Cultural Cold War: The CIA and the World of Arts and Letters.* New York: New Press, 1999.

Streeter, Thomas. *Selling the Air: A Critique of the Policy of Commercial Broadcasting in the United States.* Chicago: University of Chicago Press, 1996.

Talcin, Marsha. "Many Film Productions Hopping the Northern Border." *Showbiz Industry Digest* (n.d.).

Trumpbour, John. *Selling Hollywood to the World: U.S. and European Struggles for Mastery of the Global Film Industry, 1920-1950.* Cambridge: Cambridge University Press, 2002.

Ulrich, Pamela Conley and Lance Simmers. "Motion Picture Production: To Run or Stay Made in the U.S.A." *Loyola of Los Angeles Entertainment Law Review* 21 (2001): 357-70.

"U.S. Children Still Traumatized One Year after Seeing Partially Exposed Breast on TV." *The Onion* 26 (January 2005).

Valenti, Jack. "Intellectual Copyright Piracy: Links to Organized Crime and Terrorism." Testimony before SubCommittee on Courts, the Internet, and Intellectual Property Committee on the Judiciary US House of Representatives 13 (March 2003).

Vogel, Harold L. *Entertainment Industry Economics: A Guide for Financial Analysis,* 4th ed. Cambridge: Cambridge University Press, 1998.

Wallerstein, Immanuel. Culture as the Ideological Battleground of the Modern World-System. *Hitotsubashi Journal of Social Studies* 21 (1989), no. 1: 5-22.

Walsh, Michael. "Fighting the American Invasion with Cricket, Roses, and Marmalade for Breakfast." *Velvet Light Trap* 40 (1997): 3-17.

Wanger, Walter. "Donald Duck and Diplomacy." *Public Opinion Quarterly* 14 (1950) no. 3: 443-52.

Wartella, Ellen. "The History Reconsidered." *American Communication Research—The Remembered History.* Ed. Everette E. Dennis and Ellen Wartella. Mahwah: Lawrence Erlbaum (1996): 169-80.

Wasko, Janet. *How Hollywood Works.* London: Sage, 2003.

Waters, Dan. "Throwing Cash at Movieland." *Sacramento Bee* 23 (April 1999).

Wicker, Heidi Sarah. "Making a Run for the Border: Should the United States Stem Runaway Film and Television Production through Tax and other Financial Incentives?" *George Washington International Law Review* 35 (2003): 461-99.

Williams, Raymond. *Keywords: A Vocabulary of Culture and Society,* rev. ed. New York: Oxford University Press, 1983.

"A Yank in Thirty Days." *Film Fun* (February 1927): 56.

"Yu to Propose 5 Fresh Policy Goals Today." *Taiwan News* 17 (September 2004).

Yúdice, George. "For a Practical Aesthetics." *Social Text* 25-26 (1990): 129-45.

Yúdice, George. *El Recurso de la Cultura: Usos de la Cultura en la Era Global.* Barcelona: Editorial Gedisa, 2002.

Zwick, Steve. "Top Marks for Hollywood: German Film Production Companies are Pouring into Big U.S. Movies—with Mixed Results." *Time International* 16 (October 2000): 58.

9

Patriotism, Fear, and Artistic Citizenship

ROBERT STAM AND ELLA SHOHAT

The Definition of Patriotism

The day after a huge antiwar demonstration in Washington, D.C., CNN asked the following electronic poll question: "Do you think antiwar demonstrators should be regarded as traitors?" The very question was obscene; even we would say "unpatriotic" since it implied that a prohibition on dissent—the very kernel of a free society—was conceivable and perhaps desirable. Since treason is normally punished by death, it was as if CNN were asking the prowar faction of its audience if another faction of its audience—the antiwar left—should be tried and perhaps put to death.

CNN's prowar demogoguery brings up the definition of *patriotism* and, in the context of the arts, the question of cultural citizenship. The conventional portrait of patriots goes more or less as follows. Patriots wave the American flag, literally or figuratively, on all possible occasions; they fly it over their door, glue it to their windshield, and carry it to football games. They tirelessly repeat that they live in "the greatest country in world." They see their country's history as an endless story of wondrous victories—or terrible betrayals—and reflexively support all of its wars. They agree with every presidential policy, since "the president has more information than we do." They accept the media's word, since "they wouldn't say it if it weren't true." They do not mind the extraconstitutional abuse of prisoners, since they want to believe "they wouldn't be in prison if they hadn't done something." When demogogues speak, the patriots are there in the audience chanting the name of their country above all others: America *uber alles.*

But is this the portrait of the perfect patriot or of the perfect idiot? Of the perfect citizen or of the perfect hypocrite? The same superpatriots who brag about living in the greatest country in the world might know very little about their own country or, for that matter, about the other countries to which they feel superior. The same people who wave the flag might be shirking their fair burden of taxes through a tax haven in the Caribbean. The same people who support all the country's wars might not be informed citizens, or might be

reluctant-to-fight chicken hawks, or might not realize the war they are supporting actually hurts not only the other country but also their own.

Those of us who are critical of certain U.S. government policies are constantly berated for our lack of patriotism. We are called "America haters" or the "Blame America First" crowd. But let us make one thing clear. We do not hate America; we only hate what right-wingers are doing to American democracy. We do not really even hate Bush—only his illegitimate power over the rest of us. All this impugning of patriotism is just a not very polite way of telling us to shut up. Unable to deal with us on the level of argument, they deal with us on the level of slurs and labels.

Personally, we would rather that the debate be open, with everyone's patriotism simply assumed, without the issue of patriotism being part of the discussion. But since the right constantly denounces us as unpatriotic—with comments such as "they are not real Americans," "they are not normal Americans," and "they are out of the mainstream"—the left is forced to deal with this rather stupid yet often powerfully effective charge. So let us meet it head on. It is not just that we do love the country; it is also that we think the right gets the issue of patriotism upside down. We would therefore propose our "patriotic law of inverse proportion." This law suggests that those who speak most about patriotism are often in fact the least patriotic. Just as we know that televangelists or members of Congress who constantly denounce sexual immorality and pornography or homosexuality are precisely those most likely to be closet gays or involved in kinky sex, so those who speak most about patriotism, according to our law of inversion, are often the least patriotic. Conversely, those who speak least about patriotism—who are even irritated by patriotic talk—might be the most patriotic. It was King Lear's most faithful daughter, Cordelia, after all, who refused to say that she loved her father the most precisely because she thought it did not need saying. Those like her sisters who were constantly proclaiming their love were for Cordelia the most despicable of hypocrites.

The same holds true regarding patriotism. We are not speaking here about the everyday, relatively powerless people who show American flags or yellow ribbons to express solidarity with the victims of September 11, 2001, or with American troops abroad. We are speaking about the powerful people who use patriotism as a blunt instrument to justify war and to suppress dissent. But why would we say that those who speak most of patriotism are actually the least patriotic, and how do we define patriotism? Patriotism—we actually prefer the phrase "love of country"—can be summed up in a few words and principles: the love of one's country and compatriots; a hope for and activism on behalf of their collective well-being; and, in the United States case loyalty to basic principles of the Bill of Rights, the Declaration of Independence, "all men are created equal," the Constitution, freedom of speech, separation of church and state, life, liberty, and the pursuit of happiness, and government of, for, and by the people.

But the George W. Bush administration has, to paraphrase an anti-Kerry Republican attack ad, some wacky ideas about patriotism. The mistake of the centrist Democrats is to accept the right-wing framing of the issue of patriotism and then to offer a servile mimickry of "us too" militaristic patriotism. But the real point is to change the frame, even in terms of the sacred cow of patriotism. (We must turn a sacred cow into a *vache qui rit*.)

By our definitions, the right fails the test of patriotic love of country. In common-sense terms, one would think that patriotism or love of country would mean, first of all, loving the land itself—that is, the beauty and resources and the air and water of the country itself. The word *land,* as in the song "This Land is My Land," means both Earth and country, and the two are deeply linked. Our national anthems speak of "purple mountains' majesty" and "fruited plains." But the "this-land-is-my-land" kind of love should also embrace the peoples who loved the land before Americans did—that is, Native Americans. Indeed, the very word *American* initially meant "native American." Perhaps patriots could learn from Native Americans about how to really love and nourish and protect our common land. Whereas for the colonists the land was virgin territory to be deflowered and fecundated, for the natives it is the source of all sustenance, a mother widowed by European conquest. Far from loving the land, the self-proclaimed patriotic right wing and the corporations that support them and that they support violate the land, strip it, and sell it to the highest bidder; pollute the water with arsenic and PCBs; and send carbon monoxide into the air. They contaminate the soil and foul the waters of America the Beautiful, all in the name of the sacred rights of corporations. And since pollution and acid rain and global warming do not respect national borders, they contaminate the world as well.

Second, one would think patriotism, or love of country, would mean loving the people of the country by caring for their bodies and their interests and their welfare. It is important to distinguish, in this sense, between *liking* and *loving.* Patriots do not have to like all the people in the country of their birth or adoption; that would be implausible, even silly. Indeed, what Benedict Anderson called the "horizontal camaraderie" of national belonging is premised on not knowing the vast majority of one's compatriots. But patriots can love the people in the aggregate, in the sense of acting democratically and having their best interests in mind in terms of their physical, medical, moral, economic, and social well-being. The current superpatriots—William Bennett, Ann Coulter, John Ashcroft, and others—clearly fail this patriotic test. They do not care for the well-being of the citizens. If they really cared about the well-being of all the people, they would be fighting for such things as universal health care, affordable or better free education, a progressive tax code, well-paid jobs, and the end of racial profiling and police brutality. The true patriots are those who want to facilitate opportunity; to prevent disease;

and to provide security through health care, retirement programs, and unemployment insurance—all that is necessary to the well-being of people.

Against the currents of the histories of all of the advanced countries, and even those of some less advanced ones, the right wing—after resisting the advances of the welfare state in the form of the New Deal, such as progressive income tax and federally insured loans (i.e., measures that ultimately saved capitalism from its own excesses)—is currently trying to undo that system entirely, just as they are trying to do the postwar international consensus institutions. As a result, the United States clearly has the worst record of all the industrialized, modern, democratic countries. Countries such as France, England, Canada, Germany, Holland, Finland, Norway, and Costa Rica all provide universal health care for their citizens. Even countries with very few resources, such as Tunisia, offer health care. In these countries, health care is seen not as a privilege but as a fundamental right due all human beings. No one in a country like Canada, as Michael Moore reminds us, ever says "I hate my job, but I have to keep it because of the health benefits." In a civilized country, health care does not depend on a job; it is one's birthright as a human being.[1]

Antiterrorist security is only one form of love for the bodies and minds of the people. And even in terms of security, this new national security state has failed even in its own terms, since it has been more invested, in both the psychological and financial meanings of that word, in profits for coporations than in actually protecting the populace from terrorism. Generous with funds for destroying and rebuilding in Iraq, it has been very stingy with funds for beefing up police and fire services in American cities or for protecting ports and chemical factories. Forgetting that the greatest weapon of mass destruction on 9/11 was not massed armies or foreign missiles but rather the hatred—and the cookie cutters—of Al-Qaeda terrorists, the Bush administration spends money on redundant or risky programs, such as Star Wars, while neglecting both Al-Qaeda and the real national defense of the crowded metropolises of this country. The administration argues that we are fighting them in Iraq so we won't have to fight them here, but that argument is fallacious since (1) the Iraq war stimulates more hatred and thus more terrorists; (2) Iraq provides a hands-on training ground for terrorists; (3) Iraq is where American soldiers and contract workers are actually being killed; and (4) Iraq diverts billions of dollars that might have been spent on really protecting the American people.

Third, one would think that patriotism, or love of country, would mean loving the Constitution of the country—a love that has been called civic patriotism. Yet the Bush administration seems to see the Constitution as nothing but an annoying piece of paper, something to be gotten around through clever, lawyerly manipulation of words so that even torture becomes justified in the name of the president as a commander-in-chief clause in the Constitution. Exploiting the hastily approved—and largely unread—Patriot Act, which

Moore calls "about as patriotic as *Mein Kampf*," the attorney general secretly detains thousands of Arab American and Muslim men, corrals or deports aliens, and sends Federal Bureau of Investigation agents into libraries and bookstores to probe what patrons read. In terms of civil liberties, the right systematically undercuts the separation of church and state—through support for faith-based initiatives—and the right to privacy—through such programs as Total Information Awareness—giving the lie to all the glorious talk about small government and trusting the people. An Internet joke suggested that John Ashcroft wanted small government, one so small that it could fit into your computer. It was as if, as Lewis Lapham put it, "they would like to put the entire country behind a one-way mirror that allows the goverment to see the people but prevents the people from seeing it."[2] Thus, we get official secrecy about such public matters as energy policy, for the government, while the lives of citizens are an open book. In terms of government of, by, and for the people, the superpatriots fail on all counts. Despite their sloganeering about trusting the people, not the government—meant only for political campaigns anyway—they do not actually trust the people with information or power of decision.

Fourth, one would think that patriotism, or love of country, would mean a readiness to contribute to the general welfare by paying one's fair share of taxes. Yet the veritable theology of the right is that all tax cuts are good tax cuts; the loudest applause at Republican conventions is usually for lines that promise even more tax cuts. The right is so hysterically hyperbolic about the issue of taxes that one of its gurus, Grover Norquist, president of Americans for Tax Reform, in what must be the most outrageous abuse of the Holocaust analogy ever advanced likened the mentality that defends a progressive tax on the rich to "the morality that says the Holocaust is okay."[3] In a language of false victimization, Norquist equates the racist murder of millions with the loss of a few tax perqs for the super rich. Thus, the super elite of the United States, abetted by the administration, avoids paying taxes by finding tax shelters, loopholes, and off-shore havens and by getting the rest of us to pay a disproportionate share of the taxes they refuse to pay.

Fifth, one would think that patriotism would mean not profiteering from the country's wars, a misdeed that used to be seen as the equivalent of treason. Whereas some corporations are literally guaranteed a profit in that war, the rest of us are guaranteed the inevitable losses in both life and treasure. The Bush administration doled out over a billion dollars in government contracts in advance to American companies for the reconstruction of Iraq, even as it was claiming to be looking for a peaceful solution. The Bechtel Group, the Fluor Corporation, and Haliburton—all major contributors to the Republican Party—lined up to reap their rewards. We have seen repeated charges that Haliburton was overcharging on Kuwait oil (to the tune of $61 million) or on military meals. Meanwhile, Republican legislators stripped funding bills of any

provisions that would hold corporations accountable for profiteering. The division of labor in this profiteering had the Pentagon destroying property through shock and awe destruction and American corporations and their subcontracted labor rebuilding the destroyed property in the reconstruction phase, with huge profits at both ends of the process. Yet the Iraqi people still do not have the promised cheap oil or health care or even electricity; perhaps Iraq in its present state gives us a glimpse of what the right wants for us in America—the flat tax and misery all around. All those companies profiting from the war in Iraq, at the expense of the taxpayers, could be compared to camp-follower prostitutes, but the comparison would be unfair to prostitutes, since prostitutes do not usually create the wars from which they sometimes benefit.

Sixth, one would think that patriotism would mean love of democracy. But with Bush we are confronted with the manipulation of Congress and of the American people, where secrecy is a byword and democracy is not a concern at all. The same right wing that found it normal to expose the most lurid details about Bill Clinton's sexual shenanigans, including even titillating information about the the shape and bend of the presidential penis, found it normal to hide the details of government meetings on energy policy, meetings which, unlike Clinton's liaisons, have real impact on the American people. The war, although supposedly perpetrated to advance democracy, was not decided on democratically even within the Bush cabinet. The president conferred with Saudi prince Bandar before he conferred even with his own secretary of state. One can imagine how the right would have skewered Clinton over a similar lapse. The cabinet never voted on the war, nor did the American people, apart from a kind of coerced charade in Congress, resulting in an approval that Bush said in advance that he did not need anyway. And Bush prodded other countries to join in a war for freedom, even though the war was opposed by huge majorities among their populations.

Seventh, one would think that patriotism would have something to do with protecting the honor of the country in the eyes of the world, out of what those old-fashioned founding fathers called a decent respect for the opinions of mankind. Yet the Bush administration has dishonored and shamed the nation by creating a situation where a hyperpowerful country bombs a weak one and where American soldiers have indulged in the most sadistic forms of torture, in the euphemistic name of softening up the suspect. The same administration officials who prattle constantly about moral values currently enjoy absolutely no moral standing whatsoever in the world; they are almost universally regarded as criminals and mafiosos. In the world's eye, the Statue of Liberty, as an icon of freedom, has been replaced by that wired statue-like prisoner in Abu Ghraib. Tokens of civilization have been replaced by tokens of barbarism.

It is ironic that the right constantly accuses us of treason, when the right in some respects seems to be literally treasonous, at least in terms of its

rhetoric. Treason is usually defined as an attempt to subvert or overthrow the government. Yet Norquist, the grand guru of the right-wing surge, speaks of "drowning the government in the bathtub." Our form of government calls for government of, for, and by the people, not antigovernment of, for, and by the people. Our form of government calls for loyalty to the flag and the Republic for which it stands. It is ironic, in a sense, that the right call themselves Republicans, since they are so obviously opposed to the classical ideals of the republic itself. They are antirepublican, first of all, in that they are imperialist, when republics—and even conservatives like Pat Buchanan make this point—are the polar opposite of empires. *Republic,* to put it simply, connotes self-rule; *empire* connotes imposed rule. Those on the right are antirepublican also in that their whole philosophy goes against the root etymological meaning of *republic* as *res publica*—the public thing, or public matters and issues. The right, in contrast, displays a virulent rage against all things public—whether public schools, public radio and television, or public national parks—and a converse fetishization of all things private—privatization, private enterprise, or private savings accounts—even while they dismiss concerns about citizens' privacy.

Patriotism and love of country, we would argue, has nothing to do with waving the flag or with grand proclamations such as "I believe that the United States is the greatest country in the world." To think patriotism is reducible to such claims would be like thinking that love for one's children meant constantly calling them the greatest children in the world. As with parenting, patriotism means not a blind endorsement or grandiose declarations but rather a quiet, ongoing, informed, quotidian caring. The whole "greatest country in the world" megalomania, in our view, should be thrown on the trash heap of history. Just as ordinary people tend not to like individuals who constantly proclaim their fabulousness, furthermore, so it goes with nations. Saying one country, any country, is the greatest country in the world is like saying that English, or Wolof, is the greatest language in the world. Every language is the greatest language for its speakers; it is the vehicle for expressing their feelings, their ideas, and their wisdom, just as every country—at least any country not plagued by poverty or war—is the best medium of expression for those born in it.

Furthermore, patriotism does not always mean supporting official policies; often, it means precisely the opposite. When slavery was the law of the land, the real patriots were not those who supported slavery and thus the law of the land but those who dared to oppose it or tried to change the law. Of whom are we prouder now: the slaveholders or the rebels such as the maroons and the abolitionists? Was Huckleberry Finn a hero when he supported the official code of slavery like his father or when he decided to go to hell by helping Jim? During the McCarthy period of the blacklists, who were the real patriots: those who jumped on the bandwagon of persecution, or those who opposed it? When the United States was supporting dictatorships and coup d'etats against

elected governments in Latin America—in Guatemala, Brazil, Argentina, and Chile—who were the real patriots: those who defended these antidemocratic interventions, or those who thought the United States should be true to its covenant with democratic rule?

Patriotism, unfortunately, has been militarized; it has become collatoral damage in the war against terrorism. The corporatized right lies its way into starting ill-advised wars that serve their own interests and then, once the war is started, begins the usual blackmail: "we can't cut and run"; "we must support our troops"; "it would be a victory for the terriorists." Thus, the question of patriotism comes up especially with the endless chain of U.S. - led wars. Obviously, it was a patriotic duty to support the U.S. government during World War II, since the fight was indeed for survival and was against fascism. But in the case of Vietnam, who were the real patriots? Those who pursued the war—then too against a country that had never attacked the United States—who had American soldiers kill and be killed, with millions of Vietnamese dead and wounded and 55,000 American dead, along with countless wounded and maimed both physically and mentally? Or were the patriots those who warned that war was unjust, unwinnable, and against the interests of the United States? According to the pseudopatriotic logic that confuses loyalty to country with loyalty to a specific government, the true German patriots, during the Nazi period, would be those who supported the Nazi regime. But for us, the real patriots were those who opposed the regime or even those like Dietrich Bonhoffer who tried to kill Adolf Hitler. And in the case of the Iraq war, who were the real patriots—those who naively believed every fanciful claim advanced by the administration, or those who remained skeptical, calling for more information and reflection before rushing off to war and who turned out to be right in their skepticism?

Over and over, one is struck by a paradox in right-wing moral and patriotic values. Consistently, the right seems infinitely more concerned with simulacral violations having to do with harmless images—Janet Jackson's breast or naked statues in the Justice Department—rather than with actual deeds that really do hurt people, such as the rape and sexual humiliation of real people in Iraqi, or for that matter American, prisons. Right-wing fury is strangely iconoclastic, more concerned with images than reality. It is a matter of keeping up certain kinds of appearances rather than of preventing certain kinds of brutal behavior. Thus, the right is so unforgiving of the sexual offenses of Hollywood films, even Clint Eastwood films, and yet so infinitely forgiving of sexualized tortures in Guantanamo or Iraq. On one level, it is a question of racism—for example, that sexual abuse of dark-skinned people is seen as permissible. In fact, there is a double standard based on who is commiting the abuse. Thus, whatever abuses "we" commit, even to the point of over a hundred detainees dying in military custody—the kind of phenomenon usually associated with the most brutal dictatorships—are somehow passed over, while the abuses

"they" commit are seen as a sign of their barbarity. Patriotism is redefined as the right to commit unethical acts toward others; sadism is a noble cause.

Patriotic exceptionalism often goes hand in hand with the demonization of enemies. The exaltation of the self—"we are a generous nation," "they hate us because of our freedom"—runs parallel to the denigration of the other. The tradition of what Michael Rogin called "political demonology" specializes in the creation of monsters through the "inflation, stigmatization, and dehumanization of political foes."[4] What is especially striking about some of America's enemies in recent decades—Manuel Noriega, Saddam Hussein, the mujhadin in Afghanistan, including bin Laden—is that have all been partial creations of the United States. The demonization was precisely of those who had earlier been adopted by the U.S. corporate military elite, thus giving the demonization a strange, almost incestuous quality. The same Hussein who was praised as moderate and pragmatic by earlier administrations, who was an ally of American policy and the darling of American, British, and German corporations, and whose hand was shaken so enthusiastically by Donald Rumsfeld in 1983 was transformed into a reincarnation of Hitler with the rapidity with which enemies for Hate Week were fabricated in George Orwell's book *1984*. The same Dick Cheney who later demonized Hussein did business with him up through the 1990s. After the 1992 election, Halliburton rebuilt Hussein's war-damaged oil fields for some $23.8 million, even though Cheney, as secretary of defense during the First Gulf War, had been part of the campaign that destroyed those very same fields. In fact, *New York Times* columnist Nicholas Kristof wrote that Cheney-led Haliburton had "sold more equipment to Iraq than any other company."[5] Commentators also have pointed to earlier Bush links to the Taliban and to bin Laden's family and even to the uncanny parallels between George Bush and Osama bin Laden as two rich and spoiled playboys linked to Middle Eastern oil who became religious late in life, who claimed a mandate from God, and who were ready to kill in the name of their fundamentalist beliefs.

Artistic Citizenship As an Answer to Pseudopatriotism

For us, the point is neither blind patriotism nor blind critique of one's country. In terms of the former, the idea of "my country always wrong" is as stupid as "my family right or wrong" or, as G. K. Chesterton put it, "my mother drunk or sober." The point, for intellectuals especially, should be an intelligent and informed critique of one's country, a critique made not by perpetual malcontents or self-hating snobs but rather by those who actually want to make their country better.

The arts have played an invaluable role in this process. Here we would like to offer some examples of artistic citizenship at its best, one drawn from the spoken word movement and the other from sketch comedy and cable television. Both deal, albeit very differently, with the issue of fear in an age of terror.

The first comes from a very evocative poem penned by Suheir Hammad, titled "first writing since," dedicated to the bombing of the World Trade Center. A Palestinian American who grew up in Brooklyn within a multicultural environment of blacks, Latinos, and East Europeans, Hammad's spoken readings are tinged with an African American accent; one of her collections of poetry was titled *Born Palestinian, Born Black*. She forms part of a burgeoning spoken word movement among minority (i.e., black, Latino, Asian American) and progressive white youth in the New York Area, a movement that gained mediatic expression in the cable program "Def Poetry Jam," which was subsequently performed on Broadway. The multiracial coalition of poets generally combines percussive verbal style, performative smarts, and socially conscious lyrics.

Suheir Hammad gives eloquent expression to the conflicting feelings of a Palestinian American New Yorker responding to the 9/11 attacks. Hammad speaks first of her fear and shock and the lack of poetry "in the ashes south of Canal Street" and the lack of "prose in the refrigerated trucks driving debris and DNA." She speaks of the "sky where once was steel" and "smoke where once was flesh" and of her initial fears that the pilot might be Arab or Muslim: in short, someone who "looks like her."

> First, please god, let it be a mistake, the pilot's
> heart failed, the plane's engine died.
> Then please god, let it be a nightmare, wake me now,
> Please god, after the second plane,
> please don't let it be anyone
> Who looks like my brothers.

She then tries to imagine what might have led such people to commit mass murder:

> I have never been so angry as to want
> to control a gun over a pen
> not really
> even as a woman, as a Palestinian,
> as a broken human being.
> Never this broken

Hammad scores the ignorance of Americans who fear generic "orientals," who "do not know the difference/Between indians, afghanis, syrians, muslims, sikhs, hindus." But this scoring of ignorance does not preclude an affectionate hommage to the multiethnic streets and people of New York, in this case the Koreans:

> Thank you korea for kimchi and bibim bob, and corn teat and the genteel smiles of the wait staff at wonjo the smiles never revealing the head of the food or how tired they must be working long midtown shifts ...

A verbal collage follows, based on words drawn from the shakily xeroxed printouts and photos of those who had disappeared, whose names and physiognomies suggest the most diverse ethnicities and origins, distributed by people looking desparately for their loved ones: "please help us find george, also known as Adel, his family is waiting for him with his favorite meal ..." The poet, meanwhile, is looking not for relatives but for peace and mercy and evidence of compassion. She thanks the white stranger who hugs her as she cries.

At the same time, Hammad is irritated by the e-mails from leftists and Arab nationalists saying "they had it coming" or "let's not forget US transgressions." She feels resentful about such comments, since "i live here, these are my friends and fam, and it could have been me in those buildings, and we're not bad people, do not support America's bullying, can i just have half a second to feel bad?" She also resents the chauvinistic Arab haters who ask if she personally knew the highjackers or those who say "they had it coming" but assume that "they" did not include the Arabs or Muslims or Mexicans who died in the World Trade Center. She denounces the media double standard whereby white terrorists like Tim McVeigh are not seen as representing for the white race. "When we talk about holy books and hooded men and death," she asks, "why do we never mention the kkk?"

And then, in a sudden and surprising turn of association, Hammad makes what at first seems a surprising claim. No group of people, she writes, is better positioned to understand the grief of the victims in the terror attacks than the Palestinians: "if there are any people on earth who understand how new york is feeling right now, they are in the west bank and the gaza strip." To those pro-Israelis who would say "now that you Americans have been the victim of suicide bombers, now perhaps you will understand us," Hammad answers, "no, it is Palestinians who understand this kind of victimization." At the same time, Hammad dissociates herself completely from bin Laden; he is not the spokesperson or agent of her anger: "his vision of the world does not include me or those i love ..." But she also knows who will end up paying in their blood for the attack: "in the world, it will be women, mostly colored and poor" and "in america, it will be those amongst us who refuse blanket atacks on the shivering, those of us who work for social justice, in support of civil liberties, in opposition to hateful foreign policies."

The poet then expresses a kind of local, metropolitan patriotism: "I have never felt less american and more new yorker." She worries about her Arab American brothers and sisters: "what will their lives be like now? –realizing that "over there" i.e. Palestine is now "over here." She describes the aftermath of the attacks as life returns to a shaken kind of normality:

> All day, across the river, the smell of
> burning rubber and limbs
> floats through. The sirens have stopped
> now. The advertisers are
> back on the air. The rescue workers are
> traumatized. The skyline is
> brought back to human size. No longer
> taunting the gods with its
> height.
> … i cried when i saw those buildings collapse on
> themselves like a broken heart. I have never
> owned pain that needs to spread like that.

Against those who might aestheticize suffering, she writes, "there is no poetry in this" but only "cause and effects," "symbols and ideologies," and life:

> There is life here, anyone reading this
> is breathing, maybe hurting,
> But breathing for sure. And if there
> is any light to come, it will
> Shine from those who look for peace and justice after the
> Rubbble and rhetoric are cleared and the phoenix has risen.

And refusing Bush's call to declare oneself to be with "us" or with the terrorists, the poet rewrites the choice as one not between "us" and "them" but between life and death:

> Affirm life
> We've got to carry each other now.
> You are either with life, or against it.
> Affirm life.

The Hammad poem gives an incandescent sense of what it is to live in the multination in the age of globalized error and globalized terror, of overlapping and conflicted loyalties to family and neighbors on the one hand and to nation states on the other. But neither nation is unitary; the Palestine Hammad supports includes the bin Laden-like fundamentalist figures she abhors, and the United States whose official policy she abhors also includes people like her who are looking for "peace and justice."

The Hammad poem points to the possibility of an intelligent anti-Americanism, or better, an intelligent critique of official American actions that recognizes both the ugliness of some U.S. policies and of terrorism and the dappled beauty of American multiculture. This view might better be called an antidominant American policyism, a complex view that exalts America's

endangered civil liberties and revels in the polyglot energies of American cities while being deeply critical of national chauvinism and imperialism.

Fear and the Uses of Satire

Fear, it seems, often favors the right. Nazi Herman Goring suggested that those who wanted to enhance their power, whether in a democracy or a dictatorship, "need only tell the people that they are being attacked and denounce the pacifist for their lack of patriotism ..." Today, the right speaks of fear while the left speaks of hope, as in the PT (Brazilian Workers Party) slogan "unafraid to be happy," or in the Clintonian (if one can call Clinton part of the left) "vote your hopes, not your fears," or Jesse Jackson's "Keep Hope Alive." Today, fear is at the heart of the right-wing message. Franklin D. Roosevelt's famous slogan in the wake of Pearl Harbor, "The only thing we have to fear is fear itself," has been replaced, at least implicitly, by the new slogan, "The only thing we have to fear is the end of fear itself." Republicans used ridicule to great effect, lampooning John Kerry as an elitist, a flip flopper, and an effeminate milquetoast.

But parody and ridicule also can be the privileged arm of the disempowered. Because parody appropriates an existing discourse for its own ends, it is well suited to the needs of the relatively powerless because it assumes the force of the dominant discourse, only to deploy that force through a kind of jujitsu against the dominant discourse. In 1964, at the very height of the cold war, Stanley Kubrick exercised artistic citizenship by releasing his brilliant film *Dr. Strangelove: How I Stopped Worrying and Learned to Love the Bomb.* The film was an adaptation of a suspense-thriller by Peter George called *Red Alert,* in which a psychotic general orders B-52s to attack the Soviet Union. Although the novel treated its subject seriously, Kubrick decided that the absurd and the comic were at the very core of the story, since nothing could be more absurd than the very idea of two megapowers willing to wipe out all of human life in the name of minor political differences. The subject of nuclear war, Kubrick decided, could only be treated in the mode of satire and dark comedy.

Dr. Strangelove formed part of a much larger artistic current in the period, a form of satirical sketch comedy variously called *sick humor* or *black humor.* Represented by such artists as Lenny Bruce, Tom Lehrer, Mike Nichols, and Elaine May, this performative tradition ridiculed a number of sacred cows, mocking such touchy and fear-provoking topics as racism and nuclear war. Lehrer, for example, performed satirical songs about nuclear destruction, all sung in an inappropriately cheerful music-hall tone. The refrain of one song about a nuclear holocaust, consisted of variations on "We'll all go together when we go/every Hottentot and every Eskimo." Another song, delivered in a country-and-western style, recounted the delights of watching atomic mushroom clouds rising over test sites in Nevada: "Mid the yuccas and the thistles, we'll watch the guided missles/dropping bombs in the cool, desert air ...

Yahoo!" In a Brechtian manner, the bitterness of the lyrics contrasted with the comic style and burlesque tone of the music. By depicting the worst, but in a comic tone, the songs both invoked fears and symbolically dispelled them.

The challenge for Kubrick was that the subject of nuclear warfare still seemed very abstract, at once real and unreal, impossible and inevitable. People had become anaesthetized to the very possibility of a nuclear war. Kubrick had to give terror, in William Shakespeare's words, a "local habitation and a name," and the weapons he used were humor and satire. Kubrick exploited diverse artistic and rhetorical resources, one being litotes, or understatement. At one point, General Buck Turgidson, played by George C. Scott, refers to the death of twenty million people, for example, as the equivalent of "getting our hair mussed." At times, a technique of radical simplification portrays the generals as completely infantile; when one hears of the other side's new nuclear device, he says, in the manner of a child who envies his neighbor's toy, "I want one too!"

Elsewhere, the technique works through oxymoronic contrast, as in the climactic finale that superimposes a sentimental love song—"We'll Meet Again"—on images of nuclear clouds and explosions. Like the sick humor comics, Kubrick too mocked such famous cold war figures as General Curtis LeMay, scientist Edward Teller, and former Nazi Werner von Braun. Many of the stand-up sketches, for example those of Shelley Berman, Nichols, and May, involved single-voiced or double-voiced telephone conversations, and it is noteworthy that *Dr. Strangelove* proliferates in scenes involving telephones, intercoms, public address systems, and other communication devices. The technique is uncannily apt for a story where the slightest miscommunication could indeed end in nuclear disaster in a time when military and communications technologies were becoming more and more interlinked.

Dr. Strangelove transmutes fear and pain into artistic pleasure and cognitive knowledge. The film treats, after all, the least pleasurable of subjects: the extermination of the entire human race and, by implication, of the spectator. The basic mechanism, we would suggest, is the comic exorcism of fear. The film names and gives artistic shape to a shared nuclear nightmare and thus tells spectators that we are not alone in being afraid or in thinking our leaders are crazy. At the same time, the film conjures away those same fears by making the powerful villains of the film into objects of fun and satiric derision. The relation to fear in *Strangelove* is similar to carnival in the Middle Ages. Carnival took place against the backdrop of real plague and imagined apocalypse. For Mikhail Bakhtin, carnival was a symbolic victory over cosmic terror and pious paranoia; it nourished the principle of hope in an age tending toward apocalyptic despair.

Kubrick's satire was so effective that *Strangelove* soon came to be applied to cold war warriors such as Edward Teller and Henry Kissinger in an earlier period and to Dick Cheney today. The film was made at a time when

the dominant system had begun to deploy fear to buttress a political system dominated by what President Dwight Eisenhower called the "military-industrial complex." Americans were frightened into thinking that the Russians were coming, that the Soviet Union was always just about to unleash a nuclear strike, and that Americans had to be on guard at all times.

It is rumored that Eisenhower, in his farewell address, thought of warning the nation about the military-industrial-congressional complex but dropped the word *congressional*. Nowadays, we would have to add the word *entertainment*: the military-industrial-congressional-entertainment complex. With George W. Bush, we have, perhaps for the first time, a situation where the president not only is influenced by that complex but, in a certain sense, also is that complex. But Bush has many allies in the media. And although the direct object of Jon Stewart's critique is George Bush, the indirect object of the critique is the media itself and its passivity and complicity in the face of the administration lies. The scandal, in this sense, is that this kind of critique is being left up to the comics and is not part of the normal political debate within the media.

With the end of the cold war, we have moved, as Paul Virilio put it, from the "equilibrium of terror between States to the disequilibrium of terrorist terror." We do not believe that Americans as a people are more paranoid or narcissistic than the peoples of other nations. Indeed, foreign—and native—commentators often suggest precisely the opposite, noting Americans' naive optimism and faith in humanity. Nor should we see the United States as having always been an intrinsically militaristic nation. In his September 17, 1796, farewell address, George Washington warned that "overgrown military establishments [were] … inauspicious to liberty …" Currently, we find two forms of fearmongering and scapegoating—one internal and the other external—that are built into the American political system. A certain paranoid strain of political demonology within American life targets "designated scapegoats." The internal, domestic form has to do with a political situation where the right, whose natural constituency of the very rich and the corporate wealthy is by definition miniscule and whose policies are profoundly unpopular, has to expand that constituency by frightening the population, thus persuading some people to vote against their own economic interests. Thus, the right exploits fear by emphasizing social wedge issues, which divide the electorate over fears about crime (read black crime), abortion (linked to women), affirmative action (linked to both women and blacks), or single-sex marriage (as a response to fear of gays). This right-wing populist mechanism is a massive confidence trick that channels fear and hostility away from the corporate elite and the right toward the left and minorities, thus persuading people to vote against their own interests. Thomas Frank called this situation a French revolution in reverse, where the *sans culotte* demand more power not for the people but for the aristocracy. And up to a point, the trick works, swelling the

tiny natural constituency of the right with a massively angry coalition of the naive, the resentful, and the deluded.

Within the battle between the culture of fear and the culture of laughter, satire and parody have become potent weapons. Moore's film *Bowling for Columbine* ridiculed the right wing's penchant for provoking fear to win elections. His *Fahrenheit 9/11* again mocked the fears manipulated by the Bush administration. The most successful documentary ever made, it is estimated that it will be seen by over half of the American people. Indeed, the film has become a part of the electoral debate. Speaking more generally, satire and parody are also very much alive on television and on the Internet. Scores of anti-Bush websites have emerged, many of which use satire and parody, turning *Lord of the Rings* into "Lord of the Right Wing," for example.

But the contemporary heir of the sick comedy tradition, in our eyes, is Jon Stewart, whose program is "The Daily Show." The show carries the logic of entertainment news to its logical conclusion, by making the news really entertainment. Yet this comic show paradoxically tells us more about events than the conventional, serious news. The program has been such a success that it is by now regularly cited on the real news. In fact, surveys show that young Americans are more likely to get their news from Stewart than from other news programs.

As the current pop culture deconstructionist, Stewart night after night deconstructs the contradictions of right-wing discourse. One of his favorite themes is the tension within White House discourse between fearmongering and reassurance. On the one hand, the dominant discourse tries to frighten us: "The terrorists are coming!" On the other hand, another discourse tries to reassure us: "Thanks to George Bush and the War on Terror, Americans are safer." Stewart often juxtaposes contradictory clips displaying the two tendencies, one trying to frighten and the other to reassure. During the 2004 campaign, the administration wanted to frighten Americans by making us think this is not the time to change horses in midstream and convincing us to worry that perhaps the election might even be suspended. Yet at the same time, Bush wanted to reassure Americans with a claim that he had made us safer. The people have to be frightened into submission, but only up to a certain point.

Through a kind of jiujitsu technique, Stewart makes the adminstration's own discourse boomerang against itself. This boomerang technique is especially appropriate to a president who constantly projects his own aggressions onto others and who is given to projective diabolizations. Thus, Bush repeatedly accuses others of doing exactly what he is doing himself. He accused Hussein of defying the world and making a fool out of the United Nations, when that was exactly what he was doing. Stewart's boomerang technique sends back Bush's aggressions to Bush himself. On one episode, Stewart showed Condolezza Rice speaking of Hussein's regime as "obsessed with secrecy and ready to use force." Stewart simply repeated the words, forcing viewers to hear them

in a new way: "obsessed with secrecy and ready to use force ... hmm ... I won't even comment on the irony of those words." The clear implication was that the Bush administration too was obsessed with secrecy and ready to use force. Another episode shows Bush describing Iraq as "a country under the control of one cruel man." Stewart's addendum, backgrounded by a photo of Rumsfield and Cheney, was, "And now it's under the control of two cruel men"; the insult has the additional implication that Bush was not really the president.

Another Stewart technique is to cut through the mendacious idealizations so typical of Bush—"I am a patient man"; "the terrorists hate our democracy!" We are a generous people"—by clarifying the narcissistic and illogical nature of the claims. When Bush said that the abuses at Abu Ghraib prison did "not represent the true, essentially good, America," "The Daily Show" mocked such narcissistic denial by having his fake reporter say, "John, the important issue isn't whether American soldiers actually tortured those Iraqis; the important point is that we are not the kind of people who would torture those Iraqis." Elsewhere, Stewart cuts through the euphemisms that the military uses to beautify what is cruel and ugly. One of the high-level memos regarding the use of torture in U.S. military prisons spoke of a new paradigm that might bypass the Geneva Conventions. Stewart's comment was, "What a relief! So it's not really torture; it's just a new paradigm. But you'll be better off if that new paradigm doesn't get attached to your balls!" During the hearings concerning Alberto Gonzales's candidacy for attorney general, Stewart noted that Gonzales was evading the questions and that perhaps a bit of pressure was required to get him to open up. Then Stewart gave the viewers, in a vivid lesson in reciprocity, the famous Abu Gharib photographs, but this time with Gonzales digitally inserted, sitting on a naked "man pile," attacked by angry dogs, and so forth. Through comedy, then, Jon Stewart has probed the most serious issues: mendacity at the top, the false rationale for the Iraq war, and the possibility of a right-wing coup d'etat. But he has done it in a mode appealing to young people, appropriate to a postmodern media-saturated era.

Although the direct object of Stewart's critique is George Bush, the indirect object of the critique is the media itself and its supine passivity in the face of administration lies. The scandal, in this sense, is that this kind of critique should be left up to the comics and not be part of the normal political debate within the media. Angered by the complicity of the media in administration mendacity, "The Daily Show" serves, in lieu of an honest media, as our balm and our stimulant; it tells us that Bush's lies are laughable, that our leaders are crazy and dangerous, and that the Emperor is naked!" As an iconoclast, Stewart destroys the fabricated image of Bush as strong leader; he strips off the pious mask to reveal the clown and the bully. And once again the laughter of the crowd reassures us, and we know that we are not alone.

Patriotism and the Pursuit of Happiness

We have tried to show that narcissistic forms of patriotism actually hurt the country. When every legitimate criticism of policy is answered with shrill accusations of treason, then the United States will never improve; indeed, it can only become more unfair, more unequal, more paranoid, and more imperialistic. Patriotism has been wrongly defined as loyalty to governments, not as loyalty to what one sees as the deeper interests of the nation. Patriotism for us is nothing more than wanting one's country to be the best that it can be. Anything less is cynical indifference or blind obedience. The arguments begin with the meaning of *best*. Does it mean being the most militarily powerful? The most democratic? The most humane? The most spiritual? A critical patriotism—a kind of tough love patriotism—excludes blind, generic, quasifascistic endorsements of any and all governmental policies. Right-wing CSPAN callers, for example, often express a kind of absolute faith in government and a kind of content-free endorsement. One often hears such blank-check statements as "I believe Bush is our president and we should support him"; "The government wouldn't put people in jail if they didn't do anything wrong"; "If you're law-abiding, you don't have to worry about the Patriot Act; it's only meant for terrorists." Such statements carry ominous undertones of fascist authoritarianism.

Our call, then, has been for a kind of alternative patriotism. Bottom-up patriotism. Multicultural patriotism. Rainbow patriotism. Chief Seneca patriotism, Harrriet Tubman patriotism, Cesar Chavez patriotism. Stevie Wonder and Public Enemy and Lauryn Hill patriotism. Michael Moore and Jon Stewart patriotism. Full-throated many-voiced patriotism. Rosa Parks and Susan McDougal patriotism. Polyphonic patriotism. Walt Whitman and Carl Sandberg and Paul Robeson and Pete Seeger and Studs Terkel patriotism.

Americans have a lot to be proud of: our democratic mores, the vibrancy of our popular cultures, the diversity of our ethnos, the brilliance of our universities. At the same time, polls report that large majorities think our country is on the wrong track or moving in the wrong direction. It is obvious that something is rotten in the state of America: All is not well. Despite the pursuit of happiness clause in the Declaration, the increasingly oppressive structures of American life, and America's oppressive role in the world, are making Americans profoundly unhappy. Many surveys suggest that Europeans are happier with their lives than Americans.[6] Alexis de Tocqueville in the 1830s caught a sense of this American unhappiness when he spoke of Americans' "restlessness in the midst of prosperity." Tocqueville spoke of seeing "the freest and best-educated of men" in the "happiest" circumstances, yet where a "cloud habitually hung on their brow, and they seemed serious and sad even in their pleasures" because they "never stop thinking of the good things they have not got." Tocqueville blamed this restlessness on "the competition of all."[7] Of

course, it would be simplistic and essentialist to see all Americans as essentially unhappy, or as all unhappy, or as all unhappy all the time, and we know that America also has been the site of utopian and communal experimentation, yet one does recognize a kernel of truth in the de Tocqueville account. Unhappiness is a social trend, that of the country which has long been on the cutting-edge of capitalist globalization. It is no accident that Chalmers Johnson etitled his book *The Sorrows of Empire.* Could it be that imperial domination and competition make people nervous—that the same forces that place the United States on the cutting edge also make Americans edgy? Could it be that exacerbated individualism makes people lonely and isolated rather than happy? One of the great failures of the left has been in not tying the everyday forms of unhappiness to corporate and systemic causes and in not proposing the utopian possibilities of that other world all of us know to be possible.

Just as the founding fathers inscribed the pursuit of happiness as a political goal, today unhappiness is a political problem. Today, the tell-tale signs of unhappiness are everywhere. Rich white kids in a suburban school, at the very top of the global food chain, vastly entitled and privileged compared to adolescents elsewhere—indeed, young people in many countries do not even have the luxury of having an adolescence—show hearts full of murder as they shoot up their fellow students, just because they feel dissed. Or look at those right-wing talk show hosts, again among the richest and well-off people in the world, yet so full of rage and spleen, railing at those less well off than they are. Unhappiness rears its ugly head as well in the degraded discourse of political talk shows, where everyone tries to shout down or outmanuever opponents—where no one ever acknowledges an opposing point or admits to a mistake even after a claim has been proven wrong. The Native Americans even before the American Revolution already expressed amazement at how rude and interruptive Europeans were to one another. Surely, Stewart was right to suggest that such shows harm America.

What fears and aggressions do we read in the faces of the hawks—those at the very top of the planetary hierarchy of wealth and power. What we see is Cheney's permanent gangster smirk, Richard Perle's affect-challenged visage, Paul Wolfowitz's terminally depressed look, and Ashcroft's stern abused-child look— Rumsfeld would seem to be an exception, but in his case his "shit happens" breeziness is disturbing. They are among the richest and most powerful people in the world, capable of unleashing the shock-and-awe firepower of the mightest military machine ever invented, yet they look at the world as a holocaust about to happen—and thanks to them, it might. Such are the wages of exceptionalism, of the price of national narcissism, and of a life dominated by possessive individualism and cut-throat competition. Americans certainly enjoy some of the rewards of being at the cutting edge of transnational capitalism, but we should not be so deluded as to think that we do not also pay a very heavy price.

Conclusion

Blind patriotism and its gang buddies, xenophobia and the demonization, actually hurt the nation the patriot supposedly loves. By suppressing corrective dissent, blind patriotism simply keeps the nation from improving. The demonization of enemies, meanwhile, often serves as a distraction to keep populations from dealing with the real problems at hand. We have argued, therefore, for an alert, critical patriotism, a complex patriotism that recognizes the democratic brilliance of Thomas Jefferson's words, for example, but that deplores the racism of his actual practice as a slaveholder. Our call is for a multicultural, multiperspectival patriotism, a love not of government policy but of the raucous, multiple, actively engaged nation, a love of the nation's egalitarian rebels: people like Chief Seneca and Nat Turner, John Brown and Henry David Thoreau, Malcolm X and Martin Luther King, Jr., Mark Twain and Herman Melville and Baldwin Noam Chomsky and Michael Moore, all who have been hurt into activism much as Ireland hurt John Yeats into poetry.

If citizens cannot express an honest and informed opinion about policy without having their patriotism questioned, then we are no longer living in a democratic country characterized by free speech. The unpatriotic charge is nothing less than a trick. The accusation implies that the accuser is the model of patriotism and devotion to country, while the object of the accusation is put on the defensive, obliged to prove innocence. The very question substitutes for the real issues—the wisdom of a policy or the justification and costs of war—the irrelevant, manipulative, and distracting question of patriotism: "Are you patriotic? Are you proud to be an American?" It is a case of the wife beater asking someone else if they have stopped beating their wife.

Nor does love of one's country exclude love for other countries. Patriotism is love for that slice of humanity closest to us. Love spreads outward from self to family and friends, from town to country. Why should love stop at national borders? Within a kind of polyandrous patriotism, it is for us a question of overlapping affections, a love for country without exclusiveness or demonization. Constituent power as the defense of the "historical progression of emancipation and liberation," Michael Hardt and Antonio Negri suggest, is ultimately an "act of love." Though the modern concept of love has defined it as a private affair, largely constricted to the couple and the family, love is ultimately more inclusive and embracing. Patriotism, in this sense, is a larger code within which competing discourses—one based on superiority and hatred, the other on equality and love—fight it out on the terrain of public life.

Notes

1. The right wing usually talks about health care when it is forced to, usually around election time and then only to undercut or upstage some Democratic proposal through some meaningless band-aid measure such as slightly less expensive dental care for geriatrics or occasional prescription benefits for the sclerotic. When the issue of universal health care does come up, the right wing either changes the subject or demonizes the proposal

as socialist, or as an antichoice government-run health program, scaring ordinary people by evoking some shadowy bureacracy, forgetting that these same people are already over-shadowed by Kafkaesque health maintenance organizations. The truth is that the right wing is terrified of the issue, because if the left managed to introduce universal health care the popular gratitude would overwhelm the right's electoral possibilities for decades to come.

2. Lewis H. Lapham, *Gag Rule: On the Suppression of Dissent and the Stifling of Democracy* (New York: Penguin, 2004), 88.
3. Ibid., 156–7.
4. Michael Rogin, *Ronald Reagan: The Movie* (Berkeley: University of California Press, 1987), xxi.
5. See Nicholas Kristof, "Revolving-Door Master," *New York Times*, October 11, 2002, A33.
6. See Katrin Bennhold, "Love of Lesire, and Europe's Reasons," *New York Times*, July 29, 2004, A10.
7. Alexis de Tocqueville, *Democracy in America*, trans. George Lawrence, ed. J. P. Mayer (New York: Doubleday, Anchor Books, 1969), 565, 536, 538.

Bibliography

Bennhold, Katrin. "Love of Lesire, and Europe's Reasons." *The New York Times* 29 (July 2004): A10.
Lapham, Lewis H. *Gag Rule: On the Suppression of Dissent and the Stifling of Democracy.* New York: Penguin (2004), 88.
Kristof, Nicholas. "Revolving-Door Master." *New York Times* 11 (October 2002): A-33.
Rogin, Michael. *Ronald Reagan: The Movie.* Berkeley: University of California Press (1987): xxi.
Tocqueville, Alexis de. *Democracy in America*, trans. George Lawrence, ed. J.P. Mayer. New York: Doubleday, Anchor Books (1969): 565, 536, 538.

10

Art for Whose Sake? Artistic Citizenship as an Uncertain Thing

ARVIND RAJAGOPAL

When we think of art, we imagine something that enhances awareness through universal forms of expression. But the norms of artistic expression are at the same time cultural norms, which can vary. What usually allows us to overlook this fact is that the norms of the Western art are often regarded as the universal norms of art. Art is marked by its cultural and national origins. More importantly, the label "art" only carries weight when it is backed by power. It thus calls attention to those who have the power to make the label stick, and not only to the objects called "art."

An example will clarify this statement. It is well known that European cubism would not have taken the shape it did were it not for the inspiration provided by African masks exhibited in Paris in the early 1900s. One hundred years later, African masks continue to astonish us, but perhaps the most influential theory they have inspired is that of primitivism—as in the work of the Bloomsbury critic Roger Fry—and they continue to be classified in museums as African art. Meanwhile, cubism and developments subsequent to it are classified under the more general heading *modern art*.

The classification assumes that the mainstream of historical development has a Western location and that other cultures are tributary to it, exactly as African art is in the previous example. It also points to the fact that in the West, art is a relatively autonomous sphere that for a century or more has been detached from ideas of religion and the sacred. Elsewhere however, except for a small educated and affluent class, this is not the case. In most of the world, few people can afford to buy anything labeled as "art." And even when they do, art retains its connections with the worlds of ritual and of everyday life.

This point will become clearer with another example, this one again from African art. Not long ago, Philip Kwame Apagya, a well-known West African artist, gave a lecture to an audience at New York University (NYU). He presented photographs taken of customers visiting his studio in Shama, a small fishing town in Ghana, "36 kilometers from Sekondi and 168 kilometers from Accra," as he explained. Apagya was born nearby and sounded like he was very much part of the locality. The pictures were taken against a range of

painted backdrops: a big city scene filled with skyscrapers, an airport with a plane ready to be boarded, and domestic scenes such as living rooms with an entertainment center of varying proportions, with cabinets holding books, wine glasses, a stereo, and a television set, and, beside them, sometimes, an open refrigerator stuffed with food.

In the slides we saw at NYU the painted acrylic-on-canvas backdrops were themselves the foreground, unfurling from the walls of Apagya's studio in Shama. Around was the physical environment of the studio, dim and unreflecting walls, and a window looking seedy against the freshly painted image. The pictures we saw were not what the customers paid for—their photographs would be trimmed to hide the real background. For an audience elsewhere, however, the studio background highlighted the artificiality of the pictures displayed.

Ordinary Ghanaians could never dream of experiencing the pleasures portrayed in his studio backdrops, Apagya explained. The chance to be photographed with scenes they could only inhabit in their dreams would "cool them down," he said, so the exercise could be therapeutic for them. A member of the audience remarked pithily, "They [the Ghanaians] get the illusion, we get the performance."[1]

The portraits we were seeing appeared to obey conventions of photographic realism, but these conventions are in fact not such a simple matter. Common sense tells us that realism in photography transfers what is out there in the world onto paper. But Ghanaian customers are not thinking of Apagya's backdrops as a guide to what is in the studio. Rather, the paintings are an aid to imagining themselves in a little island of privilege. Elsewhere, the artifice seems more apparent; we see these pictures differently from those who are paying for them in the studio.

We may each of us have the same visual data before us, but what we see in each case obeys certain rules of seeing, reflecting how we are socialized to perceive the world, and our place in it. It is not as if we cannot imagine how else these pictures might be seen. But our expectations about what to see and what we do see fuse together before we are aware of it.

What is our pleasure in their illusion, then? Why would audiences elsewhere be interested to know that Ghanaians desire television sets or airplane flights? These are hardly unique things, and the pleasures they promise are taken for granted now. To reexperience them through the images of poor Africans seems self-congratulatory and does not tell us much about the nature of the experiences themselves.

Anticipating such questions, Apagya pointed out that his pictures were "a little different"; he drew our attention, for instance, to the way the subjects smiled at the camera. The implication was that these individuals did not necessarily identify with the backdrop. We would be wrong to think of them as duped by consumer goods, for example, or so he implied. These were pictures taken for individuals who wanted to circulate their photos for some reason,

such as for advertisements for prospective mates when they became of age to be married.

At a minimum it is clear that the same pictures served different purposes in different places. In Ghana, they had an information value that was of little concern to us in New York City, and the kinds of aesthetic pleasures they provided too were markedly different. In Ghana, the goods displayed were compensating for an absence in people's lives. For a New York audience, the sincerity of the desire shown for these objects was perhaps a reminder of simpler times, like '50s nostalgia. But here the nostalgia was being imagined through people who had never enjoyed those objects in the first place.

So when a woman posed as if she was opening a refrigerator, or was pointing to a picture on the painted television, it might have provoked pleasure or amusement in Ghana, but the response of a Western observer, whether amused, condescending, or ironic, could not be devoid of a certain poignancy. On a more abstract level, seeing these pictures reminds us that an act of perception is also an act of judgment, because we decide what is the relative importance of the visual elements before us, vis-à-vis each other. And these judgments are not arbitrary; they are given to us by circumstances and reflect prevailing convention. What it means to be in one place and not another is conveyed through portraits of individuals, consumer goods, and background scenes—the airport, the big city, the drawing room. But it is easy to read them for what they have to say about a whole society and its people and their different destiny.

Any object, including the art object, can be seen from multiple viewpoints. Today we are increasingly aware that ours is not the only point of reference, even assuming "we" have only one viewpoint. If art involves the ordering and preferring of perceptions, and of some perceptions over others, then the rules steering and shaping perception deserve our attention.

Consider the first example discussed. An artist engaging with abstract impressionism or with cubism would be indignant at being seen merely as an African artist, or as an African modern artist, relegated to a subset of modern artists in the West. Or in the second case, imagine one of the young men from Ghana joining a New York audience, looking at himself in a picture where he points to a painting of a television in an imaginary drawing room. In the photo, he is smiling, perhaps at a prospective bride, but for the New York audience he becomes a curiosity, a poor African pictured with an imaginary television set. What might have been funny in Shama could become embarrassment or shame in New York.

To call something art is to invoke a history as well as an ideal. The separation of art and culture from the influence of the church was a slow process, possible only after western nations became largely mono-ethnic and mono-religious, over the 17th century, after all religious competition to the dominant national church was converted, subjugated, or driven out. This context of secularization allowed art to claim a functional autonomy, "art for art's sake,"

which in turn gave art a new kind of power, accessible to citizens. Elsewhere, neither the history nor the ideal is quite the same, so "art" cannot have the same status. Artistic citizenship, or the power gained from the use, making or display of "art," would then be quite different too.

Artistic Citizenship outside the West

The story sounds very different outside the West, for reasons that become clearer when we look back at recent history. Until a mere six decades ago, colonial rule existed across most of the world. Politics was forbidden to natives, and as a result, most art stayed within conventional boundaries and focused on permitted themes, such as that of religion. In any case, for the vast majority the separation between art and religion hardly existed; art was mainly sacred or functional in character. Religion frequently argued political significance, and objects of everyday culture became invested with national meaning, harboring secrets from colonial power. For instance, Frantz Fanon described the ways in which the veil in colonial Algeria was seen as a symbol of Algerian tradition by the French rulers. And in fact the veil was used to hide arms and ammunition as Algerians plotted to gain national liberation. The result was to render the veil, a symbol of women's subjugation, into a symbol of cultural politics.

Elsewhere in the colonial world, for example in India, M. K. Gandhi embraced the peasant's garb as he tried to craft a broad-based mass movement against British rule. In the process, ordinary items from peasant life such as the handspun cotton cap and the spinning wheel became powerful emblems of nationalist protest. With national independence, political freedom was gained in the former colonies. But this did not mean that complete cultural freedom followed. The task of nation building in the former colonial countries often meant cultivating new identities across existing cultural differences. It was the task of the state to steer its citizens' minds in a positive direction. In the Soviet Union, for example, socialist realism was the name for the political program that art and culture were meant to follow. It may have been an extreme case, but it had the virtue of spelling out what in other countries tends to be more diffuse and informal. The task of nation building had a cultural and educational component, as the state undertook the task of modernizing its citizens. Such a role was not restricted to developing countries. In the United States, the job of assimilating and Americanizing immigrants, to say nothing of the native American population, was often harsher and more effective than the Soviet model, for instance.[3]

The Case of India: Historical Background

The case of India, which I discuss here, is instructive for several reasons. India is not only a large and diverse country—it is the second largest Muslim nation in the world next to Indonesia as well as the largest Hindu nation—it also has

a democratic system that has endured for more than half a century. As such, it offers one of the few examples we have of a democracy composed largely of poor people from different religions and cultural backgrounds. Most of the working examples of democracy that we have are from the West, where we witness a long-term decline in voter turnout and growing apathy on the part of citizens. In the West, poor people are less likely to vote; it is the educated and well-to-do voters who exercise a disproportionate influence on outcomes. In India, it is the poor whose vote determines the outcome, and their influence has actually grown over time. India is similar to the West, then, in having a working political democracy.* It offers a useful contrast if we wish to consider how artistic citizenship might look elsewhere.

By the early twentieth century in India, as in many other countries, art, culture, and national identity had telescoped into each other, first as the result of colonial stereotypes and subsequently as anticolonial expression. Indigenous art and culture became the distinctive markers of national identity, the proof of a unique native culture that was proof against imperial power. It was not art for art's sake. But for whose sake was it, exactly?

As long as native protest centered on creating a united anticolonial front, debates over questions such as, "Whose art and culture represents the nation?" tended to get short shrift. For example, upper-caste Hindus were culturally and politically dominant, although they were in a minority. Meanwhile protests by communities that were marginalized or excluded tended to be relegated to the background of national politics. Winning independence was believed to be the most important thing. Issues of internal democracy in Indian society were postponed till decades later, by which time they often became explosive and violent.

Art became used not for citizens, but for the national state to dignify its accession to power. Art that expressed and expanded the range of rights for individuals was not something foreseen by the nationalist elite. Art was high culture—for educated connoisseurs—and consequently it performed a kind of ambassadorial function, with eminent dancers, musicians, and painters symbolizing national excellence. Given the urge to overcome a colonial legacy of belittling Indian culture, the state set about institutionalizing art and in the process, enshrining it in museums rather than allowing it to flourish as a popular language of empowerment.

The state's main emphasis, therefore, was not so much on art as it was on managing democracy to ensure it did not get out of control. In a society with great economic and social disparities and low levels of literacy, the government retained control over the broadcast media for several decades after independence to ensure they were used for prosocial purposes. In the absence of basic schooling, print was essentially an elite medium; the only communi-

* Subuk Khilnani, *The Idea of India* (New York: Farrar, Strauss and Ciroux, 1998).

cation vehicles that reached a wide audience were radio, television, and the cinema. Tight bureaucratic control ensured that creativity was not allowed to flourish within the state-controlled media, however.

In any case, it was one thing to declare the need to educate the masses. How it should be done was another matter altogether.[4] The dominant idioms of civic morality remained rooted in worship and spirituality. How was an educational program to modernize the masses and to avoid the subject of religion? On the other hand, if religion were engaged, how to avoid discriminating against minorities and affirming the majority Hindu identity? If Hindu religion did become a medium for education, how to avoid discriminating against lower castes, whose subordination was a matter of religious principle for upper castes?

The problems involved here are not peculiar to India but are at the heart of artistic citizenship. To enhance awareness through art necessarily involves questioning the rules of perception we ordinarily take for granted. This means, first, determining what the old rules are and, second, what the new rules should be. Neither of these things is a simple matter, because they involve unearthing assumptions that shape our own perceptions and require persuading others who have no particular reason to pay attention. Not surprisingly, therefore, it requires one or another kind of authority to legitimize new ways of seeing, since modes of perception are seldom assessed purely on their intrinsic merits.

If perception is shaped by expectation, during the phase of anticolonial struggle nationalism provided the framework of expectation for new ways of thinking and seeing.[5] If art and religion came to be seen through a nationalist lens during this period, the achievement of independence tacitly endorsed this understanding. The authority invested in the nation state was thus premised on an acknowledgment of the majority Hindu identity, although the society was officially secular.

The task of nation building was a delicate and peculiar one. The nation shared its traditions but required modernization at the same time. For example, caste, which organizes Hindus hierarchically, had to change if the society was to modernize. This demanded nothing less than a social revolution, but few dared to say that. As such, any efforts at reform were contested by those who were orthodox and who commanded power in Indian society. Invariably, the government compromised and formed alliances with these groups, preferring political stability to social revolution.

Two key issues of democratization that faced the new nation were religion and caste, and these were interrelated. As Indian society gradually became more politicized with the experience of electoral democracy, lower castes in the Hindu community became more assertive. New political parties that emphasized a lower caste identity began to be more prominent, threatening the major parties that existed. It was not surprising that the dominant

political parties, which were led by upper castes, began to cultivate the Hindu vote and to aggravate Hindu–Muslim tensions, leading to waves of violence against Muslims.[6]

This background illuminates the three examples—all drawn from recent Indian history—I discuss following to consider the ways artistic citizenship might occur. In each case, we can see how the effort to reach out and to address ordinary people, drawing on the available repertoire of traditional and contemporary cultures, involves negotiating different kinds of authority through varying systems of religious, governmental, and consumerist realist representation. As we saw with Apagya's pictures, the form and function of realist protocols vary extensively with context. The mimetic power of modern communication technology confers a lifelike quality on the images it conveys, but in each case the work of the imagination required to complete the meaning of the picture alters the kind of realist aesthetic operating here. As such, the outcome of efforts at artistic citizenship varies extensively.

Mythological Realism on Prime-Time Television

One of the first programming ventures of the state-controlled television system was a traditional Hindu epic, the *Ramayan*, rendered in a weekly serial format. The broadcast violated an age-old taboo against religious programming, but its success established television firmly in India and helped shape the nascent public culture as market liberalization and globalization were gaining ground. Until that time, state-imposed secularism had placed limits on the extent to which Hinduism could become a national ideology. The Hindu martial epic seemed to realize a dream of Hindu nationalists, of Indians joining to commemorate Hinduism's virtue as a fighting faith. Conservative Hindu nationalists, however, made the most of the moment, embarking on large-scale popular mobilization—but on the basis of systematic violence against Muslims.

The broadcast seemed to confirm conservatives' long-standing claim that Hinduism could reunite an ancient civilization and could make it great once more. The Hindu tele-epic's extraordinary appeal helped move this illusion out of Hindu militant training grounds and to translate it into a set of electoral campaign tactics. The embrace by Indian big business of Hindu nationalism, as a mark of its own cultural distinction in a globalizing marketplace, helped to sanction the new prominence of a cultural turn, whereby Indians saw themselves as culturally politicized subjects. This indicates the attempt by conservative groups to exploit the growing self-awareness resulting from expanding media use and the ongoing modernization of Indian society.

Hindu Consumerist Realism

If my first example is from state-sponsored cultural practice, my second is somewhat more market based, namely, advertising. Advertising, as a language

that extols the virtues of buying specific goods, at the same time educates consumers into particular technologies of the self and specific modes of comportment. This tutelary activity hardly occurs in a vacuum but tends to follow the cues of the political sphere proper. When advertisers seek to persuade consumers of the virtues of their products, they do not merely sell goods. Especially in emerging markets, they simultaneously offer a particular mode of perception, and a pattern of behavior commensurate with it, while picking their way through prevailing social divisions, inhibitions, and proscriptions. By constructing scenes of desiring and desirability, advertisers create a sense of autonomy and independence and a perception of the achievability of individual wishes that are critical in constructing the subject of consumption. Locally rooted relationships of dependence based on caste, community, and gender are gradually linked in generalized relations of commodity exchange, as more insular regional markets are transformed and consolidated within a more global market. In the process advertisers transcribe fragments of local knowledges within a wider orbit of intelligibility.

There is a twofold character to this operation. Advertisers tend to seek appeals that are familiar and recognizable and that avoid arousing the prejudices of their audiences. At the same time ads inflect the socius with a new set of possibilities and connections and offer new circuits along which individual desires might travel. In the process, existing ritual or community-centered bases for consumption become suffused with a new consciousness of publicity, and an awareness about the specific kinds of public they constitute, in a shift from earlier, more transcendentally rooted religious practice. If this is only part of a much larger process of social change, ads are at any rate useful in transforming "otherwise opaque goings-on," in Goffman's phrase, "into easily readable form."*

I now discuss very briefly two ads aimed at the Indian mass market. Advertisers in India had historically ignored the mass market, believing that adding aesthetic appeals to the products sold was not necessary or worthwhile where poor consumers were concerned. Ads adopted an explicitly pedagogical strategy, and if any aesthetic value was contained in the ads it was in terms of the score, usually something approximating a folksy jingle or a film tune. Utility was presented as the most salient aspect of consumer messages for the lower-middle and working classes, while aesthetics remained the province of their betters, the middle and upper classes. This model, namely, utility for the masses and aesthetics for the classes, began to shift with the establishment of television and the necessity of finding a means of addressing mass audiences. But the creation of a popular aesthetic in the market ultimately took shape by drawing on religion, and it was the success of Hindu nationalism that showed the way.

* Erving Goffman, *Gender Advertisements* (New York: Harper and Row, 1976).

Thus, advertising culture in India before the mid-1980s was marked by the absence of a popular aesthetic for the majority of the consuming population. This was symptomatic of an elitist politics that Hindu nationalists both capitalized on and overcame, as they drew on religion and ritual to indigenize the languages of politics in an attempt to forge a new hegemonizing ideology. Advertisers in India, long identified with an elitist colonial culture, began to follow this lead. Religio-ritualistic imagery offers valuable resources in endowing brands with the aura they lack for new entrants into the global market. The two ads from 2000–2001 that I discuss offer a glimpse of how this might work.

In the first ad, for Brahmaputra Tea, we see shots of people running from different directions toward something—we do not know what. Meanwhile the soundtrack conveys the aqueous emergence of an undefined object. A glimmering prow rises out of a river, bathed in golden light. It is the sacred Brahmaputra river, tributary to the holy Ganges River. A tall man in a white robe announces in a booming voice, "I am Brahmaputra! And I bring you Brahmaputra tea!" All of a sudden, everybody is drinking cups of tea, smiling and nodding. The audio track cuts to a folk tune, and we see footage of happy peasant girls plucking tea leaves in the plantations, ending with a chorus: *Brahmaputra ki jai!* [Victory to Brahmaputra!].

In the second ad, for Nivaran cough elixir, a man is examining vegetables for purchase at a busy marketplace. Overcome by the dirt and pollution, he begins to cough. An apparition emerges a few yards away, a celestial nymph attired in silver and gold, bearing on a cushion Nivaran 90 cough elixir. The entire marketplace has come to a halt; everyone is looking at the young woman who is spotlighted with a brilliant aura as she moves toward him. The man gratefully tears a sachet open and gulps the medicine down. The relief on his face is immediate.

Advertisements for everyday objects of consumption, we might think, would draw on scenes of everyday life, even if they used celebrity endorsements to drive home the point. In these ads, we see old-fashioned magic and myth, with gods styled after the recent Hindu tele-epics, emerging as if summoned in sacrificial rites and bearing gifts for humankind. The device is not an unusual one in Indian ads; in fact, the cheaper the good and the lower the income of the presumed consumer, the more likely it is that supernatural devices such as these are employed.

Given the austerity of the hitherto prevailing public culture, as well as its limited reach, it was to religion that advertising reached, obedient to the example of the electoral sphere, where Hindu nationalism had shown its power. What these examples suggest is that although reflexive and self-aware cultural practice is made more easily accessible by mass media and modernization, traditional, upper-caste elites remain at the helm of society. This explains the predominance of culturally conservative messages, such as in the

two examples just presented. It points to the complexity of the enterprise of artistic citizenship in traditional societies that have chosen the path of gradual social change.

Angry Young Men: Cultural Entrepreneurialism in an Urban Setting

My final example draws from the work of individual artistic entrepreneurs. A curious sight that will strike the visitor to Ahmedabad, one he or she is unlikely to see elsewhere, is a series of luridly painted rubber flaps on the backs of autorickshaw tires. These pictures feature well-known Hindi film stars painted in enamel colors. A frequent theme of the pictures is action—for example, gunfights or knife battles—and often an actor appears with blood on his face or hands or on the blade of his knife. Sometimes we see the star holding what looks like a bottle of wine or a martini glass. Violence and immorality as portrayed in Bombay cinema appear in many of the images. Sometimes we see the picture of a man with a cycle chain wrapped around his fist, his face tense with anticipation. This could have been a scene from a film, but in Ahmedabad the image suggests the weapon of the street fighter and, in India, the violence of the rowdy or the thug.

Although among the most heinous of massacres in postindependence India took place recently in Ahmedabad, a visitor will find little public sign of it beyond these pictures.[7] I tracked down two of the artists best known for producing the pictures that adorned most of the autorickshaw tire flaps in the city. One, Mulchand, was a laid-off textile worker, who lamented that a city that used to be called the Manchester of India had discarded most of its workforce, drawn like himself from all over the country to find jobs in Ahmedabad.[8] The other, Bobby, was the son of a textile worker and had been a commercial artist most of his working life, albeit on the roadside. Like Mulchand, Bobby had made his home as one of the many immigrant workers now settled in the city. Both artists said they were responding to what customers asked for. Nowadays, many customers wanted action pictures.

We are accustomed to thinking of images as part of a chain of information links, text providing caption and commentary on pictures, and pictures illustrating what print or spoken words are saying. In Ahmedabad, when I asked people about the curious images on tire flaps, no one had much to say, not even the artists or the autorickshaw drivers who apparently commissioned them.[9] The images were usually described as just *shauq*, a matter of taste or fancy; the pictures were not accompanied by commentary, nor did they elicit it, even on questioning. They were simply there, mute testament to a cinema culture that increasingly featured bloodshed, as well as the only public images of violence in a society in which large numbers of people, backed by the state, had recently sanctioned violence against the Muslim minority.

If these silent reflections of violence were treated as benign or as incidental, news reports by the televisual media were widely regarded in Gujarat as

Figure 10.1 Painted rubber flaps on autorickshaws in Ahmedabad, Gujarat, are an informal aspect of the city's visual culture. The pictures invariably feature well-known film stars, and since the '90s, the stars are usually in action poses, shown in close-up. Shown here is Sunjay Dutt swinging a club, 2004. Photograph by Arvind Rajagopal. Reproduced with permission.

Figure 10.2 Amitabh Bachchan with a liquor bottle, 2004. Photograph by Arvind Rajagopal. Reproduced with permission.

Figure 10.3 Kamalahasan aiming a revolver, 2004. Photograph by Arvind Rajagopal. Reproduced with permission.

Figure 10.4 Shah Rukh Khan with a cycle-chain wrapped around his knuckles, 2004. Photograph by Arvind Rajagopal. Reproduced with permission.

culpable. Television channels were publicly attacked by the government, were periodically banned, and faced the constant threat of mob violence. These various forms of practical criticism were not simply state censorship but reflected popular opinion—that violence shown to be committed by Hindus was evidence of biased reportage—in contrast to violence believed to be committed by Muslims, which deserved wide publicity.

Conclusion

Raymond Williams wrote in a justly famous book that we are in the midst of a long revolution, one in which individuals are slowly acquiring the powers of self-expression and are asserting their rights of equality.* The Industrial Revolution transformed economic conditions, but the social and cultural revolution occurs much more slowly and unevenly, and with much greater resistance. Even today, literacy and education are far from universal; ideas of equality remain excluded from many domains, and the rights of citizenship continue to be challenged and debated: what shall they be, and who shall have them? Ideals of equality and universal dignity seem more distant and unrealizable today, perhaps, than they did than when Williams wrote his book in 1961. Without question, however, more people embrace these goals, although they express them in ways that are often mutually opposed to each other. As individuals become more capable of reflexive and self-aware behavior, assisted by modernization and the expansion of mass media, they begin to construct themselves as cultural and political subjects, seeking charge of their own destiny. Yet the circumstances in which they do so are not to be taken for granted. In the three examples I offer in this chapter, which are entirely symptomatic of events in contemporary India, we can see that artistic citizenship may easily culminate in cultural particularism and in exclusive identities that are affirmed through the exercise of violence.

Notes

1. Philip Kwame Apagya, Lecture and slide-show (New York: New York University, June 24, 2005). The audience member who made the remark I have quoted was James Clifford, who was visiting from the University of California at Santa Cruz. I am grateful for the chance to have discussed this event with Carlos DeJesus. My thanks to Faye Ginsburg and Fred Myers for alerting me to the occasion of the lecture. For examples of Apagya's work, see Tobias Wendl and Heike Behrend (eds.), *Snap Me One: Studiofotografen in Afrika* (Munich: Prestel, 1998).
2. Faye Ginsburg, Lila Abu-Lughod and Broan Larkin, eds. *Media Worlds* (California, 2002).
3. The Soviet Union launched the first such experiment, with the onset of the Russian Revolution in 1917, and it became the model for subsequent new nations, especially those who were not under the direct influence of the West. One scholar observed that the work of the state was not simply political and economic in the Soviet Union. The Soviet order was in fact a work of state art. The achievements of the Soviet state were not only meant to be good; they were also supposed to be seen as beautiful. Boris Groys, *The Total Art of Stalin-*

* Raymond Williams, *The Long Revolution* (Westport, CT: The Greenwood Press, 1961).

ism: Avant-Garde, Aesthetic Dictatorship, and Beyond, trans. Charles Rougle (Princeton, NJ: Princeton University Press, 1988).

4. The underlying condition was that government budgets for primary schooling were minuscule, suggesting that the priority of the ruling elite was in educating the well to do rather than the poor. The subject is obviously larger than we can explore here, but see Krishna Kumar, *Raj, Samaj aur Shiksha* [State, Society and Education] (New Delhi: Rajkamal Prakashan, 1985).

5. C. S. Pierce, "Perceptual Judgments," in *Philosophical Writings of Peirce*, ed. Justus Buchler (New York: Dover, 1995), 302–5.

6. These tensions had a recent precedent. For example, the partition of India in 1947 into its Hindu and Muslim majority regions (i.e., into India and Pakistan) was accompanied by communal riots in which perhaps a million people died. The postindependence government that took shape in India sought to build safeguards for the remaining, and still large, Muslim minority population. Nevertheless, pervasive discrimination and ghettoization ensued; for instance, Muslims were underrepresented in government service and in the private sector, and educational levels were disproportionately low.

7. More than 2000 Muslims were raped, burned, or hacked to death, with the active encouragement of large numbers of the Hindu majority, as well as the compliance or assistance of state machinery. Muslim shrines were razed to the ground and paved over. Muslim businesses and homes were attacked, and in many cases—not only in Ahmedabad but across Gujarat—Muslim-occupied areas were converted into Hindu areas in what Hindu militants described as a process of cleansing.

8. One of the foremost sociologists writing on Gujarat has in fact argued that the two events are connected, deindustrialization having caused the unrest that was fodder for communal violence, fomented for political ends. Jan Breman, *The making and unmaking of an industrial working class: sliding down the labour hierarchy in Ahmedabad, India* (Amsterdam: Amsterdam University Press, 2004).

9. Usually, the drivers rent the vehicles; it is the owners who commission these pictures, painted at a cost ranging from 250 to 500 rupees a tire flap, which ranged from 8 to about 20 inches each in width. On occasion, I met a rickshaw driver who owned the vehicle he drove, but this was rare.

Bibliography

Bunuel, Luis. *My Last Sigh*. Trans. by Abigail Israel. Minneapolis: University of Minnesota Press, 2003.

Groys, Boris. *The Total Art of Stalinism: Avant-Garde, Aesthetic Dictatorship, and Beyond*. Trans. by Charles Rougle. New Jersey: Princeton University Press, 1988.

Kumar, Krishna. *Raj, Samaj aur Shiksha* [State, Society and Education]. New Delhi: Rajkamal Prakashan, 1985.

Peirce, C. S. "Perceptual Judgments." In *Philosophical Writings of Peirce*, ed. Justus Buchler. New York: Dover (1995): 302–5.

11
Public and Violence*

GEORGE YÚDICE

The subject I would like to tackle here: the role of the public and the publics in art and in present cultural action. I use the term *cultural action* because I believe that, as already explained by Neil and Marysia, art has reconverted into a practice that participates in the constitution of a symbolic economy, that is to say, in the circulation of signs of value. Through a technological and politicohistorical transformation—end of the cold war and the narratives that legitimized the detention of power in that context—we inhabit a real virtuality that, as Castells explained, not only configures our consciousness but also increases the diversity of norms that guide differentiated consciousnesses at the same time as it makes it difficult for one generalized authority, and even common communication protocols, to impose itself. In this context, culture has little to do with notions of transcendence according to the legacy of the aesthetic ideal, which goes back to Immanuel Kant; distinction in Pierre Bourdieu's sociological model; and even of the self-regulating disciplining of subjects in the line of inquiry that Michel Foucault initiated and that Tony Bennett extended to art in *The Birth of the Museum*. As Charles Esche argued, with the disappearance of European social democracy of the welfare state in the United States and even in some Latin American countries, culture molds itself more and more as a resource with which to solve social and economic problems; that is, it is evaluated and justified in terms of utility, both inside governments and across international cooperation agencies and the prolific world of nongovernmental organizations. It is worth noting that the submission to a mediation based on utility does not mean that the argument of the autonomy of art has been completely lost. But even that autonomy has a place in the machinery of the production and circulation of value if we consider that what comprises the essence of art and creativity function as the engine for the generation of innovation in the so-called new economy. All of this rhetoric surrounding creativity erases the violence that configures what we believe to be the public sphere and the state that must care for it.

* Lecture presented at the conference "Nous paradigmes per fer, produir, representar, distribuir i discutir l'Art" (Caixa Forum, March 13–14, 2004). Translated from Spanish by Sebastian Calderon.

If this utopia of the new creative economy functioned really well, we would all be happy and would not even have to face what Esche called art's own task, since culture by itself would solve any discord and we would become rich with our own creativity, something akin to what is promised by the Universal Forum of Cultures. In fact, once the conventional materials of art have been replaced by sociopolitical relationships, we see the proliferation of artistic projects. These seek to catalyze consensus through the sociability that is supposed to emerge from the artistic encounter in cultural institutions and even in spontaneous convocations and open calls, for the formation of more or less stable communities. And what to say of those communities, which not only aim to reach consensus but also the generation of employment with the construction of museums in which heritage is staged and practiced. This plan circulates mouth to mouth and ear to ear, from the most powerful leaders of the global economy to the rhizomatic third sector of nongovernmental organizations and tiny indigenous communities, like in the Andean highlands, where I have listened as a member of the jury for the "We Are Heritage" prize of the Andrés Bello Convention—a UNESCO-type organization for South American countries. James D. Wolfenson, president of the World Bank, said, "Heritage generates value. Part of our joint challenge is to analyze local and national returns for investments that restore and derive value for cultural heritage, be it buildings and monuments or live cultural expressions such as music, theatre and indigenous craftsmanship" (World Bank 1999a: 13).

A report from the National Endowment for the Arts in the United States:

> The arts, no longer uniquely restricted to the sanctioned spheres of culture, would literally diffuse themselves across the whole civic structure, finding a place in a diversity of activities dedicated to community service and economic development—from youth and crime-prevention programs to job training and racial relations—very far from the traditional aesthetic functions of the arts. Likewise, this expanded role of culture can be seen in the many and new partners which accepted artistic institutions in the last years: school districts, parks and recreation departments, convention and visitor centers, chambers of commerce and an army of social welfare organizations which work, all together, to highlight the utilitarian aspects of the arts in contemporary society (Larson 1997: 127-128).

What to do in this context in which participation is already swept up by utility? Castells posed a similar question and made the following reflections: (1) provoking art has no purpose since provocation itself has been normalized; (2) one can silence, refusing representation in a world saturated by images—in fact, this was the strategy of the Chilean artist Alfredo Jaar when he hid in padlocked boxes photographs of victims in the style of Sebastião Salgado something that everyone was supposedly fascinated in looking; or, on the

contrary, (3) there must be an attempt to create an impact in the mediatized world, as activists do, but as do terrorists, with or without state consent.

Another possibility, which has been rehearsed for a while, is the attempt to catalyze codes of mutual comprehension among heterogeneous publics. Grant Kester, in his book *Conversation Pieces: Community and Communication in Modern Art*, features a myriad of experiences in which artists endeavor to facilitate a sense of community through diverse interactive strategies, especially with minority or marginalized groups. Among these experiences, we are of Suzanne Lacy's *new genre art,* such as "The Roof Is on Fire," which brought together minority youth who strived to take control of their own mediatized representations through dialogue. There's also the ROUTES project, which mobilized bus drivers, artists, and other collaborators in Northern Ireland to circulate and interact in all of the public spaces in Belfast without restrictions based on religious identity; or the collaborative art projects of Mary Jane Jacob in which all social classes participate, especially communities outside the circuit of dominant institutions.

The trap of the "catwalk of differences," which according to Marina Garcés has as a result, "to capture creativity, not in rigid jails, but in prisons of possibility." The great problem with these projects, which convene publics so that they can reach consensus amid their differences, is that they appeal according to recognized categories, and therefore the principle through which they get to know each other and the organizers is the previous knowledge of those groups, even though they have as a task to question stereotypes. That is to say, they operate within regimes of visibility and invisibility that remain untouched. These groups are nurtured and strengthened by the incorporation of those excluded from the distribution of value but not from the regime of representation, based on which such incorporation takes place. This is the great flaw of American multiculturalism and also evident in the dilemma presented by the South East Asian scholars of subalterity. Amid this prison of representation, Garcés proposed the practices to get rid of public of invisible theater in the Vallecas de Cesar de Vicente room.

But this negation of alterity, characteristic of subalterity, is not a purposeful program, and its longing to escape from the regime of visibility–invisibility ends up being impossible and useless, since eluding representation is nothing but settling in an invisibility, a fundamental aspect of representational dialectics. A possible way out of this negation is the performative strategy proposed by Judith Butler, through which subjects reproduce themselves through the repetition of deferred normative acts and features. This performativity allows for the evasion of the Heideggerian law of representation, which at the same time visualizes a certain order of things and hides a whole other possibility. Allow me to review this argument, since it has a lot to do with the way art, thought of from a traditional standpoint, ends up being the expression of the

occult, which in any case seems to be what is disappearing from the regime of digital symbolization in the new turn of the postmodern screw.

In "The Question of Technique," Heidegger identifies technology as a way of understanding in which nature derives a resource: a means to an end or an "available reserve." It arrives at a point where everything, including human beings, constitutes a permanent availability ready to be used as a resource. In an earlier essay, "The Time of the Image of the World" (1938), where he did not yet talk of the available reserve, Heidegger however characterized modern time—in which representation is offered as a resource—as that which make the essence of things invisible. Science, technology in regards to the autonomous transformation of praxis, the transmutation of art into the object of "mere subjective experience," and the consummation of human life as culture and the loss of the gods (1977, Page 177) are the phenomena that give birth to the time of the image of the world, where the embodied cognition of the previous era is made invisible. Heidegger posited that "the calculation, planning and molding of all things"—precisely Foucault's definition of governability that characterizes the transition from the economy of the home to that of society in general. With the advent of governmentality, it became essential that the *res publica* or things such as the weather, wealth, health, disease, industry, finances, and traditions were ordered and calculated through statistics and were managed through the *knowledges* of discipline (Foucault 1991: 95-103). These are the processes which, in light of this same ordering, "throw an invisible shadow with regards to all things", that is to say, they render their essences invisible (1977: 135). The blocking of other types of revelations constitutes a danger: "the advent of the presence of technology threatens revelation, the threat of the possibility that all revelations will be consumed in the ordering and that all will present itself merely in the disclosure of the available reserve" (1977, p. 33). But we should ask ourselves in a world where there are no more origins and originals if the dilemma of subalterity has disappeared, since it could now be manifested through recombination and sampling.

Some have characterized this constitutive recombination as simulacrum, that is, an effect of foundational reality on the "precision of the model" (Baudrillard 1983: 32). I prefer the term *performativity*, since it alludes to the processes through which identities and entities of social reality are constituted by reiterated approximations to the models—that is, to the normative—and also by residues, or constitutive exclusions that end up being insufficient. And as was already mentioned, in globalization, by approximating different cultures. Normativity is acutely questioned and performativity is favored.

Butler observed that power constitutes the domains or fields of intelligibility of the object taking as the material effects of that constitution "material data or primary determinations" that seem to operate outside of discourse and power. She recognized Foucault with showing that those material effects result from an "investiture of discourse and power," but to her judgment, he did not

provide a way of discerning "what constraints the domain of that which is materializing" (1993: 34-35). The principles of intelligibility inscribe not only what can be materialized but also the zones of unintelligibility that define constitutive exclusion. Theories of the unconscious, whether psychoanalytic or political, tend to condense multiple processes in a specific law—the Oedipus complex or paternal law, the law of classes that underlines ideology as false consciousness—that put a brake on, so to speak, the diversity of deviations. Performativity, as Butler explained, indicates that instead of fundamental laws, there is instead a competition of many and different principles of inclusion and exclusion: "to supply the character and content to a law that secures the borders between the 'inside' and the 'outside' of symbolic intelligibility is to preempt the specific social and historical analysis that is required, to conflate into 'one' law the effect of convergence of many, and to preclude the very possibility of future rearticulation of that boundary which is central to the democratic project that Zizek, Laclau and Mouffe promote" (1993, 206-7).

Here Butler invokes the interconnection of the individual subject and of society with an implicit recommendation in favor of social democratic change. The subject and society find themselves interconnected by performative forces, which operate on the one hand to brake, or converge, the many differences or interpellations constituting and singularizing the subject and on the other to rearticulate the broader ordering of the social. Both individuals as well as societies are force fields that constellate multiplicity. According to Butler, the tension between these forces or laws allows individuals in constellations to change and not to conform to the circumstances. However, the contours of the social remain. I can think of two metaphors that facilitate the clarification of this vision of the individual and the social. One of them is Mikhail Bakhtin's interpretation of the novel as a myriad of discursive registers—*heteroglossia*—that nevertheless assemble and constitute a discursive genre. Bakhtin said,

> It is necessary to define the novel as a diversity of types of social discourses and a diversity of individual voices, artistically organized. The internal stratification of any national language into social dialects characteristic of group behavior, professional jargons, generic languages, generational or age-based languages, tendentious languages, languages employed by authorities, by diverse circles and those that response to passing styles, languages that serve the specific socio-political effects of the day and even the hour (every day has its own slogan, its own vocabulary, its own emphasis), in short, this internal stratification present in all tongues at any moment of its historical existence, constitutes an indispensable prerequisite of the novel as genre (Bakhtin 1984, p. 263).

What for Bakhtin defines the novel closely resembles Jacques Derrida's law of genre, which "is precisely, a principle of contamination, a law of impurity,

a parasitic economy" (1980). According to Bakhtin, the effect of the novel resides in "another consciousness [which] does not insert itself in the frame of the authorial consciousness, that reveals from within as if something it were outside ..." (1984, p. 284). For Derrida, "the stroke which marks affiliation inevitably divides; the limit of the entirety forms, through invagination, an internal pocket larger than the whole and the result of this division and this enlargement is still as singular as it is unlimited" (1980). A consciousness that is within and yet without and a singular although limited invagination, constitute both the virtual models and the models of virtuality of what Laclau denominated as the social. Just as subjects are contradicted and leveled by the name, also the impossibility of society is composed of myriads of unstable differences managed by hegemony. The rearticulation of the ordering of differences characterizes both Butler's subversive performative subject as well as Laclau's idea of social change. "Hegemonic relationships depend on the fact that the meaning of each of the elements in a social system is not definitively fixed. Without this, it would be impossible to rearticulate it in a different way, and in consequence, rearticulation could only be thought of under categories such as false consciousness" (Laclau 1988, p. 254).

InSITE

There is something of this law of genre in the actions of inSITE, an art triennial that spans an 80-kilometer corridor between San Diego, California, and Tijuana, Mexico, and runs across the border between the United States and Mexico. InSITE is composed by a network of staging sites where artists and their collaborators assemble cultural events of growing national and international recognition. The same takes place regarding the collaborating publics.

InSITE distances itself from the link with the place, understood as the entirety of physical attributes—more than social or historical—privileged to install a sculpture or to stage an intervention: a link that completely characterized the different works of Robert Smithson, Carl André, Robert Serra, or other appropriation artists such as Jenny Holzer. In turn, it is assumed that the city or the region should provide the opportunity to explore the tendencies toward publicization and privatization, particularly as experienced by residents and itinerants. Instead of parachuting the artists in a site, the artists are invited to spend a season there, with a frequency of more than a year, to get to know its story and its community and from this base to arrive at the concepts and materials that will compose the project. In inSITE's case, there is no obligation to thematize the region or any of its aspects, but it is expected that aspects related to the region will function as starting points for the artists' projects. One could say that they are obligated to produce surprise, even though this is not always the result, particularly in projects that seek to overcome the effects produced by the border. And given that many of the artists come from abroad and enjoy international fame, many of the works

behave as imbrications of the local and the transnational or global, as well as the inclusion of institutions and spaces not usually associated with art. As inSITE evolved, its focus went from finished and staged works to more process-oriented projects, which according to the 2000 catalog edition "ensure the active participation of the public in its development" and "weave artists and works in the fabric of the communities … during a period of eighteen months."

In relation to the artistic manifestations mentioned before, particularly those that deal with the representation of excluded groups, in its 2000–2001 edition—and even more in 2004–2005—inSITE has more to do with the fluid construction of networks, which according to Osvaldo Sánchez, curator of the new edition, "self-generate and articulate through a shared experience within the frame of the social contract…And that experience, is in itself the nature and matrix of the public; its structure of interconnection is its own constitution" (Sánchez). This declaration is verified in the work of Krzysztof Wodiczko, which appears in the projection on the dome, known as "the ball," of the Tijuana Cultural Center and consists of the faces of six female maquiladora workers, who denounce the bosses and the men who abused them throughout their lives. Completing this project took the work of various networks: According to the projects description, Wodiczko strived "to give visibility and voice, through the use of advanced mediatized technologies, to women who worked in the maquiladora industry in Tijuana" (Wodiczko 2000). In the debate following the video projection (García Canclini, Wodiczko & Yúdice 2001), Wodiczko said that his intention was to take the privatized suffering of the women into the public space controlled by hierarchies of class and gender, especially in the Mexican context. We would need to formulate certain interesting questions: Who worked with the workers to accomplish those effects? Only Wodiczko? Or also the personnel and residents of inSITE? And if they also participated, how do they insert themselves in the artistic process?

The women had been coming together for about a year, from the moment Wodiczko asked for their help in identifying the appropriate participants for his project. According to Garza, the process was similar to group therapy, and it took a great and rigorous effort—which in the debate following the projection of his video, Wodiczko called "psychological evolution"—to allow the women to feel comfortable and capable of talking freely about their lives, particularly about the abuses suffered at the hands of their bosses, husbands, lovers, and the authorities. Wodiczko wanted to politicize everything that is repressed due to the stark division between the public and private in Mexico. The projection of the testimony of these women in the dome of the Tijuana Cultural Center, the most important public building in the city, represented the opening of a public space for those who do not have access to it in a non-democratic society.

For that same reason, some critics compared the project with television interviews such as those carried out by Oprah and Sally Jessie Raphael, where pathologized people, or those who suffer their vexations in secret, can according to popular therapeutic models take control of their lives. Certain talk show hosts even obtain professional therapy for their guests (29). Wodiczko defended his work, affirming that this was not about mere entertainment where people who are looking for their fifteen minutes of fame will nor alter anything by exposing themselves. But there is a more important difference: Talk shows tend to confine the analysis of pathology to the familial realm; Wodiczko in turn considers it a failure of democracy, understood in psychological terms as the staging of conflicts about values in the public sphere and the limitation of access to those spheres or *agora*—to use the word he borrowed from Hannah Arendt. In fact, the Greeks called *obscene* or out of the scene the space that kept private and psychic life, and sometimes violent, from the public space of representation. And undoubtedly the absence corresponds to a social space where it is not acceptable for the subordinates—or the *defeated,* to use Wodiczko's term—to represent publicly the memory of what has happened to them.

At the same time, to achieve those testimonies that we all saw implied the work of many individuals, not only Wodiczko and the inSITE personnel but also nongovernmental organizations such as Grupo Factor X, a community-based women's labor and reproductive rights organization, and a group of female lawyers. According to Sánchez, it is possible to insert discouraging devices that keep on working as a work of art at a first level and not as witty parodies or aesthetic models of social struggle. And this, in a context where cultural practices incorporate and draw from everyday economic reality various strategies of adaptability, interconnectivity and recycling, the same situation that conditions survival at the border.

It usually happens that some critics rush to disqualify the materials and methods with which artists work and, thus, place these under the avant-garde criteria of efficiency: If art does not transform the world—if it only partially benefits institutions—then it is a failure. Artists respond in various ways. For Manglano Ovalle, the artists might simply be taking advantage of the opportunity given by current sponsors. After all, exhibits are spaces to obtain recognition, besides increasing the value of the works that circulate in the market. Judith Berry, another inSITE participant, alleged that many critics do not make a sufficient effort to transcend their own ideological axis, and she responded to Foster with the same questions he formulated: "Those who write about art, are they qualified to value our extra artistic investigation?" (1998b). Mauricio Dias and Walter Reidweg, who prepared a project for inSITE2000 where they refer to the border patrol, also privileged the intervention of art over a romantic acquiescence to the hyperinstrumentalized rhetoric of community and otherness. They prefer to work with "groups that habitually do not

work with culture" and provoke, through a series of questions, a vulnerability that produces "more complex and fragile perceptions of them and ourselves … We understand art as a tool with which to pose questions. Not to resolve them, but to point them out, making them as present and significant as the final resulting products. Art can create a space that allows for doubts and fragilities that are more attuned with real life than with specific results" (28).

Another project, DOVOTIONALIA, happened over the course of six months in eighteen poor communities in Rio de Janeiro and involved making daily wax molds of the feet and the hands of 600 children who live on the streets there. Again, the purpose was not to solve their poverty, eternal efficacy in the nonvirtual world, but rather to work on what animates these youth and to acknowledge their vulnerability that is not limited to a vulnerability to death—although this was the case with some of the children. It is also about the process of assuming our performed identities to be in public. To reveal vulnerability is an important act about something the public hides. It is known that since classical Greek times, the public sphere erects itself as the space of sociability at the same time as the order of violence is relegated out of the scene, that is, to the *ob-skene*, to the obscene of the proscenium. An important part of being in public is to make visible sanctioned violence that defines our vulnerability. To be in public means establishing protocols to expose ourselves—not to our representation but on the contrary to our vulnerability, which defies normalization and makes possible for us to experiment with our foreignness.

This performative process, as Sánchez indicated, opens terrains of displacement and hybridity among political and artistic practices, which somehow models of life and personal projects interconnect. It is a project open to chance but also subject to an incorporated selective process that strengthens certain aleatory changes so that these can become part of the system, in this way impeding the dispersion of samples. Analogically, societies maintain their form according to the law of genre in spite of the rearticulations. In this model, social change is similar to the turning of a kaleidoscope.

A key premise of modernity is that tradition, kept safe in the domestic sphere, is eroded by the constant changes of industrialization and the new divisions of labor and its concomitant effects such as migration and capitalist consumption. The latest theories of disorganized capitalism consider, however, that the system itself benefits from the erosion of these traditions, namely, that it can do without governability. Disorganized capitalism progresses with this erosion, assisted by new technologies that allow, for example, the reduction of time in financial markets, the internationalization of advanced services to the consumer, the spread of risk, the greater mobility of people, goods, sounds and images, the proliferation of styles, and what I have characterized as a new international division of cultural labor. The system feeds itself from these changes and also from the attempts to recuperate tradition. In consequence,

the failure in repeating normative behavior as a constitutive feature of subversive performativity can strengthen and not threaten the system. The system nurtures itself from disorder.

Lash and Urry (1987) affirmed that instead of the incremental order Karl Marx and Max Weber presupposed, capitalism displaced itself toward a deconcentration of capital within nation states; a growing separation of banks, industry, and the state; and a redistribution of the relations of production and the patterns of residence related to class. Analogously, we would have to add that there is a process of undisciplining, evident in the withdrawal of the welfare state and its replacement by heterogeneous and increasingly micromanaged institutions of civil society and their homologous counterparts—organizations of uncivil society such as mafias, guerrillas, militias, and racist groups. It is about what Gilles Deleuze called the society of control, reigned by the code and the market and processes of interchange and backed by the force of the law and the auditing Jeremy Vallentine talked about, which operates in favors of corporations and, when physical might is necessary, through violence. According to Deleuze,

> The conquests of the market are made by grabbing control and no longer by disciplinary training, by fixing the exchange rate much more than by lowering costs, by transformation of the product more than by specialization of production. Corruption thereby gains a new power. Marketing has become the center or the "soul" of the corporation. We are taught that corporations have a soul, which is the most terrifying news in the world. The operation of markets is now the instrument of social control and forms the impudent breed of our masters. Control is short-term and of rapid rates of turnover, but also continuous and without limit, while discipline was of long duration, infinite and discontinuous. Man is no longer man enclosed, but man in debt. It is true that capitalism has retained as a constant the extreme poverty of three-quarters of humanity, too poor for debt, too numerous for confinement: control will not only have to deal with erosions of frontiers but with the explosions within shanty towns or ghettos.

If we return to the proposed analogy between Greek tragedy and today's public, we could equip the gods with the forces of control that constitute the sphere of imposed necessity. Having responsibility and capacity for action implies understanding the ways the subject is implicated, in a creative way, in the structures of control that are covered by the self-representations of the identity of the victim. By attributing an autonomy through which they are freely identified with the law, human beings exert the capacity of imposed action.

Human beings "cede control to a strange entity" to the purpose of administration, but this concession of power has instrumental ends that go against the needs and interest of others and of our own alterity. It is important to

consider here the ethics of Emmanuel Levinas's responsibility with the "other," which should not be treated as an object or as a representation, as in the rational operations of the administration of the modern state and the market. To assume this responsibility implies questioning the identities and representative inscriptions according to which these structures operate and which capture and create the fiction of an autonomous subject. An ethics for our contemporariness consists in ceding that tragic sense of life, which would be possible through the detour of Levinas's ethics of the other not be represented. "The ethics of hospitability of Levinas, that is founded on the asymmetric encounter in which the subject is constituted welcoming the other without expecting reciprocity, differs incredibly form the universality required by modernity and its definition of subjectivity, politics, democratic institutionality and human rights" (Basterra). It seems like what is asked for is a renunciation of subjectivity but what is endeavored for instead is a tensed equilibrium between subjectivity and ethics.

It is through the vulnerability implicit in this concession and opening of ethics that violence is made manifest—that something similar to the friendly enemy, mentioned by Esche, is formed in the "construction of a human community in which a common epistemological and cultural foundation cannot be presupposed" (Butler 27). It is precisely when vulnerability can be recognized that the recognition has the power to change the sense and structure of the vulnerability itself. This is the version of the future community offered by Butler, and it is another way to affirm what Sánchez says: It is in this construction that "another idea of the public, can and must act. Where heuristics displace hermeneutics." And it is specifically this traditional and fundamental feature of art that serves us not instrumentally to fight the violence we confirm and in which confirmation we dwell and not avoid the process of mourning, that estranges us and allows us to connect with others without causing them violence. This experience of another public might not save us from the violence that others may do unto us. It does, however, allow for the acknowledgment of humanity amid the machinery of representations and identities made, from the well-known categories, that would otherwise leave us unrecognized to ourselves and each other.

Bibliography

Arendt, Hannah, 1958. The Human Condition. Chicago University of Chicago Press.

Bakhtin, Mikhail. 1981 (80) "Discourse in the Novel." In The Dialogic Imagination. Four Essays by M.M. Bakhtin. Ed. Michael Holquist. Trans. Caryl Emerson

_____. 1984 Problems of Dostoevsky's Poetics. Ed. and trans. Caryl Emerson. Minneapolis University of Minnesota Press.

Barry, Judith. 1998. "Questioning Context". Nexus Conference, Philadelphia. Context (Autumn).

Basterra, Gabriela. 2004. Seductions of Fate Tragic Subjectivity, Ethics, Politics. London and New York Palgrave Macmillan.

Baudrillard, Jean. 1983. Simulations. Trans. Paul Foss, Paul Patton and Philip Beitchman. New York Semiotext(e).

Bennett, Tony. 1995. The Birth of the Museum History, Theory, and Politics. London Routledge.
Boudieu, Pierre and Wacquant, Loïc. (1999) "On the Cunning of Imperialist Reason." Theory, Culture and Society 16 41-58.
Butler, Judith. 1993. Bodies that Matter On the Discursive Limits of "Sex". New York Routledge.
Castells, Manuel. 2004. "Nuevas tecnologías y cambio social." Conferencia presentada en el simposio Nous paradigmes per fer, produir, representar, distribuir i discutir l'Art, La Caixa Forum, Barcelona, 13, March.
Cummings, Neil and Marysia Lewandowska. 2004. "The Value of Things." Conferencia presentada en el simposio Nous paradigmes per fer, produir, representar, distribuir i discutir l'Art, La Caixa Forum, Barcelona, 13, March.
Deleuze, Gilles. 1990. "Society of Control." L'autre journal, no. 1 (May). http//www.nadir.org/nadir/archiv/netzkritik/societyofcontrol.html.
Derrida, Jacques. 1980. "The Law of Genre." Avital Ronell (trad.) Critical Inquiry 7, 1 (Fall), pps. 55-81.
Esche, Charles. 2004. "Changes in the Production of Art." Symposium "New Paradigms of Art — Nous paradigmes per fer, produir, representar, distribuir i discutir l'Art." La Caixa Forum, Barcelona, 13 March.
Foster, Hal. 1996. "The Artist as Ethnographer." In The Return of the Real. Cambridge, MA MIT Press.
Foucault, Michel. 1991. "Governmentality." In The Foucault Effect Studies in Governmentality. Eds. Graham Burchell, Colin Gordon and Peter Miller. Chicago Chicago University Press.
García Canclini, Krzysztof Wodiczko y George Yúdice. 2001. Conversation IV. "Image Power Cultural interventions as public memory in post-modern spaces." Centro Cultural Tijuana, 25 February.
Garcés, Marina. 2003. "Circulación en red. Procesos artísticos y otros métodos de construcción de públicos." Seminario sobre "La construcción del público Actividad artística y nuevo protagonismo social." Museo de Arte Contemporáneo de Barcelona (MACBA), 28-29 November.
Heidegger, Martin. 1977 [1938]. "The Age of the World Picture." The Question Concerning Technology and Other Essays. William Lovitt (trad.) New York, Garland.
Heidegger, Martin. 1977. The Question Concerning Technology and Other Essays. Trans. William Lovitt. New York Garland.
inSITE2000. 2000. Curatorial Statement. http//www.insite2000.org/testweb/english/curators-e.html.
Kester, Grant. 2004. "Introduction." Conversation Pieces Community and Communication in Modern Art. Berkeley University of California Press. http//digitalarts.ucsd.edu/~gkester/Projects/ CPintro.html
Laclau, Ernesto. 1988. "Metaphor and Social Antagonisms." Marxism and the Interpretation of Culture. Cary Nelson and Lawrence Grossberg (ed.) Urbana, University of Illinois Press.
Larson, Gary O. 1997. American Canvas. Washington, D.C., National Endowment for the Arts.
Lash, Scott and John Urry. 1987. The end of organized capitalism. Madison, University of Wisconsin Press.
Lévinas, Emmanuel. 1985. Ethics and Infinity. Trans. Richard A. Cohen. Pittsburgh Duquesne University Press.
Museo de Arte Contemporáneo de Barcelona (MACBA). 2003. Seminario sobre "La construcción del público Actividad artística y nuevo protagonismo social." 28-29 noviembre.
Vallentine, Jeremy. "Audit." Conferencia presentada en el simposio. Nous paradigmes per fer, produir, representar, distribuir i discutir l'Art, La Caixa Forum, Barcelona, 13 de marzo.
Wodiczko, Krzysztof. 2000. Project Description. http//www,insite.2000.org/ testweb/artist_projects/Wodiczko/project-e.html.
World Bank. 1999. Culture Counts Financing, Resources, and the Economics of Culture in Sustainable Development. Proceedings of the Conference. Washington, D.C. http//WBLN0018.Worldbank.org/Networks/ESSD/icdb.nsf/D4856F112E805DF4852566
Yard, Sally. 1998. "Stories from down the block." En inSITE97 Private Time in Public Space/Tiempo privado en espacio público. Sally Yard (comp.) San Diego, Installation Gallery.
Yúdice, George. 2003. El recurso de la cultura Usos de la cultura en la era global. Barcelona Gedisa.

12

"'Twixt Cup and Lip": Intentions and Execution of Community-Based Art as Civic Expression

JAN COHEN-CRUZ

All the critical partners need to be in the circle with the artists. I'm talking about community development corporations, educational institutions, housing authorities, boys and girls clubs, neighborhood associations, immigrant associations, all these folks who come and say, "This creative resource has incredible potential for moving and advancing our issues and agendas."

Bill Cleveland, community cultural development consultant

There's many a slip 'twixt cup and lip.

English proverb

It is July 30, 2005. There is a strong police presence in the Hunts Point section of the South Bronx this Saturday morning but not because of a criminal investigation; rather, the Second Annual Fish Parade, the opening event of the daylong Summer Festival, is about to begin, and nearly 200 children, parents, artists, and friends are lining up. The energy is palpable. Everyone is at once participant and spectator, as jazzed to be decked out and the focus of multiple flashing cameras and compliments as they are to see each other in parade regalia. A police car leads the way, followed by local congressman Jose Serrano wearing a red felt, lobster-shaped hat. Next is a samba corps: first several rows of drummers, then Kelly di Bertolli, in a low-cut sparkly black outfit, on stilts, dancing with her team of girls in green sequined, scale-like halters and red skirts. A young guy dressed as a sea god in a marvelous cape, crown, and trident is followed by two adults carrying a sign stretching the breadth of the street that reads "Stop Water Pollution." Next, children carry paper puppets on strings depicting fish and other animals that they made in workshops in preparation for the parade. One man carries two of the puppets, exclaiming

163

with pleasure, "I came to drop off my daughter, but someone asked me to fix these and I ended up joining the Parade!" Some children "ride" 3D papier mâché fish that are the size of small ponies, cut out in the center for the children's legs. Others push a papier mâché whale mounted on a wagon covered in waves, which they helped a local artist make in a summer program sponsored by the South East Bronx Community Organization. Grinning kids rush

Figure 12.1 Kelly di Bertolli on stilts leading the drum corps at the Fish Parade, in the Bronx, July 2005. Photograph by Lisa Lindstrom. Reproduced with permission.

Figure 12.2 Three young dancers in the Fish Parade, the Bronx, July 2005. Photograph by Lisa Lindstrom. Reproduced with permission.

up to onlookers and give out small gummy fish candy. Three dancers from a company called Inspirit carry a large bamboo fish high up on bamboo poles. Members of Arthur Aviles Typical Theater Company are dressed like animals, from a fur bunny to a sea creature in cloth scales. Performer Sita Frederick carries a cutout of a person with a suitcase; she is surrounded by young people with suitcases decorated with fish. Several rows of teenagers display broad banners created in a printmaking workshop directed by Alejandra Delfin. There is a group of young dancers all in pink, from a neighborhood program, and another stilt walker, garbed like a butterfly. At the end of the parade are more percussionists followed by another police car escort.

The parade makes a large loop of the neighborhood, past warehouses and gas stations, shops, bodegas, and apartment buildings, including the Erma

Figure 12.3 Resident of Erma Cava Houses for seniors participating spontaneously in the Fish Parade, the Bronx, 2005. Photograph by Lisa Lindstrom. Reproduced with permission.

Cava Houses for seniors, where an elderly woman sporting a parasol and shopping cart bedecked with colorful paper fish briefly joins in. Onlookers smile from their cars, wave from apartment windows, come out of the stores, and pause in the midst of their errands, enjoying the child-centered spectacle of color, music, dance, and fish. The parade ends where the afternoon's festival will begin, at the two blocks of Hunts Point Avenue closed off from traffic to make space for a large sound stage, children's games, booths publicizing local organizations—the Bronx Botanic Garden, a local winery, and BAAD!, the Bronx Academy of Art and Dance—and food stands, featuring fried fish. Now seasoned musicians take over the samba playing as parade participants, particularly the children, listen and keep rhythm.

The artists who provide the parade's aesthetic structure and who facilitated most of the workshops that brought participants into the event are part of Action Lab, a two-year initiative through which a combination of eight artists and companies created projects with and for people in the Hunts Point section of the South Bronx. Action Lab rented a storefront on Hunts Point Avenue, which on this day displays art from Delfin's printmaking workshop. In front of the storefront lounges a six-foot-tall male dressed as a mermaid, with seashell bra, a tight scaly mermaid tail, and a long pink wig. In the storefront windows, televisions play videotapes of Action Lab performers. Project artistic director Arthur Aviles has taped a large cardboard map of the neighborhood onto the street alongside a poster board sign that reads, "Anti-Gentrification League invites you to: 1. take a sticker; 2. write down what needs fixing or

Figure 12.4 "Mermaid" in front of Action Lab's storefront, Hunts Point Avenue, the Bronx, July 2005. Photograph by Lisa Lindstrom. Reproduced with permission.

improving in Hunts Point; 3. place sticker on the spots where the fixing needs to happen."

I have watched Action Lab unfold from a unique vantage point, having been invited to introduce participating artists to the work of Augusto Boal, whose theater of the oppressed is a touchstone for the project. In this chapter, I consider what Action Lab reveals about making art in response to community concerns and where that agenda overlaps with citizenship. Community and citizenship share an idealistic, utopian aura, but both are difficult to engage with actively. That is, despite the inclusive rhetoric of community and citizenship, there is often a slip between cup and lip, a gap between intention and execution. And what is the nature of collaboration in each?

Action Lab Intentions

Action Lab was created with a $200,000 Small Business Administration grant Serrano obtained to support a mutually beneficial and potentially sustainable partnership between the Point Community Development Corporation, a center for arts, education, and activism in Hunts Point, and the Bronx Museum of the Arts. Hunts Point is a bustling economic zone made viable by the presence of the Bronx River, railroad lines, and plentiful space for industrial development. But it has not fared well as a residential district. In the 1970s, arson was so pervasive that two-thirds of the population left. In the last fifteen years people have been returning, but most families there are headed by single mothers, and a majority of children live below the poverty line. The neighborhood remains fraught with a high level of health, safety, and environmental problems.[1]

The Point Community Development Corporation focuses on youth development and the cultural and economic revitalization of Hunts Point. Point projects "celebrate the life and art of our community, an area traditionally defined solely in terms of its poverty, crime rate, poor schools, and substandard housing. We believe the area's residents, their talents and aspirations, are the Point's greatest assets. Our mission is to encourage the arts, local enterprise, responsible ecology, and self-investment in the Hunts Point community."[2] The Point features after-school programs and visual, music, and performance projects. Action Lab provides an opportunity for the Point to partner with the Bronx Museum and to explicitly explore, through art, what is on its neighbors' minds.

Bronx Museum of Art education director Sergio Bessa explains his institution's interest in Action Lab:

> Our origins in the 1970s reflected a community-based, activist approach that somehow got diffused over the years. The very history of the Museum's development shows the interconnection with the community: we were originally housed at the rotunda of the Court House, and we soon

opened a number of "satellite galleries" around the borough. Later we moved to the current facility which was originally a synagogue. Now we are going through an expansion with the expectation of offering the community not only a new museum, but also an educational center to foster the development of the arts in the borough. In order to structure this center the Museum needed to have a sustained dialogue with the community; to understand its needs and to bring the several parts of the community together.[3]

Even as Action Lab will help the museum stretch "out" more, the Point aspires to get their artists' work "in" more. Paul Lipson, director of the Point when the grant was conceptualized and now Serrano's chief of staff, asserts the imprimateur established institutions like the Bronx Museum of Art confer by expanding what they consider worthwhile art.

Lipson looks to Action Lab to provide a context for people to tell their own stories about local issues, to display their own diverse images of the neighborhood, and to bring in audiences whose perceptions of Hunts Point might thereby be expanded. He is concerned with the loss of meaningful traditions in Hunts Point, such as the obliteration of Little League and its concomitant parades in the economic devastation of the 1970s because parks were so unsafe they were closed down. Now there is a desire to set up new hybrids of old traditions and entirely new practices. To that end, one of the goals of Action Lab is to present work developed by artists and community members at the Fish Parade, which organizers hope will be an annual event. It began in summer 2004, conceived as a critical response to the relocation into Hunts Point of the city's largest fish market, the Fulton Street Market from lower Manhattan. Many residents were against the move, fearing it would bring rats and flies, congestion and stench to a neighborhood that, according to Lipson, already sees 15,000 trucks a day because of the wholesale green markets there.[4] But before the parade happened, the decision to resituate the fish market was a done deal. According to its press release, the parade's purpose was not to voice opposition to the fish market but rather "to herald the arrival of the Fulton Fish Market to Hunts Point, celebrate the revival of the neighborhood's waterfront, and recognize the artists who have contributed to the revitalization of its community."[5] Artists and other participants decorated supermarket food carts like floats, with only a few protesting the coming fish market. At the BAAD! table, Aviles recounts, "we had 'BAAD! ADVICE,' a fact sheet on the benefits of eating fish and the problems of the fish market coming to Hunts Point—so that our community wouldn't just get swept up in the celebration and forget the issues."[6] The parade was followed by a street fair, featuring a fish fry, local vendors, music, and performances.

The Fish Parade's shift in strategy from opposition to welcome is emblematic of the approach to artistic citizenship that I write about in this chapter.

The welcoming approach bespeaks an invitation to dialogue; arguments on its behalf include more access to public resources as a result of willingness to work with those in power, commitment to bringing a full range of positions to the table, and the desire to not alienate conservative and timid people. According to Lipson, the parade was a way to open a dialogue with the people bringing the markets, important because of community needs:

> We want jobs, especially as old timers retire and they need to hire younger people. We want the market to be as green as possible and we want a greenway on the edge of it. We want to bring more fish to the market by boat than by truck. This is possible; we're on the water and so are the airports that fly the fish in. We didn't want to do a protest parade because it was already decided they were going to be there; we couldn't shut them down. The best thing that could happen was to begin a conversation.[7]

The value of dialogue notwithstanding, performances of protest, protected by the rights of citizenship, constitute a great tradition in the United States. Reasons why people might choose such an approach include distrust of or lack of access to those in power, unwillingness to dilute their message, outside resistance to their point of view, and the desire to express the emotional tenor as well as the practical issue itself—what we might call the theatricality of protest. How pressing the issue is also affects aesthetic strategy; while against framing the Fish Parade as protest, Lipson supported ACT-UP[8] protest performances in the late 1980s and early 1990s "because it was a question of life and death." Arguably the choice is also aligned to the mood of the time. The post-September 11 zeitgeist is top down, with a sense that those in power think they know best; remember President George W. Bush disregarding the anti-Iraqi war demonstrations on February 15, 2003, when millions of people worldwide said no to that war. Proponents of both protest and a welcoming or dialogic approach attest to unifying the community around important issues. In this chapter I focus on the effort to take a dialogic approach.

Although one of the material goals of Action Lab is participation in the Fish Parade, one of its philosophic goals is self-expression of neighborhood concerns, building on ideas of Brazilian educator Paulo Freire. At the core of Freire's pedagogy is replacement of what he calls "the banking method" of education—the teacher depositing knowledge in passive students' heads—with a problem-solving approach with teacher and students as partners. Bessa is exploring a Freirean conception of the museum itself; rather than like the teacher in the banking method of education, where the museum is the holder of everything of worth and the museum visitors are merely the receptacle of its riches, the museum becomes a place to interact with community members and to shelter their stories as well as objects. Ron Chew, director of the Wing Luke Asian Museum in Seattle, Washington, articulates such a model:

"These things that had passed into our care—immigration papers, discarded cultural artifacts, family heirlooms—once belonged to people, were created and touched by human hands, imbued with life through the stories they told and continue to tell. As important as its role as caretaker of the stuff is, the museum has an obligation to also caretake the stories, the living pieces of our cultural legacy, memories that unite one family to another, that weave families into the fabric of community, connecting the generations."[9] Such museums thus look to community members for what is of value to them.

Translating Freirean philosophy into Action Lab, Bessa and Kellie Terry Sepulveda, current director of the Point, have looked to

Boal, a Brazilian theater maker and thinker grounded in Freire, as a quintessential model of art in dialogue with community. Boal has explored many ways of using theater to engage people in the expression of social concerns, one of the best known being forum theater. In forum, the main character tries unsuccessfully to overcome some kind of oppression relevant to that audience. Spectators are then invited to try out possible interventions a person in that situation might use. This leads to a discussion about the oppression and is, in effect, a rehearsal for a real situation.

Many of Boal's experiments constitute a theater of citizenship. In the early 1990s, sponsored by the governor of the Brazilian state of Rio, Boal trained thirty-five people who generated short shows around issues of most concern to them and their constituents, including unemployment, health, housing, sexual violence, incest, sexism, ageism, and drugs. They presented the shows in public venues such as schools and then invited forum interventions into those that most interested each specific audience. This, Boal contended, "helped the citizens to develop their taste for political discussion (democracy) and their desire to develop their own artistic abilities (popular art)."[10]

Boal continued his quest for theater that could create change beyond the duration of the show. He and his company offered their services to like-minded political parties; the Workers Party suggested one of them run for office under its umbrella. Boal ran and in 1992 was elected to Rio de Janeiro's city council. Though other artists have held political office, particular about Boal was that he did not leave his art behind to do politics; the one was an extension of the other. Whereas many politicians engage with citizens primarily during election season, Boal made the relationship with his constituents ongoing through what he calls Legislative Theatre. Boal explained, "Instead of applying ourselves to the citizenship 'in general'—as we do in our electoral rallies—we turned our attention to small organic units. Groups of individuals brought together by some essential necessity- teachers, doctors, laborers, students, farmers, domestic servants—and not merely by chance, as occurs in street theatre shows."[11] Among the theatrical techniques he employed was forum theater; only this time, when people could not come up with potential solutions to

the problems enacted, Boal proposed laws to the city council to ameliorate the situations. Thus, thirteen laws were passed during his four-year term.

Applicants for Action Lab grants were not required to know Boal's theories and practices but were expected to become acquainted with them if funded. Their projects did not have to use Boal's methods but did have to share his intentions, as articulated in the call for proposals: "The Bronx Museum is accepting proposals for arts residencies to be developed in Hunts Point ... A strong proposal will address issues of importance to the residents and will involve the participation of one or several segments of the community—students, children, seniors, professionals of the area, etc. At the end of the year, all individual projects will be integrated into a larger community-based pageant."

On Artistic and Political Citizenship

It is in the realm of participatory democracy, not merely via the electoral system of voting, that political citizenship has its greatest vitality. Law theorists Lani Guinier and Gerald Torres assert that democracy is more about group needs than individual rights; it is less about "the right of individuals to choose individual candidates" than "about the value of groups that form around common concerns and participate in an ongoing democratic conversation."[12] What role can artists play in promoting participatory democracy; that is, how are artists citizens, and what do artists bring to the table? How are artists positioned to further active citizenship because of their unique access to the public sphere?

Public, as first used in English, was identified with the common good of the majority of people, in contrast to *private,* which meant "privileged—at a high governmental or bureaucratic office or station," apart from the common people, with its own debates.[13] As theorized by Jurgens Habermas, the public sphere was the place that people, independent of their station in life, could exchange ideas that might have an impact on social life. The public sphere, as Habermas described in *The Structural Transformation of the Public Sphere* (1989), emerged with capitalism and was originally a platform on which merchants, bankers, and manufacturers "hoped to diminish the power and influence of the state in matters relating to trade and commerce."[14] Habermas described public space as "a forum in which private people coming together to form a public, readied themselves to compel public authority to legitimate itself before public opinion."[15]

However, without the economic power that characterizes participants of the Habermasian public sphere, from whence does the power of contemporary public space emanate? How might the points of view expressed through Action Lab impact public decisions? I asked Serrano, Action Lab's patron, if he is willing to read Action Lab's findings concerning what is on the minds of people in the neighborhood. He said of course, but most important to him is what kind of art Hunts Point residents want. A cynical view of Action Lab

is that Serrano is co-opting local frustrations by paying for Action Lab. Like medieval carnival, occasions of popular expression act as safety valves, releasing built-up energies and then returning to business as usual.[19] But the fact is, without Serrano's support there would be no Action Lab. Still, an efficacious relationship between his office and popular expression has yet to be developed.

Informal associations apart from both government—which Action Lab is not fully—and the marketplace—which Action Lab is—are part of an important tradition of civil society. Such associations emerge in the United States for a myriad of reasons including (1) so government is not so big as to overshadow local initiatives and decision making; and (2) so people of different social status mingle and work together.[16] 1). Like Habermas, political scientist Benjamin R. Barber described civil society as "the free space in which democratic attitudes are cultivated and democratic behavior is conditioned." Barber sees civil associations and voting in decline and "social trust in jeopardy," and, thus, "the repair of civil society obviously becomes a sine qua non of democratic survival."[17] While Barber notwithstanding, voting in the 2004 election was relatively high, and Barber's emphasis on the need for this third sector apart from the government and marketplace, is well placed. People in whose names government policies are created must not be superseded by politicians who operate independent of their constituents as public "professionals."[18]. Action Lab is a laboratory to develop such independent thinking.

Experiments like Action Lab are not without contradictions. Workshops with a broad spectrum of participants are challenging to arrange yet alone sustain. How to get people to show up and keep showing up? Even once there, how to break the internalized sense that one has nothing to contribute? Even once people express their real concerns, who hears them? How can these pronouncements have any impact? Is there even such a thing, in our time, as a public sphere? Is issue-oriented art an oxymoron? Are the particular projects that Action Lab artists created relevant to people in Hunts Point?

Action Lab Execution

Action Lab workshops were physically accessible, taking place at sites including schools, senior centers, and a storefront the Bronx Museum rented on Hunts Point Avenue. Nevertheless, a challenge facing nearly all the artists was getting and keeping workshop participants. The grants were modest; the artists were necessarily working on other projects at the same time, in and outside of New York, so the extensive networking necessary to arrange workshops was often fragmented. The artists' liaisons at various community centers were also busy. Even once people were attending regularly, they were unaccustomed to and were often timid about expressing their views in public. The twelve participants I observed in a workshop at a senior center, for example, only participated in exercises when they were told exactly what to do. As a result

of inconsistent and modest participation, artists had to adjust their visions. Nevertheless, the aesthetic strategies that the artists selected were promising.

Three Action Lab projects drew on aesthetic forms indigenous to the neighborhood while stretching beyond them. Nelson Rivas, working with local teens—one of whom had spent a month in jail for spraying graffiti on public property—proposed the collective creation of three graffiti murals, the first of which was painted on one of the walls of the Point. Although other graffiti murals in the neighborhood have meaningful content—several of them memorialize slain Hunts Point residents—this was the most positive I saw there, depicting what people accomplish with their hands and including images of filming with cameras, holding protest signs, grasping microphones, and gardening. Pattydukes created the Girls Hip-Hop Project, training female emcees and using hip hop for social commentary. This built on the popularity of hip hop in the Bronx even as it aspired to take the form further by engaging young women in what has been more a young man's and sometimes misogynist form. Kelly di Bertolli led workshops in various Afro-Brazilian cultural forms including samba dancing, drumming, and mask-making, which were integrated into the Fish Parade. This brought a rich Brazilian flavor to the neighborhood tradition of parades.

Strategies most parallel to Boal's were evident in three other endeavors. Christal Brown's Becoming Project was a holistic set of ten workshops for teenage females to become conscious of their stereotypic self-images and to expand ways of expressing whom they are and whom they want to be. Brown is concerned with negative stereotypes surrounding young women involving early pregnancy rates, violent behavior, and lack of education. The young women in the project explored these issues through text, movement, spoken word, costuming, and displaying themselves at the Bronx Museum of Art to raise their consciousness about self-presentation. Another project entitled, Transaje, intended to engage both Dominicans who had migrated to the Bronx and Dominicans still on that Island about their perception of the Bronx. However, liaising with senior centers in Hunts Point, Transaje artists mostly encountered Puerto Ricans and African Americans. They discovered that not so many Dominicans in the Bronx go to senior centers; more look to family members for support. The elders they worked with also had interesting and important stories, changing the project but not for the worse. Like Boal, Transaje hoped to address large issues, such as immigration, as well as an expanded perception of who lives in Hunts Point through individual stories gathered. Delfin's printmaking workshop shared Boal's emphasis on issue-driven art. However, even though some of the teens made posters against police violence, focus on issues did not go beyond art-making. Missing was what Boal called metaxis: the image of reality becoming the reality of the image, such as art bringing up issues that are then treated in one's life. But this was an unresolved issue for everyone in Action Lab.

The inclusion of Silver-Brown Dance Company and Arthur Aviles Typical Theater, both grounded in modern dance, made the important statement that the Bronx is not defined by hip hop exclusively. Silver-Brown both performed and worked with students at a local school. Aviles did not seek out community partners because he himself is "of the" community. He describes himself as an outsider, a gay man in a Latino community struggling to be seen and respected. Aviles's combined need to protest and to be in dialogue resonates with the same impulses vis-à-vis the first Fish Parade. I thus turn now to Aviles.

While identifying Hunts Point as his community, Aviles expresses a minority position within it as non-Spanish speaking, gay, and private-college educated. In this sense, Aviles is in a classic, alienated relationship of artist to community. Yet at the same time, he has chosen to be there. Aviles grew up in the Bronx as hip hop was being born. He recounts that even though he was as gymnastic as many of the phenomenal hip-hop breakers, the atmosphere was not welcoming to gay people, and yet that was his community. Aviles left the neighborhood, attended Bard College, and was a core member of Bill T. Jones's Arnie Zane Dance Company from 1987 to 1995. Experiencing the incredibly lively response Jones's work generated—"even whether what Bill is doing is art"—shaped Aviles's notion of political art (interview with Aviles 2005).[20]

Aviles began Action Lab skeptical about Boal. He considers his company's frequent partnering of men and men, and women and women, political; the delicacy of dance, which he has sometimes explored in public parks in the Bronx to mutterings by passersby of "faggot," is political. For Aviles, art is political, indeed art is art, when it generates heated discussion: "If a piece you do doesn't elicit some kind of discussion outside and inside of what you've presented then you haven't really presented art or made a statement."[21] Aviles left Jones's company to come back home "because I need to be a part of my community. I have an affinity for Latino people so my departure from them was very scary. At the same time I'm apprehensive because I'm building something that is different. I came back to take a stand. My come-back is very defiant."[22] He set up BAAD! especially for gays, lesbians, bisexuals, transsexuals, women, and people of color generally. Aviles was apprehensive about Action Lab's concept of listening to the community, because he is the community, too, and they have not been listening to him. It is therefore important to emphasize dialogue over passive listening. Aviles addresses the difficulty of being a minority voice in his community:

> Whenever I am surrounded by the Latino culture and homosexuality comes up, it's very difficult to get my point of view across in a way that is about taking a stand rather than coming from underneath and saying, "Would you allow me to say this please?" So that's the little bit of positioning that I'd like to take within the really wonderful influence of Boal

in Action Lab. Because I find that a lot of the voices of "the community" that get heard are from the status quo. I want to push against that. All voices need to be heard (interview with Aviles 2005).[23]

Aviles makes an important case for the element of protest in community-based performance to resist the homogenizing force of the worst kind of majority-driven collaboration.

Aviles created "El Yunque is in the Laundromat," whose central image of the Puerto Rican rain forest, El Yunque, where many local people's ancestors would have washed their clothes, was combined with what for most people in the neighborhood was an unfamiliar array of dance, music, and visual aesthetics. Thus, Aviles enacted both celebration of and protest against the mainstream Hunts Point population, to which I shall return.

...

Action Lab performances took place over three Saturdays in July. The last was the Fish Parade, with which I opened this chapter. Although from Bessa's perspective, the other two were "rehearsals"[24] as public events they invite response. The first, by Transaje, began across the street from the Hunts Point Avenue subway with a dozen people of different ages carrying suitcases. They demonstrated a range of responses—confusion, sadness, excitement—to the journeys on which they appeared to be embarking. The performers led the audience that congregated—mostly friends of the performers and Action Lab—to the storefront for a multimedia installation created from materials gathered in their research. That evening, participants from Pattydukes and Christal Brown's workshops also performed in the storefront to enthusiastic audiences.

The second performance, two weeks later, evidenced the challenge of enacting artists' visions in very public settings. It began with di Bertolli and company's samba drumming and dancing with a handful of young people looking somewhat uncomfortable. The street was not closed off to traffic so they marched on the sidewalk, circling the block from the Point to Action Lab's storefront. Without a clear context like the Fish Parade had, this procession did not apparently engage passersby. Marchers continued up the block, pausing in front of public housing while Aviles's and Silver-Brown dancers performed short pieces. The sound system, from a car driving alongside the parade, malfunctioned. The event stalled as Aviles waited for the music to be loud enough to hear. When that never happened they performed anyway, mostly for friends and participants of Action Lab who were marching along. Some people looked out their windows, but few stopped along the street. Eva Silverstein spontaneously abandoned the taped music and asked the drummers to play a beat, a

good choice, but neither her duet with another woman nor two men's duet to "Home on the Range" generated a lot of spectatorial interest.

Then the performers moved inside a large laundromat, the site of Aviles's "El Yunque is in the Laundromat." Aviles wanted to connect the ritual of washing as it takes place in ancestral natural settings with the way he and his neighbors wash their clothes now. His idea was to juxtapose elements of shared Puerto Rican identity like El Yunque, familiar music, and a common site for the performance with less-known movement forms. Aviles intended to put *Animal Planet* on a VCR to contrast with the talk shows typically played there. He wanted the whole laundromat engulfed in tropical plants and animal sounds through collaboration with a horticulturalist and a sound designer.

In its actual iteration, the performance did cause a stir among the thirty or forty people there of all ages who were doing their wash. Many paused to see what was happening; kids sat at the edge of the impromptu performance space. Evocatively, the company performed in front of a long row of washing machines, some with water splashing away on the clothes inside. But the space, with the addition of a few hanging plants, had not been transformed into a rain forest. The music—"Always and Forever" by a group from the 1970s called Heatwave—was hard to hear and took several tries to get going. Aviles chose the song because it is romantic and well known in the neighborhood, often played at Latino weddings and Sweet Sixteens. He finds it calming, important given the possible tension of performing in an unusual place. Way in the upper corner of the space, a television screen showed a tree in the wind, a far cry from the video of a rain forest that Aviles said would replace the talk shows usually playing there.

The six dancers were costumed as animals, two of which were Disneyesque: a chicken with a plastic mask and a generic fur bunny. The other four were more creative, featuring cloth scale-like fringes, feathers, wings, and a green unitard, respectively. Aviles chose them because "forests and animals go well together, and animals ease the tension of performance in an unusual space. I tried to make them familiar benevolent animals. I think the children might remember real animals weaving in and out of each other in harmony." Aviles saw the Disneyesque costumes as humorous, valuable to relieve tension, but agreed that the other costumes were more aesthetically pleasing. The bottom line was that he needed to use costumes the company had from past pieces given financial restraints.[25]

Though Aviles feels the performance achieved his goal of creating "a surreal, quiet, Zen-like atmosphere," he also commented that "El Yunque" had a pretty rocky birth. I agree that the performance temporarily changed and softened the atmosphere. But overall, audience response seemed to be low-level curiosity and momentary puzzlement. When it ended and the artists danced back into the street, people went back to the talk shows and their laundry. It is unlikely that audience members saw a connection between the rain

forest and the laundromat, particularly because Aviles was not able to hire sound and visual designers to carry out his vision. But Aviles took a long view, knowing the project was huge and multifaceted. In what he sees as the first of several attempts, he chose to focus this time on the relationship with the laundromat owners, to gain access to the space, and to get the dancers comfortable performing there: "It felt like a mini-Christo project.[26] In the future I imagine all the same elements—plants, a tv, music, and live performance—but tenfold. Given what I know now, we can take the next step to a more realized transformation (laundromat/rainforest)—a true and complete space where cleaning one's clothes and the experience of performance could be possible."[27] Looking at the three Action Lab performances as a whole, a larger effort is needed to bring out an audience and to more fully include them in the vision. Public participation is central to the realization of this kind of work; the final product is not the art created alone but also the public engagement that happens around that art. Audience development in the context of artistic citizenship includes making work that audiences can enter without watering down the artist's vision, getting people to view the work, and using the gathered public to further collective goals. What a tall order indeed.

Conclusions

Action Lab artists took a modest step toward facilitating participatory art projects that engaged Hunts Point communities around self-defined issues of importance. The most broadly inclusive project, the Fish Parade, was a classic example of how involving kids also pulls in some family and friends. Size does matter—no one could miss the parade, which took up a city block—and so does spectacle: the parade looked and sounded terrific. Intersectorality—the participation of people from different strata of society, in this case residents of all ages, artists, the local congressman, and supportive police—signaled the event as of some importance. Though not addressing local concerns in depth, the Fish Parade was Hunts Point celebrating itself, audaciously taking to the streets, playfully making itself the center of attention, and was a poignant exclamation point to a year of arts' activities about revisioning the neighborhood. However, local participants did not so much collaborate with as follow the artists' lead. Indeed, there are two meanings of collaboration: cooperation of more than one player and complicity with institutional authority. Are the by-and-large light-hearted images of the Fish Parade a way local government can show that the district is not as bad as people think or a way that participants can show that they are multidimensional without lessening the pressure for self determination, played out as the Fish Market prepares to move to the neighborhood? Both could happen, but only by deepening the partnership with the government so it also includes substantive follow-up and accountability vis-à-vis people's expressed needs.

Partnerships, as community cultural organizer Dudley Cocke likes to say, are like bridges: They need to be supported by firm structures on either end.[28] Serrano has all the apparatus of government. Action Lab artists have methodologies of envisioning. What strong structures exist in community groups? Perhaps if community groups already united in collective purposes were engaged as partners, the joint projects would function as bridges, well grounded on both sides. Boal said the most important factor in creating dynamic theater with people unused to public self-expression is choosing a topic about which the intended participants, actors, and audience care deeply.[29] Preparing for its second year, Action Lab is already identifying organizations that may want artist partners to cocreate projects expressing their concerns. Conversations with Serrano's office would also be worthwhile to identify a structured way the congressman might respond to Action Lab's findings besides joining the parade.

Action Lab evidences how long it takes to create community-based artistic citizenship. This does not mean that Action Lab is a failure; on the contrary, one must seize the rare opportunities for broad public expression. They just have more time-consuming facets than one might initially realize. These include exploring roles for the arts in economically strapped neighborhoods, recognizing artists' needs to experiment with genuinely public work, developing ways to encourage deep participation, finding strategies that are familiar enough to engage a community at the same time as stretching it, and discerning ways for art to affect public policy.

In this historical moment, it is not a question of gaining additional rights, as in the activist era of the 1960s, but of merely not losing ground. Artists have much to contribute to safe-guarding fundamental rights through mobilizing mass protests, building coalitions, developing critical consciousness, and providing processes for getting in touch with what people want and expressing and acting on it. As artist–citizens we can do as much to affect the climate surrounding laws—such as Arthur Aviles' effort to make Hunts Point a more congenial environment for homosexuals—as political citizenship can to offer recourse when these rights are transgressed.

Action Lab made a significant impact on participating artists. Both Delfin and di Bertolli will continue to work at the Point.[30] After a late start due to visa problems—Rivas is Chilean—and difficulty keeping participants, Rivas and a youth team are working on two other murals. They will paint one, conceptualized by Rivas and one of the teens, on the storefront gates. Showing how the area looked at an earlier moment in history, it will communicate that things do change. They imagine the other on the wall in front of the Hunts Point subway stop, proclaiming to people emerging from the station that this is a place with color, energy, and art.[31]

Evidencing his own willingness to dialogue and expand, Aviles was inspired by Boal to get two interns at the Fish Parade to "ask people who were walking

by the street map to let us know what they considered a problem in the neigh-borhood ... We got about 50 stickers on the map, highlighting: garbage needs to be picked up, too many rats, too many roaches, too many police; need to get rid of the 'Wedge' (a topless bar), the pier burnt down, concentrated places of drug activity, concentrated places of unfortunate situations of prostitution." Aviles now wants to find some way of getting the information to governmental officials. He e-mailed me that "the community is lit. Charles [the mermaid in front of the storefront on the day of the Fish Parade] and I walk down the street and we get congratulations from the larger as well as the fringe community. Action Lab *has* helped us create a stronger bond with the community!"[32]

Though gratifying that Aviles ended the year feeling more connected to Hunts Point, his initial skepticism about Boal and inclusion of an element of protest in the first Fish Parade ought not be forgotten. Protest and welcome are not two entirely different approaches but are rather energies that combine in different proportions, depending on the piece. In a way any celebration of Hunts Point is also a protest against a view of the neighborhood as all about crime and poverty. Paul Lipson explained that the Fish Parade was politically efficacious because "it shows that we're not docile, not a passive population, that we will be watching what happens and witnessing."[33] The dialogic under-pinnings of Action Lab and the aesthetic choices are where protest and wel-come blend; good dialogue invites people to say what they truly care about, and good art keeps the communication from being overly controlled and sani-tized, thus welcoming exchange and protest.

Notes

1. See http://bronxcb2.org
2. See www.thepoint.org
3. From private correspondence with Bessa 5/25/05.
4. From interview with Lipson 8/11/05.
5. Unbeknownst to even longtime residents, the Bronx River runs along the edge of Hunts Point, but until recently the community lacked recreational access. Industrial plants bordered the river banks; chain link fences denied access to anyone not employed there. However, one day local artist and activist Majora Carter was walking her dog when it took off under the fence. She ran after it and found herself facing the river. Stunned that this amazing resource had been hidden, she began imagining a river park replete with canoes and cafes, benches, and baby swings. Two years and $3.2 million later, phase one of the dream was realized, and though not developed to the extent that the wealthy West-chester County river-bordering towns to the north have done, the river park with public access that Carter catalyzed is a thing to celebrate indeed (personal correspondence with Majora Carter, 8/3/05).
6. E-mail from Aviles 8/11/05.
7. Lipson interview 8/11/05.
8. Act-Up is the AIDS Coalition to Unleash Power, a highly effective advocacy organiza-tion in the early years of the AIDS epidemic. ACT-Up used theatrical means of bringing attention to AIDS as a health crisis, successfully pressuring pharmaceutical companies to reduce the cost of drugs, the federal government to approve timely release of experimen-tal medicines into the population, and many other actions.
9. See Chew 2004.
10. See Boal 1998, 9.
11. See Boal, 1998, 22.

12. See Guinier and Torres 2002, 1701.
13. See Weisser 2002, 621.
14. See Weisser 2002, 68.
15. See Habermas 1989, 25-26.
16. See Stallybrass and White 1986.
17. See Fullinwider 1999, 1.
18. See Barber 1999, 10.
19. See Barber 1999, 22.
20. From interview with Aviles, 2005.
21. Aviles 2005.
22. Aviles 2005.
23. Aviles 2005.
24. Conversation with Bessa 8/15/05.
25. Aviles 2005.
26. Christo is an artist known for the enormous scale of his projects that interact with urban and rural landscapes. Works include wrapping landmarks like Pont Neuf in Paris, erecting twenty-four miles of white nylon fence through California's Sonoma and Marin counties, and erecting fifteen-foot-tall "gates" of orange fabric over the pathways of New York City's Central Park. One of the world's best-selling artists, one of his biggest obstacles to realizing his work is obtaining permission from the authorities.
27. Aviles 2005.
28. Cock 2005, personal conversation.
29. Personal conversation with Boal, 1989.
30. Sepulveda, personal correspondence, 2005.
31. Rivas, e-mail, 8/2/05.
32. Aviles, e-mail, 8/2/05.
33. Lipson interview, 8/11/05

Bibliography

Barber, Benjamin R. "Clansmen, Consumers, and Citizens: Three Takes on Civil Society" in Fullinwider, Robert K., ed, *Civil Society, Democracy, and Civic Renewal*. Lanham, Boulder, New York, Oxford: Rowman and Littlefield Publishers, 1999.

Berger, Maurice, ed. *the crisis of criticism*. New York: The New Press, 1998.

Boal, Augusto. *Theatre of the Oppressed*, trans. C. A. and M-O. L. McBride. New York: Urizen Books, 1979.

———. *Legislative Theatre: Using performance to make politics*, trans. A. Jackson. London and New York: Routledge, 1998.

Burnham, Linda, Durland, Steve, and Ewell, Maryo Gard. "CAN Report on the Field," www.communityarts/readingroom/specialprojects, accessed 2004.

Chew, Ron. "Five Keys to Growing a Healthy Community-Connected Museum," keynote speech, 48th Annual British Columbia Museums Association Conference, Nanaimo, B.C., Canada, October, reprint on www.communityarts.net/readingroom, 2004.

Cocke, Dudley. "Tamejavi," in Grantmakers in the Arts, *GIA Reader*, vol 16, #1, (Spring 2004).

Freire, Paolo. *Pedagogy of the Oppressed*, trans. M.B. Ramos. New York: Continuum, 1988.

Fullinwider, Robert K., ed. *Civil Society, Democracy, and Civic Renewal*. Lanham, Boulder, New York, Oxford: Rowman and Littlefield Publishers, 1999.

Guinier, Lani and Torres, Gerald. *The Miner's Canary*. Cambridge, MA: Harvard University Press, 2002.

Habermas, Jurgen. *The Structural transformation of the Public Sphere: An Inquiry into a Category Bourgeois Society*, trans. Thomas Burger. Cambridge, MA: MIT Press, 1979.

Stallybrass, Peter and White, Allon. *The Politics and Poetics of Transgression*. Ithaca, NY: Cornel University Press, 1986.

Weisser, Christian R. *Moving beyond Academic Discourse*. Carbondale: Southern Illinois University Press, 2002.

13

Participating in Artistic Citizenship

Constructing a National Narrative—
Considering the Passion of Terri Schiavo

KAREN FINLEY

Do you believe in the right to die? Under what circumstances would you want to be kept alive? Would you want your parents to intervene if they did not agree with your spouse's medical decisions? Do you feel a society should decide to keep someone alive whose brain is not functioning? If a person is in a persistent vegetative state, should that person be kept on life support indefinitely, no matter what the cost? Do you feel that the president, the Supreme Court, and Congress should be able to intervene and even should go against an individual's wishes about when to sustain life in catastrophic circumstances? Who pays for this care? Should a brain-dead person on life support with no hope of consciousness be given more consideration then terminally ill people who do not receive care? If a parent is unprepared to let go of a brain-dead child, should there be a provision given by the courts to keep that child alive for the sake of the grieving parent?

On March 31, 2005, Terri Schiavo died of dehydration in Florida. Her feeding tube had been removed thirteen days earlier. This woman's death occurred years after an unfortunate series of events that stretched back over fifteen years. It resulted in numerous court proceedings and sparked involvement from Florida governor Jeb Bush, President George W. Bush, members of Congress, Mel Gibson, and religious leaders such as Jesse Jackson and even the Pope.

Following is a brief summary and timeline of the Terri Schiavo case. In 1990 Terri collapsed in her home at twenty-six years of age. The doctors could not determine the cause with any certainty. There are various theories about her collapse. Some claim she had been suffering from bulimia, an eating disorder that involves binge eating and self-inflicted vomiting. She was also being treated with drugs for infertility. It is widely known that bulimia can cause disruption in fertility. At the time of her collapse she had a significantly lowered potassium level, which is consistent with bulimia. Very low potassium can cause a heart attack. A potassium drop is also a result of a heart attack.

After she had been comatose for some time, Michael Schiavo, Terri's husband, was given guardianship of his wife without any objection from her

Figure 13.1 Karen Finley, *The Passion of Terri Schiavo 1*, 2005. Sumi ink and metallic filaments on hand-made paper, 8×11 in.

parents. Michael sued the fertility doctors for not detecting her low potassium levels and won a malpractice settlement in 1992. Michael used the money he won from the court to place Terri in several experimental treatments. None of them worked. In 1993 Terri's parents sued, trying to have Michael Schiavo removed as guardian. They were concerned about the quality of her care as overseen by her husband. The courts could not find any wrong-doing, but they appointed a second guardian for Terri Schiavo, attorney Richard Pearse.

Eventually, based on medical opinion that Terri was in a persistent vegetative state and would not recover, Michael began to petition the courts to have Terri's feeding tube removed. Since there was no written document of Terri's wishes, Michael and other witnesses gave testimony of her oral statements about what she would have wanted. The guardian ad litem, Richard Pearse, asserted that he thought Michael had a conflict of interest in wanting

to remove his wife's life support because of a new relationship he had begun. In 2000, a judge agreed with Michael's request to have Terri's feeding tube removed. In April 2001, her feeding tube was removed for the first time, but it was then reinserted two days later after her parents, the Schindlers, filed an emergency motion based on new evidence. They claimed that Michael lied about Terri's wishes. Although the judge dismissed the motion as untimely, the Schindlers filed a civil suit that claimed Michael had perjured himself concerning Terri's alleged aversion to life support. Pending this new civil trial, a circuit court judge ordered Terri's tube to be reinserted. From April 2001 until the end of Terri's life in 2005, the Schindlers and Michael were in constant legal battles in the District Court of Appeals in Florida. They each tried various methods to end the conflict, including mediation and a new team of five doctors—two from each side and one court-appointed—to examine Terri. Appeals and new claims were brought by each side. Each time the courts mandated that the tube should be removed, her parents would file a new motion. In 2003 the Florida State Supreme Court refused to review the case that the District Court had ruled on. In October, the District Court decided that her tube should be removed. The Schindlers filed a federal lawsuit in response. In October 2003, Governor Bush filed a federal court brief in support of those opposing the removal of Terri's feeding tube. The Florida House of Representatives created Terri's Law, a one-time governor intervention drafted in the style of a stay of execution. The feeding tube was reinserted.

The case went back and forth between parents and husband until eventually the feeding tube was removed for the last time in March 2005, and Terri Schiavo died.

* * * * * * * *

During the last year of this saga, a great deal of public attention was focused on Terri Schiavo and her family members. Why was there such intense interest? What underlying issues did this case raise? My impulsive interest in creatively responding to the Schiavo case is initiated by the enormous, passionate, sentiment expressed on each side of the issue. The tremendous, fever-pitched emotion, although it contains real political, ethical, and moral considerations, becomes a heated exchange of energy—a life force. To me, the Passion is a character, a person, a phenomenon. The Passion is transference; we agonize over whether this person will live or die when meanwhile, halfway across the globe we are at war. We will not consider the lives of others at war with the same Passion we bring to save Terri's life.

The great public interest in the Terri Schiavo story is reminiscent of the interest in the cases of Tawana Brawley, Nicole Simpson Brown, Laci Peterson, Chandra Levy, and Natalee Holloway. It is as though these stories are episodes in an ongoing drama. These stories offer a context in which citizens are drawn

together, in sharing their opinions and passions for a national saga about people they do not know—strangers—in a Terri self-appointed membership society of estrangement. Engagement in the serial story creates an intimacy, of contemplating secret lives, of having and sharing an opinion on a personal plight, a very private matter. The victims become almost biblical, as if they are suffering for our sins. The fascination with the female victim becomes a modern cult of Mary. Will she live? Will she die? Will she be vindicated? Will she maintain her integrity? Is she good? How good is she? Did she ask for it? Did she deserve it? Has she fallen? The female victim reigns supremely with our devoutness in allowing us to project onto her suffering. As we view her vulnerability, we see ourselves. The question of who gets to live or die echoes our collective fear: Who has ultimate control? Why are those killed in Iraq not given the same focus as Terri Schiavo? At the writing of this chapter America has lost over 1,700 soldiers. Over 42,000 Americans have become maimed or mentally ill as a result over this war. By one estimate, from an independent agency, over 40,000 Iraqis have died. There are daily suicide bombings. Yet Terri Schiavo transfixed a nation with her one individual life. Maybe that is the point. The real interest is on one's own individual life worth.

The Schiavo case became a collective emotional outlet for a nation with little to claim its own except for its purchasing power. The precarious outcome of the "dumb woman" saga becomes a temporary distraction for a nation currently at war. The Schiavo case and the saving of Schiavo becomes a place of saving the self, about saving our dumb dependent adult yet child selves. Both sides have independent issues outside of Terri's best interest.

With television as our reality—as reality television becomes both fiction and fiction becomes reality simultaneously—our boundaries of self and individual rights become blurred. We suffer a national character disorder, a constant schizoid splitting. We struggle to survive in a cultural arena of dichotomies. The split over the Schiavo case functions for American society in the same way that splitting or multiple personalities serve a damaged individual: It is a way to cope with trauma. The passion over Terri mirrors a psychotic culture, divided between parent and spouse, between child and adult, between Florida and Pennsylvania.

Although hundreds of people are taken off life support every year, Terri became a national pastime, a place for us to act out as an uneasy, confused society. The divide brings a nation together. Because without her there is no side, no feelings; we become more secure being on any side of an issue than not having an issue.

If Terri is us, then we are collapsed. We have an eating disorder, collapsed as a nation on our dependency on fuel. We have a heart attack; our heart is not functioning any longer; we have no feeling. We have fertility problems—we are infertile; we are dead. We have not taken proper precautions to provide for accidental trauma, or incapacity, yet we have fallen in our youthful age as a nation.

Terri was not responding. She could not see. She was completely dependent on the state. Sounds like America to me....

The following is an excerpt from the longer text, *The Passion of Terri Schiavo*, first performed in the exhibition Navigate at the Baltic Art Centre in Newcastle Upon Tyne, England, on July 1, 2005.

The Passion of Terri Schiavo

ONE

No one loves Terri like I do. No one loves Terri like I do. I can feel Terri. I have spoken with Terri. Terri and I communicate in a way I communicate with no one else. Terri makes me feel alive for she is so dead.

Figure 13.2 Karen Finley, *The Passion of Terri Schiavo 2*, 2005. Sumi ink and metallic filaments on hand-made paper, 8×11 in.

Don't take Terri away from me.

I want to play Terri. I want to play with Terri. I want to give Terri her look. I want to dress Terri.

I am so happy because there is a chance that Terri will stay with us. At the final hour we will have her stuffed. There will be a wax museum look alike of Terri. Terri will be in every wax museum in the world. A taxidermist is offering his services to stuff Terri.

Terri is all of us. Terri could be Jerry. Terri could be Larry. Terri could be Mary. Mary could be Cary. If Terri was Jerry Lewis. If Terri was Larry David. If Terri was Mary Tyler Moore. If Terri was Cary Grant. We are all Terri. Do you hear me? We are all Terri. We all want to go back to a vegetative state in the womb before talking, before movement in the womb. But still we need to live no matter what. If we could be kept alive we would.

Mel Gibson understands Terri. He has never met her. He understands though. Mel faxed his displeasure with Terri's right to die from a Mexican restaurant. He could not spell her name. He had never met her yet he has an opinion. That is what is so incredible about Terri. She inspires people who have never met her to care about her, and to make the decisions that doctors and lawyers and her husband feel they should make. If only Mel could place the wine on Terri's dry cracked lips, Jesus's blood. Terri is being crucified. Terri is being left to die. Terri needs the body of Christ. Terri is an amazing human being.

Arnold Schwarzenegger would take over. Or how about Joan Rivers as Terri? The Seinfeld family could contribute to making a Terri family, in being Terri. Jason Alexander has offered to create a Terri look. The Terri look is a chartreuse green Terri cloth robe. Jason Alexander is a good man. Julia Louis-Dreyfuss will help. She will be there.

Terri stands for Truth Eternal Retribution Religious Internet.

Terri stands for Terminal Energy Radically Realized Internally.

Terri stands for Total Escape Reached Real Intentions.

Don' tell me Terri doesn't stand for something just because she can't stand for herself.

Everyone loves a dumb woman.

TWO

I am holding a cabbage. This is Terri. This vegetable is Terri. Eat Terri. She is this head of lettuce. I love vegetables. I love Terri. Could Terri be a fruit? This watermelon is Terri. Eat your vegetables. This is the body of Christ. The body of Terri.

I cover my body in vegetables. I want to get close to Terri. I want to get into Terri's way of thinking. I need to get into Terri's thoughts. I need to get into Terri's head. Terri, don't leave me. Don't take Terri away from me. When I go to the vegetable store I feel Terri. I see Terri. That's Terri, ladies and gentlemen. This is a vegetative state. Does everyone have to be smart? George Bush

Figure 13.3 Karen Finley, *The Passion of Terri Schiavo 3*, 2005. Sumi ink and metallic filaments on hand-made paper, 8×11 in.

understands what it is like to be in a vegetative state. Terri is about the rights of dumb people.

Everyone who is smart, who thinks for themselves, wants Terri to die. Everyone who is stupid wants her to live like us in a state of not thinking for ourselves. Does everyone have to think for themselves? Does everyone have to think? Can't you just exist? Isn't that what being a couch potato is about? Isn't that what consumer culture is about? Not to think? To be just a body, receiving constant attention and is the object of our desires?

I immerse into a loss of all senses like I immerse into mama. I immerse into the embryonic fluid. I submerge into my state before body, before brain, before infant, into nonexistence. I am the infant Jesus; I am the infant Prince of Peace.

My wife was never happy with who she was and since she was so troubled I fell in love with the female part of her that was troubled and therefore she made my masculine self more powerful.

Terri had an eating disorder. She threw up her food. Do I have to talk about this to you? Do you have to know all the sordid details? Does it make you feel above Terri? Better than Terri? If Terri didn't have that disgusting behavior she would be alive today. Is that what you think? Do you want to know how her teeth began to rot from the bile repeatedly eroding her enamel? Do you want to know about Terri's body image? Her fainting? Does it make you feel safe because you would never be as self-destructive as Terri? You would never end up like Terri?

Our favorite game was piggy. We would lie on the carpet. Stretched out on the rug and I would bring her body over mine. I would lie on my back and she would lie on top of me, her back against my belly. I would hold her and cradle her under me and then we would roll. We would roll over and over the carpet until we hit the wall. And while we would play our little game I would make piggy noises. Piggy noises that would delight her. We would snort and oink. Oink oink. Snort, snort. Terri would join in. Then we would collapse in exhaustion.

You might be wondering how the conversation came up. How did the issue come up? Well, it was after our game of piggy. Terri was in my arms. She looked at me and said, I hope we can always play our games, be children together with our children. Then I made a joke. I said, I can see us getting old in diapers playing piggy. With that Terri grew quiet. She said, "I never want to be dependent, wearing diapers or spoon fed when I am old. Pull the plug. 'Cause if I can't oink … then she laughed and snuggled me with her nose.

What does being alive mean? Terri and I had an intimacy and my love wasn't able to heal her … Should I let her die? Should I keep her alive? Maybe she was already dead spiritually? Maybe her parents killed her? Maybe she is an example of the living dead?

I will love Terri forever. I will never stop loving Terri. That is what Terri means to me. I will not stop loving. For if I stop loving I stop living and then where will we be? If we stop love then we stop life and when we love we live. I love Terri. Let me love forever and ever. I know forever is a long time. But what else is there to do?

What is wrong with being drained of all feelings by caring for Terri? If I have no feelings left, no feelings available will I understand what it is like for Terri to feel nothing? I will exhaust my existence so I can coexist with the nothingness of Terri. Some people want to go to Paris. Some people feel alive listening to Frank Sinatra. Let me go to Terri. I feel alive by knowing there is nothingness in Terri. Maybe by the grace of God I will be able to feel nothingness, the emptiness of Terri. The love of Terri fills the void of my being, the void of my life.

Everything costs something. Money and energy and resources come in all shapes and sizes. It takes many drops of water to make the sea. It is the sea that creates the ocean for the fish. How can we say how much is too much? When are our prayers too much? Is the simple prayer of a child the only prayer that

gets listened to? Maybe we need to keep praying for Terri. Maybe we haven't prayed enough for our prayers to be answered.

Life is expensive. Some houses cost more than others, but they all cost something. How much is too much? Should we have refused to build the pyramids just because they cost so much to build? Terri is like the pyramids. Everyone has to work to build and create and maintain Terri. Terri needs to be kept alive no matter how or what or why because she is the modern answer to the ancient need to preserving life.

You know how it is when you remember what you used to pay for rent and now it doesn't seem so much? That is the same way we need to look at what it costs to pay for Terri. We are paying the price now. We can't live in the future or the past to influence our care for Terri.

I will give all of my life to Terri. I will dedicate myself to her and never receive love or physical affection from anyone else. I will be with Terri only and forever. Terri will be with me. I can't accept another's love because then my bond with Terri will not be as sacred. Everyone wants me to love Terri and no one else. Everyone wants me to love her in the way they hope they will be loved.

I will be her night watchman. I will be her guardian angel, her night light, her bed clothes. I will be her full moon, her starry night, her early dawn. I will be her pet, her special kitty, snuggling close, always at attention. I will be Terri's eyes to see. I will be her ears to hear. I will be her heart, her mind, her spirit. I will experience life for her. I will be waiting for hope and heart that Terri will recognize me. I will wait for Terri to hear my heart. I will wait for Terri.

Waiting for Terri is an ecstatic state from which I will derive my identity and self-worth. I proclaim a romantic sleeping beauty is here to kiss. Let me be her sweet prince. Let her be my Briar Rose. Let me bring my lips to her cold dying love. I am her strength. This is a test of my love of God, which is what Terri is about. Do I have the love it takes to love Terri? Can I be a better person to love Terri? No one can love like I do. A pure, selfless love.

Once you love Terri you cannot love anyone else at the same time. You have to wait until Terri leaves us on her own accord. It is either Terri or me.

The normal life ceases with Terri. Terri's life is a testament to something bigger and more idealistic than our daily life of meals and chores. Terri's life is magnificent. By loving Terri I become magnificent.

My life was once meaningless but now by loving Terri, even though I have never met her, I feel meaning and purpose. Terri is my battery. Terri is my energy, my life force. I have a new attitude toward life. I am not a loser. I work at 7-Eleven. I was never very holy or religious but I have now found God in loving Terri. I see Terri and think, She could be me. And that could be my feeding tube removed. Then where would I be? Dead. That is exactly the point. This is really about me and not Terri. I thank Terri for providing me with a way to love myself and to value my life for I need to love me before I love others and

so by loving Terri I love me and then I love Terri. Terri gave her life for others to love her and identify with her.

Many people who have never met Terri love her. Some people are jealous. Some feel that since they don't know her, they can't know what is best for Terri. Has God ever met you? He knows what is best for you. Have you ever met God? Have you? There you go. We know God is involved and God had this happen to Terri to remind us what God is capable of.

What is a normal life? Is there ever a normal life? Eventually we all die and we all come to see our Maker. Terri reminds us of that every day. That is why Terri needs her own show. Terri needs her own reality TV show so she can be of value to people getting ready to die, either voluntarily or by fate, by the grace of God. The "Terri Show" or "Make Room for Terri," the public will be able to see Terri's every move (document camera) so we can better prepare for what we all will succumb to. Terri can set an example. She is a teacher, that Terri.

Terri is a nickname for Theresa. And that reminds me of Mother Teresa. It is by no accident that Terri is named Theresa. Terri is a saint. If she dies it is because God wants a saint like Terri.

Should her husband ever love again without us ridiculing and judging his emotions? Well, really the only groom for Terri is Jesus. Should he ever love again? Should he ever want to enter another woman? Should he only think about Terri to enter as a woman? Is he to stay in limbo, forever waiting for Terri to never wake up?

I feel that once you make a commitment to love someone you are not allowed to love anyone else, even if your spouse's brain is nonfunctioning. You can never look at another person with sexual feelings or love. Terri's husband should only desire Terri. If he doesn't he will go to hell. The world will cave in.

You can never have a separate existence from your spouse. The possibility of being separate can never exist. Their body is yours, is you, in you. Complete love, commitment, is best expressed in mimicking the bond of mother and child. I beg you to recreate a dependent pregnant state. You cannot escape. The other is you and that is the taboo. Terri is upholding the baby love of mommy and baby.

Yes, you are in agony while loving Terri. When you love Terri's agony, you love the agony of the world. Your loves saves Terri and in turn saves the world. You are not able to love anyone else as much and no one else can ask for as much as Terri can. However much agony is in the world is in Terri. While I am in agony in loving Terri, it is the agony of Terri, her agony, that I love more than my agony. My agony enables me to be empathetic to the agony of Terri and the agony of life. The agony I am in. I am in agony. And Terri is the embodiment of life's agony, my agony. She lives an agonized life and in loving agony, loving Terri, I am saying I am worth loving.

When I say, "I love Terri," I am asking Terri to love me. Love me Terri. Please love all of me. Love all of my shortcomings. Love my selfishness, my hateful self, love my tortured soul.

My life is devastated loving Terri but was it much of a life anyway? Now in loving a life that is worse than mine I can give of what little life I do have to give it to a life not worth living in order to live the life I can.

Those of us who love Terri don't get out much so the media and legal extravaganza is our entertainment. We do not mind the spectacle of people who are devout, confused, disoriented, disturbed, criminal, or insane. Anyone and everyone loves Terri and we do not discriminate. We allow someone to show their love to Terri even if they have no idea what they are saying. People who love Terri do not have to be rational or reasonable. We invite people who do not have their facts right to love Terri and to set their own agenda in matters of faith and state. We invite everyone to live through Terri for all causes. Terri is a champion for the underachievers and the nitwits. Nitwits unite in not knowing much but still loving Terri through it all!

I love Terri like I used to love binge drinking and crystal meth. I love Terri almost as much as I love my daddy whom I never met. I love Terri as much as I love my mother who told me I couldn't do a goddamn thing. I love Terri almost as much as I love my drunk father who porked me when I was four. I love Terri almost as much as I love my mother who beat the shit out of me with a belt while telling me to pray to Jesus. I love Terri as much as I love my sister who burned me with cigarettes. I love Terri more than I love the rapist who got me pregnant. I love Terri as much as my mammogram that I can't afford. I love Terri like fast food and no carbs. I love Terri in a way that I wish I could be loved. I love Terri like I like bowling.

Terri is my to-do list. The night before I see Terri I think of what I can do for Terri and what Terri cannot do for herself. Then I can do those things and then my night has meaning for my day is filled with doing things for Terri. What else would I do? Where else would I go?

Terri is famous. If I met her before her illness I wonder if she would be my friend. I think she would like to comb my long hair and she would tell me what I should do with my make-up. Terri and I would go to church. Terri and I would go to the prom together. If Terri was alive she wouldn't be married to that creep. God knows best but Terri knows even more. For God is Terri.

The most popular female is a victim. We love a female in trouble because we see ourselves in her. And we can help them. They need us. We prefer women down on their luck rather than women in charge. Women in charge are bitches. When a woman is a bitch we are reminded of our dependence on our mothers. With Terri we are in charge. Mommy is not in charge. There is no bitch to fear.

We don't like Hilary. I don't like Hilary. I don't like the way she talks. There is just something about her. I can't put my finger on it. But Terri isn't like that.

Terri doesn't have to lie or say things she doesn't mean because she can't. I identify with Terri. That is why God made Terri.

You asked me if God made Hilary Clinton? Why are you asking me that? Hilary speaks up and out in a way that makes me uncomfortable. Terri is a big pillow that I can lay my heavy head on. With Terri I don't need to think. I don't need to argue to make my point.

I think that we should make a cartoon based on Terri's family. It would be a new show called "The Schiavos" based on "The Simpsons." The husband would be like the man who owns the nuclear power plant. Terri is entertaining. That's right: Terri can be a lot of fun. I have thought about the entertainment pitches for Terri:

"Make Room for Terri." This would be based on "The Simple Life," the show starring Paris Hilton. Terri would travel from family to family, town to town, staying with different families. Terri would be driving them crazy, but they would all be falling in love with Terri.

"Kill Your Idol." This show would be a spin-off of "American Idol." Different catatonic idols would be wheeled around onstage with their caretakers and then each week, America would vote to decide which one of the contestants would be taken off their life support.

I'm not worried. Terri has a winning personality.

Another show would be "Survivor." You would be left on a desert island with twelve brain-dead contestants and you would have to try and keep them alive.

"How to Marry a Millionaire." Twelve bachelors and bachelorettes compete to marry a brain-dead person pretending to be a millionaire.

What are the first five letters of Terrific? Terri. Terri is terrific and we are terrific in loving Terri and keeping her on life support forever and ever.

T E R R I.

The last letters are F I C and those sound out fic –fic –fickle. We can't be fickle in our love and commitment for Terri.

THREE

How can I deny my daughter food and water? Today, I water my plants. Let me water Terri. How can I kill my daughter, to disconnect her from hope, the ever-present miracle? This mystery of faith and life?

For me to agree not to feed her is too painful. It goes against my womb, my uterus, my maternal instinct. If my daughter had been born retarded, or a paraplegic, I would have loved her just as much. Is Terri a vegetable? Is she a savory herb garden, an avocado tree? Is she a flowering pear? Let me stand in her shade. The birds nest in her limbs. Her hand can be held but it cannot hold. The ivy climbs up her back to be a little closer to heaven. The children build their tree house in her arms, play among her branches. I know the modern

Figure 13.4 Karen Finley, *The Passion of Terri Schiavo 4*, 2005. Sumi ink and metallic filaments on hand-made paper, 8×11 in.

ways of cutting timber for a parking lot. I know the look and feel of parched flesh. My flesh. My pain. I water my garden. I put the milk out for the cats. Maybe as parents, that is our job to love our daughter no matter what, and at all costs.

Please, how long was our child married to this man? We raised her. She was our seed, our egg, in my body.

How can we qualify the life force between mother and child? I felt her life in me all through the pregnancy. The nausea, the backaches, the pain of labor, childbirth. Being a mother is painful. But I have my baby. Baby wants to be with us or her life force would have left us.

Terri is our life force, beyond brain and judgment. She is the forever of life. All of my life, my night, my day, I give to Terri.*

* As an artist I do not use traditional, academic research methods. Yet for the purpose of this work I would like to show my process of creative response. I first started responding creatively to the case of Terri Schiavo by responding to e-mails I received. A vast amount of newspaper accounts, blogs, and websites were circulated to me. I started by inventing an imagined television reality show, or rather faux historical sitcom or drama, and envisioning Terri's life with guest celebrities playing Terri, her family, and those involved. I imagined the Terri Schiavo drama as *The Passion Play*. Passion plays are yearly pageants that proceed through neighborhood streets and recreate the walk of Jesus to his crucifixion. With the "passion" in my mind, I then associated to the film *The Passion of the Christ* and the tremendous citizen reaction to the film. For the purpose of my creative response of deconstructing Terri I was concerned about the passion and the unifying emotional bridge. And I was very much aware of the tremendous violence and anti-Semitism associated with Mel Gibson's film. I never saw the film, but it became emblematic of a public discourse—a collective, cultural reference of being on the "right" side of God. After considering the religious aspect that was constant in the divide over Terri Schiavo and in responses to the Gibson film *The Passion of Christ,* I associated to the Rothko Chapel. This chapel with black abstract paintings by Mark Rothko surrounds the walls. The viewer contemplates the depth of the paintings. The Rothko Chapel is in Houston, Texas.

I envisioned a Schiavo Chapel with life-size Rorshachs and the text heard as prayers or meditations. Other methods would be for the viewers to be able to record their responses, which would be heard in succession in the room. The voices would be archived and activated—in some sense a way of having prayers heard and voiced.

From here I started envisioning Schiavo as a Rorshach test. I began making ink paintings with gold and other metallic paints. The style is borrowed from Japanese Sumi technique. You can see an example in this chapter.

In my personal life I have a history of working in nursing homes. I also have family members that I have been involved in "saving" medically. At the time of the writing I had two brothers that were in and out of hospitals.

The ink drawings are to illustrate an abstract, intuitive portraiture of Terri Schiavo. We are to consider the portraits as both representing Terri and as an image of cultural, emotional projection, a national Rorschach test. The images have various exhibition potentials: one, to be projected larger than life as a backdrop during the reading of the performance text; two, to create a drawing as part of the performance; three, to exhibit, create "Schiavo" paintings as in monument, as in the Rothko Chapel. In this case, Terri becomes a place for us to place our relationship with God, self, and religion, a place to provide worship.

Bibliography

Campbell, Joseph. *Joseph Campbell and the Power of Myth*. A production of Apostrophe S. Productions, Inc in association with Alvin Perlmutter, Inc and Public Affairs Television; presented by New York: WNET, Chicago, New York: WTTW, 1988.

"The Message of the Myth." Program 2 (video).

"Sacrifice and Bliss." Program 4 (video).

"Love and the Goddess." Program 5 (video).

Didion, Joan. "The Case of Terri Schiavo." *New York Review of Books* 19 (June 2005).

Friedman, Robert Friedman. "Living Will is the Best Revenge." *St. Petersburg Times* 27 (March 2005).

Hamilton, Edith. *Mythology*. New York: First Bayback, 1942.

Mitchell, Stephen and Margaret Black. *Freud and Beyond, A History of Psychoanalytic Thought*. New York: Basic Books, 1995.

Tallis, Frank. *Lovesick, Love as Mental Illness*. New York: Thunders Mouth Press, 2005.

Contributors

Mary Schmidt Campbell is Dean of Tisch School of the Arts, chair of the Art and Public Policy Department, and Associate Provost at New York University. Her most recent work is *The Life and Work of Romare Bearden* (Oxford University Press, 2004). She served as New York City Commissioner of Cultural Affairs from 1987 to 1991 and as executive director of the Studio Museum in Harlem from 1977 to 1987. Prior to those appointments, she was curator at the Everson Museum of Fine Arts in Syracuse, New York, from 1974 to 1976.

Jan Cohen-Cruz is Associate Professor in the art and public policy and drama departments at New York University. She has codirected or produced Experimental Theatre Project, Inc.'s experimental and activist performances in rural and urban settings beginning in the 1980s. Her most recent book is *Local Acts: Community-Based Performance in the United States* (Rutgers University Press, 2005) and *A Boal Companion: The Joker Runs Wild* (Taylor & Francis, 2005).

E. L. Doctorow is Lewis and Loretta Glucksman Professor in American Letters in the English department at New York University. He recently published two works: *The March* (Random House, 2005) and *Sweet Land Stories* (Random House, 2005).

Karen Finley is Professor of art and public policy at the Tisch School of the Arts. She received an MFA from San Francisco Art Institute and performs and exhibits her work internationally. As well as being an artist and performer, she is the author of six books, her most recent being *George and Martha* (Verso, 2006).

Randy Martin is Professor in the Department of Art and Public Policy and Associate Dean at New York University's Tisch School of the Arts. His most recent publications are *Financialization of Daily Life* (Temple University Press, 2002), *On Your Marx: Rethinking Socialism and the Left* (University of Minnesota Press, 2001), and *Critical Moves: Dance Studies in Theory and Politics* (Duke University Press, 1998).

Toby Miller is Professor of English, sociology, and women's studies at the University of California at Riverside. He is a contributing author in *Global Hollywood 2* (British Film Institute, 2005) and *Companion to Cultural Studies* (Blackwell, 2001), and he recently became coeditor of *Social Identities: Journal for the Study of Race, Nation, and Culture.*

Arvind Rajagopal is Associate Professor of culture and communication at the Steinhardt School of Education at New York University. He is the author of *Politics after Television: Religious Nationalism and the Retailing of Hinduness* (Cambridge University Press, 2001). He was also guest editor of *Social Text* No. 68, on technologies of perception and the cultures of globalization, and is coauthor of *Mapping Hegemony: Television News and Industrial Conflict* (1992).

Richard Schechner is Professor of performance studies at New York University. He is long-time editor of *The Drama Review: Journal of Performance Studies*. In addition, he is author of *Performance Studies: An Introduction* (Taylor & Francis, 2002).

Gail Segal is Assistant Arts Professor in the graduate film department and serves on the faculty advisory board of the art and public policy department at Tisch School of the Arts at New York University. She has worked in the documentary film community in New York City for over twenty years. Her film and video credits include the 1999 Peabody Award winning film *Arguing the World*. She is also an accomplished poet and writer. Her poems have been published in many journals and magazines; she has also written a book, *In Gravity's Pull* (IML Publications, 2002).

Ella Shohat is Professor of both Middle Eastern studies and art and public policy at New York University. Her work includes *Multiculturalism, Postcoloniality, and Transnational Media* (Rutgers University Press, 2003), *Dangerous Liaisons: Gender, Nation, and Postcolonial Perspectives* (coedited, University of Minnesota Press, 1997), *Talking Visions: Multicultural Feminism in a Transnational Age* (MIT Press and the New Museum, 1998), and *Forbidden Reminiscences* (Bimat Kedem, 2001).

Robert Stam is Professor in the cinema studies department at New York University. His most recent works include *Literature through Film: Realism, Magic, and the Art of Adaptation* (Blackwell, 2004) and *Multiculturalism, Postcoloniality, and Transnational Media* (co-edited with Ella Shohat, Rutgers University Press, 2003) (Rutgers University Press, 2006), *Francois Truffaut and Friends: Modernism, Sexuality, and Film Adaptation*, and *Flagging Patriotism: The Dilemma of Patriotism in Transnational Perspective* (Routledge, 2006).

Ngũgĩ Wa Thiong'o is Director of the International Center for Writing & Translation and Professor of English and comparative literature at the University of California at Irvine. He is an accomplished author of works including *Weep Not, Child* (Heinemann, 1964) and *Penpoints, Gunpoints and Dreams: The Performance of Literature and Power in Post-Colonial Africa* (Oxford University Press, 1998) and is the founder and editor of the Gikuyu language journal *Mutiiri*.

Deborah Willis is Professor in both the photography and imaging and Africana studies departments at New York University. She has pursued a dual professional career as an artist and as a leading historian of African American photography and curator of African American culture. She was appointed as a MacArthur Fellow in 2001. Past exhibitions of her work include *Regarding Beauty* (University of Wisconsin, 2003), *Embracing Eatonville* (Light Works, 2003–2004), and *HairStories* (Scottsdale Contemporary Art Museum, 2003–2004).

George Yúdice is Professor of American studies and Spanish and Portuguese languages and literatures at New York University. He is also director of the Center for Latin American and Caribbean Studies at New York University and director of the Privatization of Culture Project for Research on Cultural Policy. He is the author of *The Expediency of Culture: Uses of Culture in the Global Era* (Duke University Press, 2003).

Index